INK THERAPY
SATISFYING YOUR NEED TO BLEED
COMPILED & EDITED BY INK4AUTISM

INK THERAPY CONTRIBUTORS

CHRIS 'CEBE' BURKE
COSMIC PRIMATE TATTOO, HATBORO PA
TRAVIS 'BONES' DALLAIRE
LOST ANCHOR TATTOO PARLOUR, BOWMANVILLE ON
JENNY GODIN
JGCOMICS.COM
RICK KEMPF
UNITED TATTOO, EL MIRAGE AZ
QUENTIN 'TROLL' KILLIAN
DERMAWERX CUSTOM TATTOO, HELENA MT
LEE LARABIE
THE RED DRAGON TATTOO PARLOUR, TORONTO ON
JENNIFER LEONARDI
LEONARDI TATTOO, SACRAMENTO CA
DYLAN MCCRAE
BLACKWATCH TATTOOS, OSHAWA ON
LUCKY MCGOVERN
ONE SIXTEEN TATTOO, MANTECA CA
JESSE NESSE
NUCLEAR INK, OMAHA NE
LEO OLIVEIRA
LEO BRAZ TATTOO, GOIANIA BRAZIL
KEVIN ONEILL
DON OSBORNE
SPARKLE CITY TATTOO, SPARTANBURG, SC
ISRAEL PENA
UNITED TATTOO, EL MIRAGE AZ
MICHAEL PENA
JOHN RIENDEAU
EVOL INK STUDIO, BIRMINGHAM AL
BILLY JOE SHEDD
PSYCHO CLOWN TATTOO, FORT WORTH TX
CHRISTOPHER 'PER' SIMMONS
LUCKY IN LOVE TATTOO, MORGANS POINT TX
DAZ TATTS
SIN CITY INK, LAS VEGAS NV
SCOTT TERRY
STEVE THOMPSON
ONE SIXTEEN TATTOO, MANTECA CA
COLLIN VANKOUGHNETT
MAD BOHEMIAN TATTOO, BOWMANVILLE ON

Ink4Autism is a worldwide collective of tattoo shops that ink autism themed tattoos with a portion of the proceeds being donated to autism services. Over 275 tattoo shops from 11 different countries participate and have raised over $90,000 since 2012. For more information visit www.Facebook.com/Ink4Autism.

All images copyright by the respective artists. Copyright © 2016 Ink4Autism. All rights reserved. No part of this book may be reproduced or copied in any manner without prior written permission from the publisher.

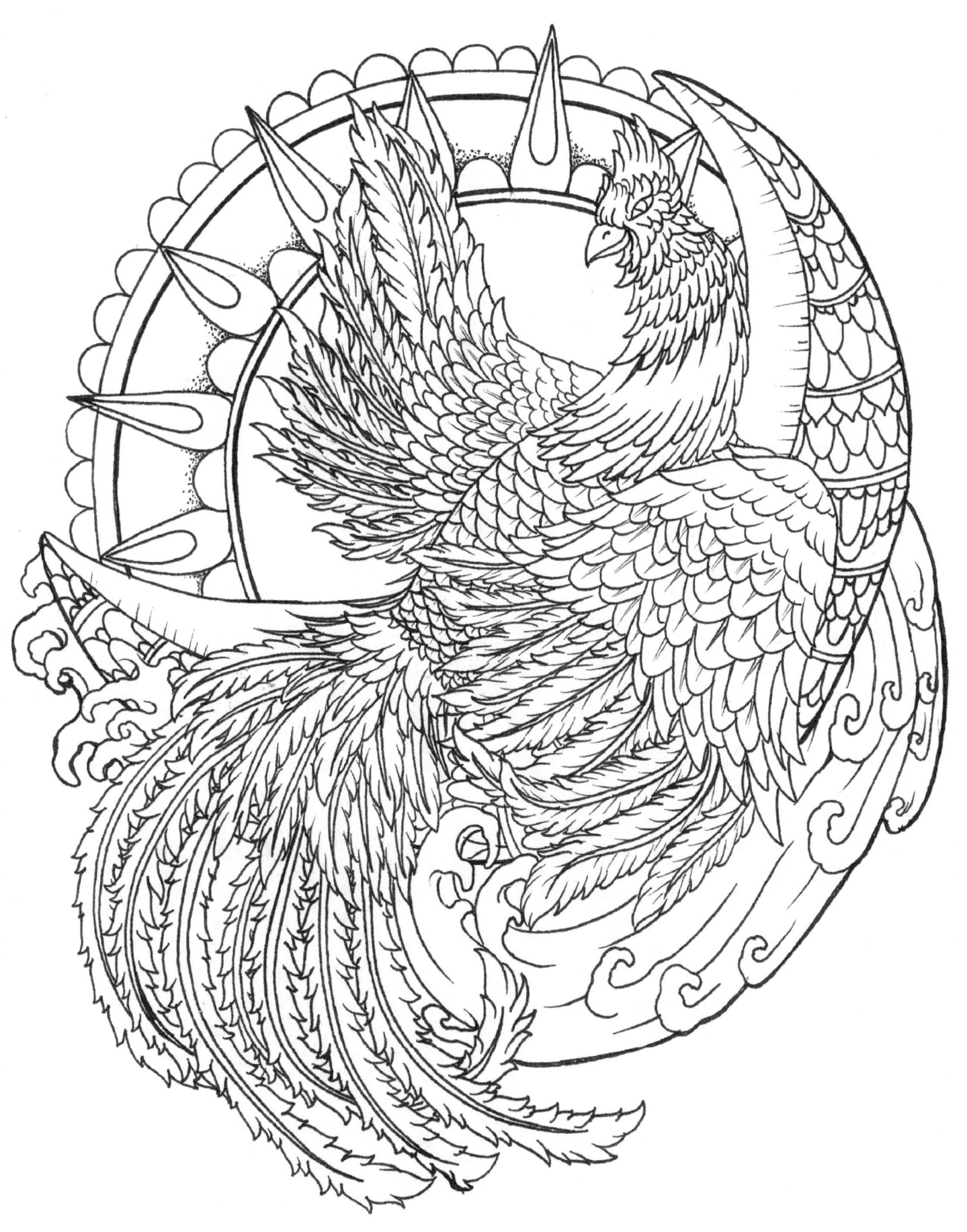

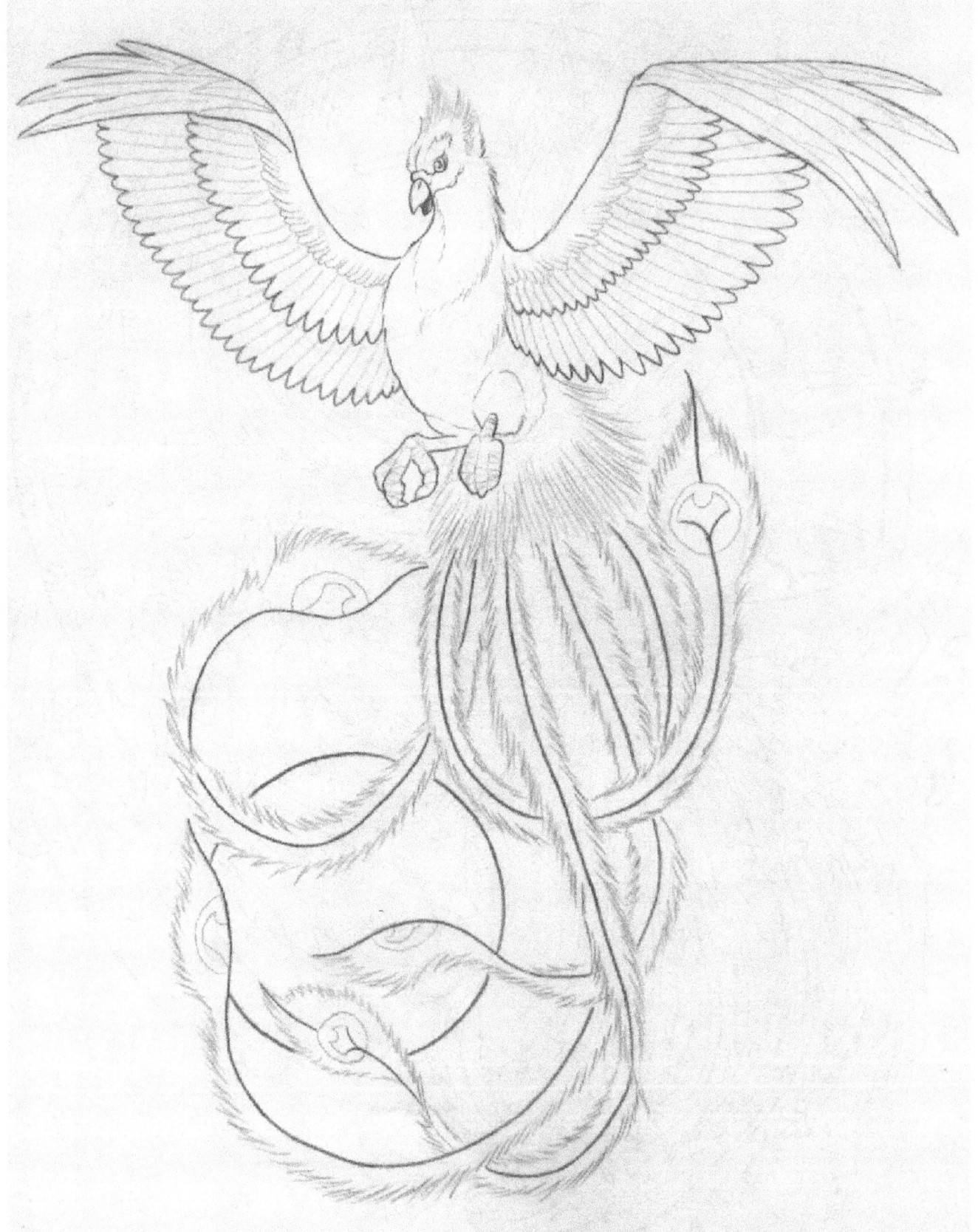

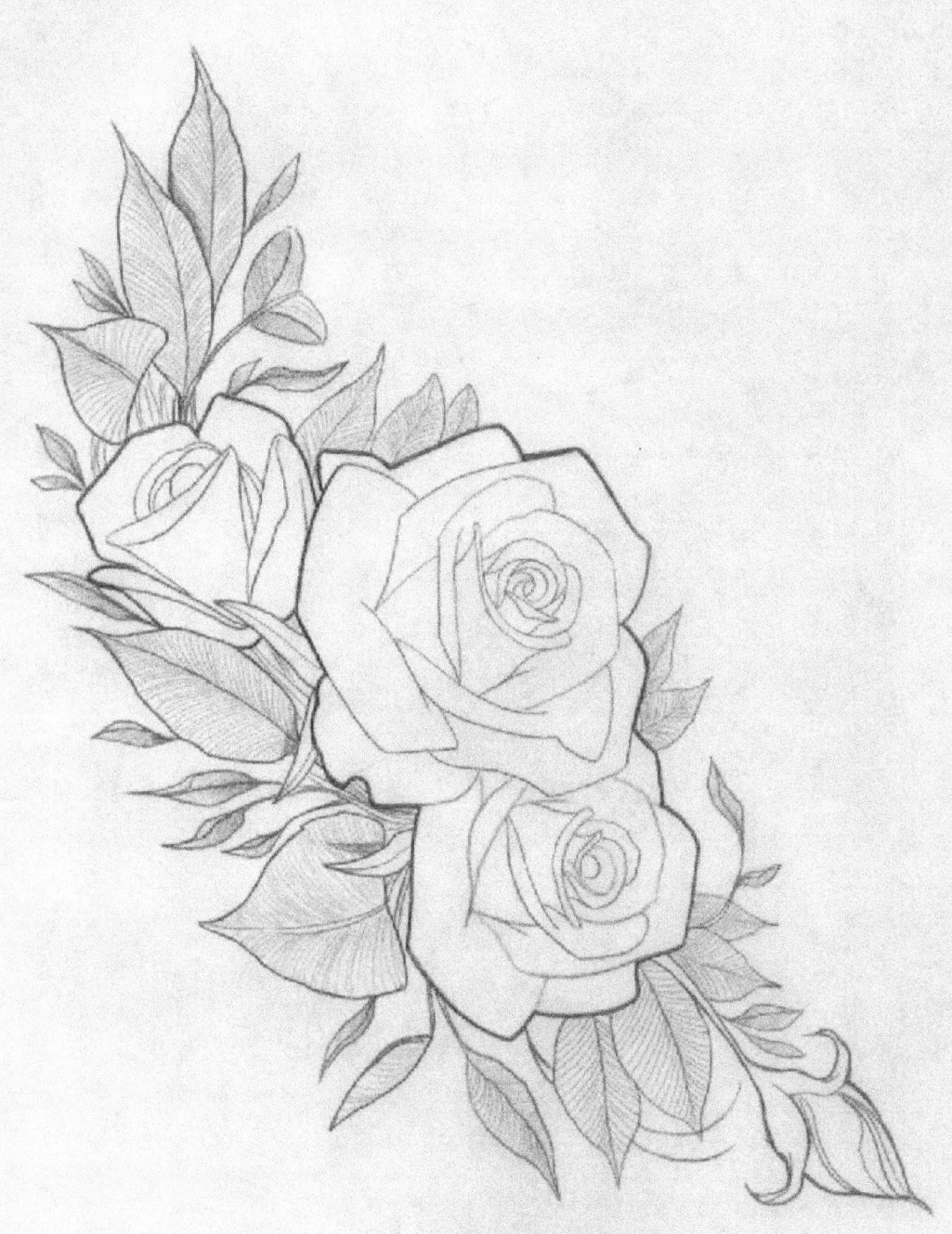

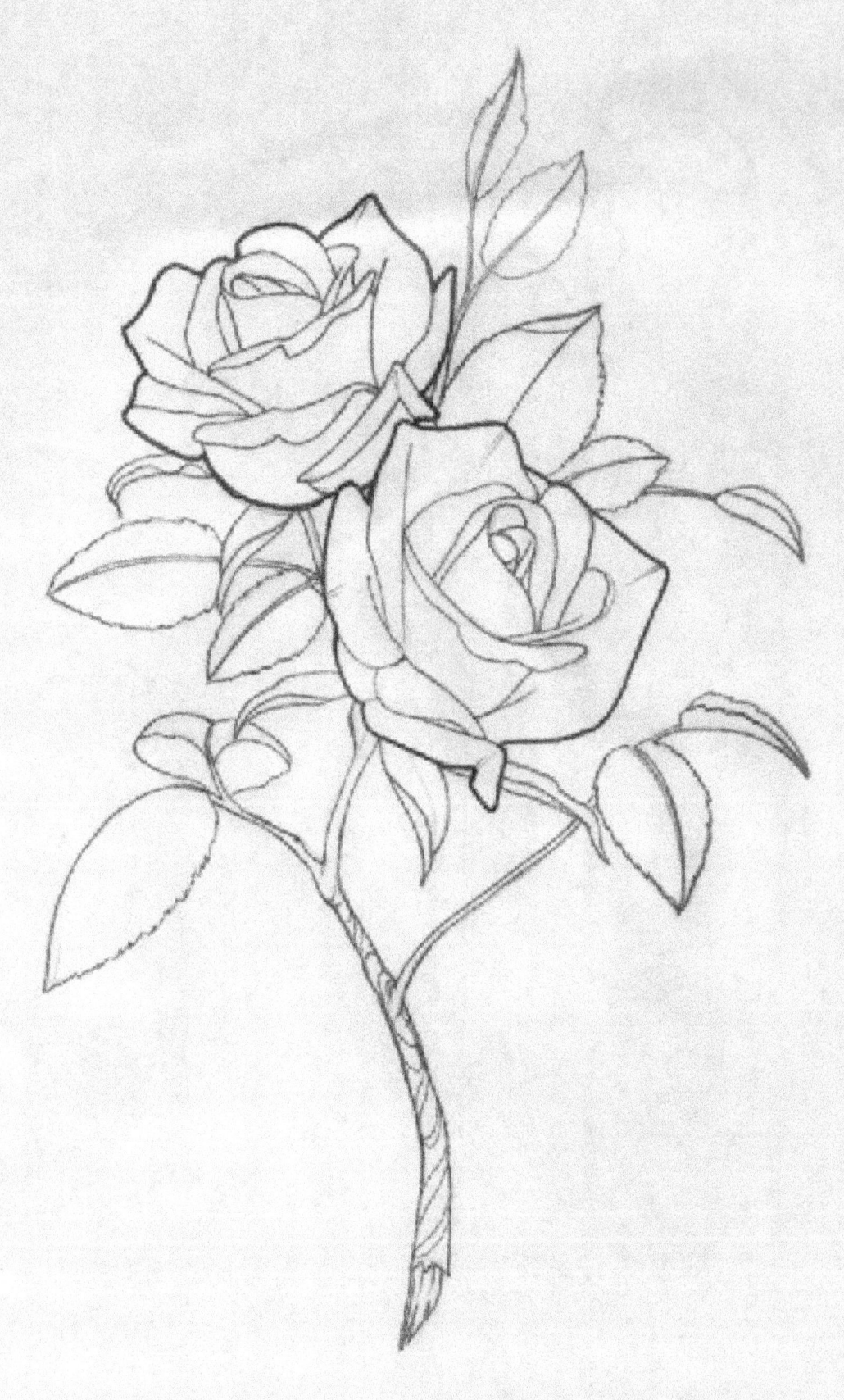

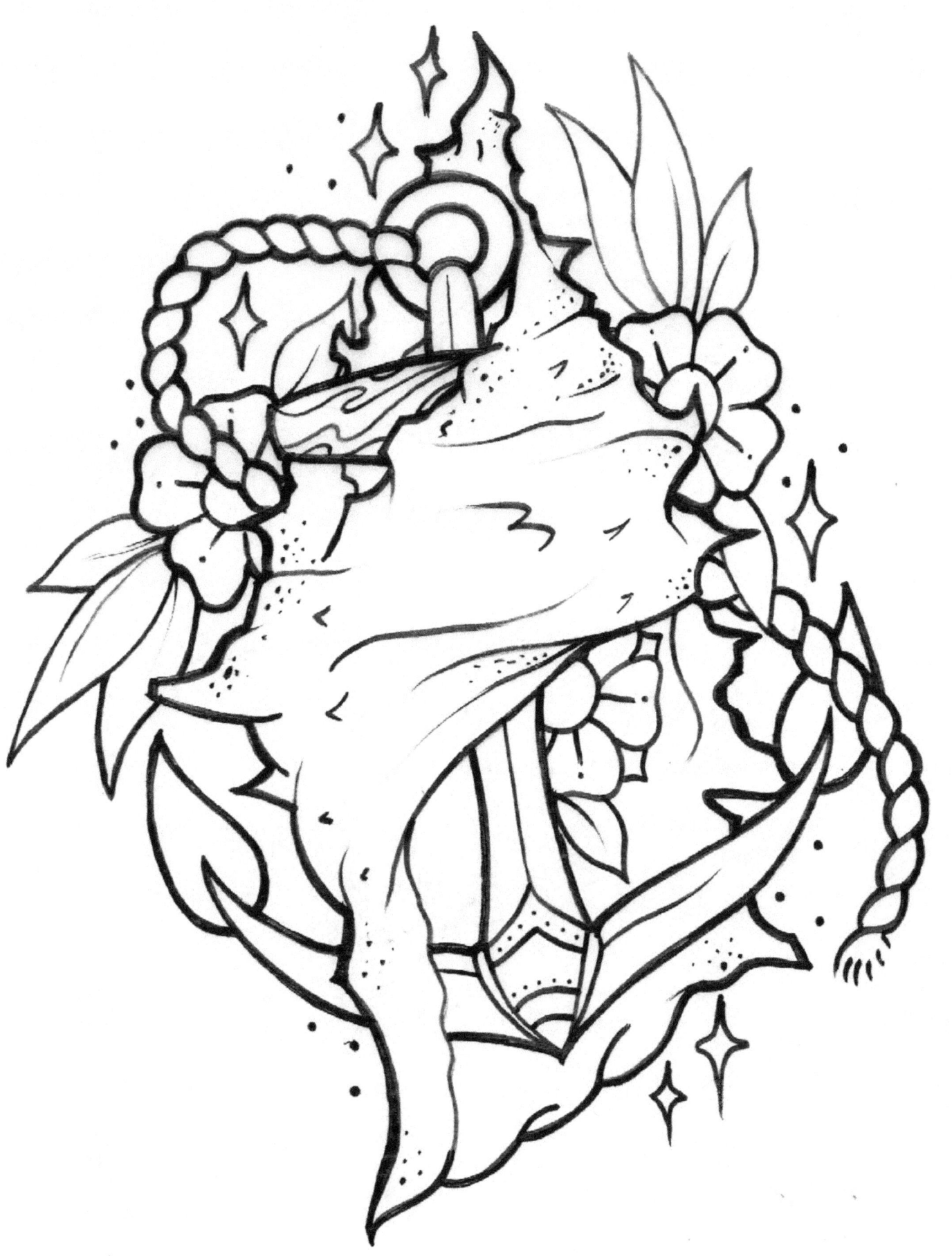

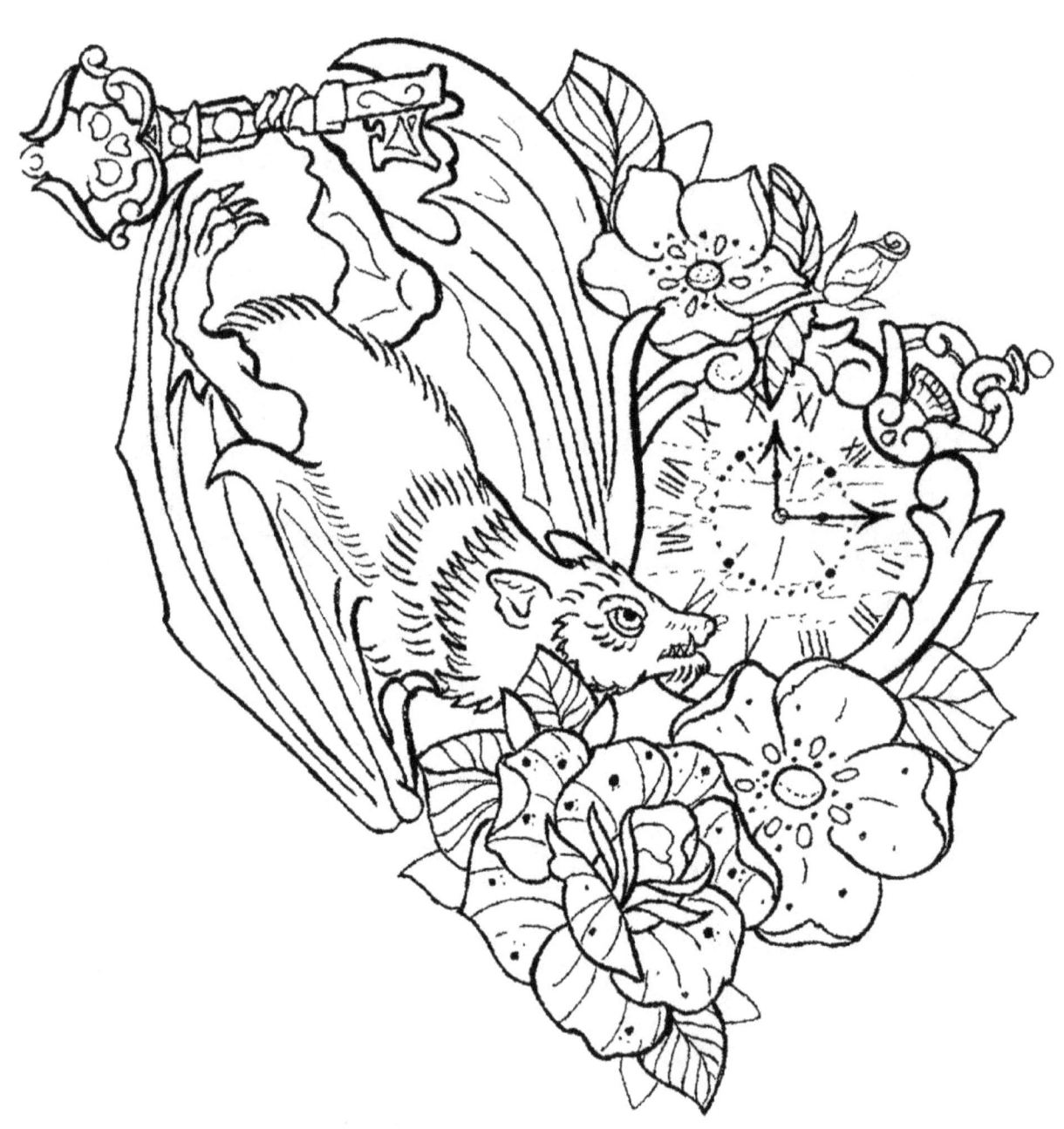

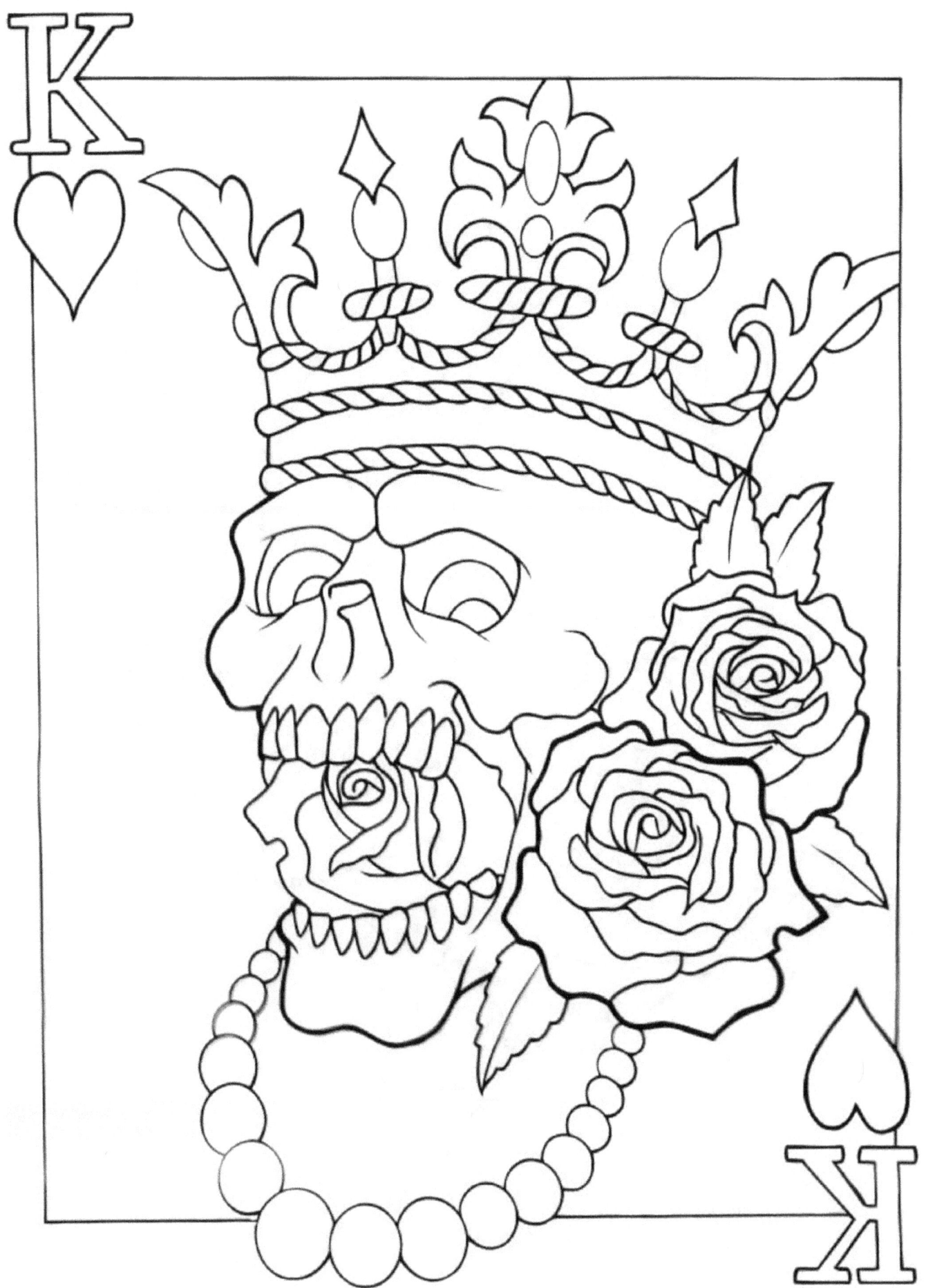

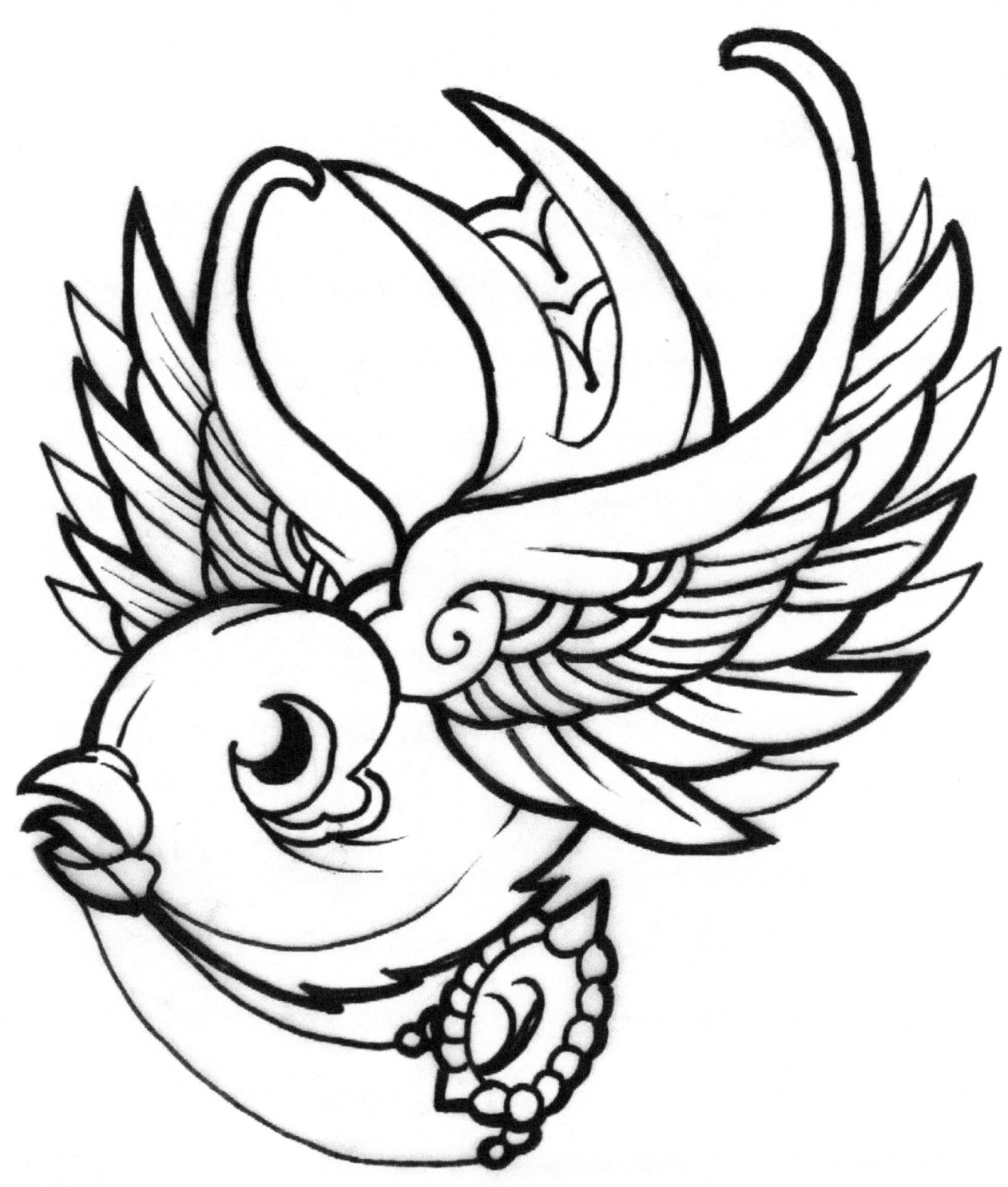

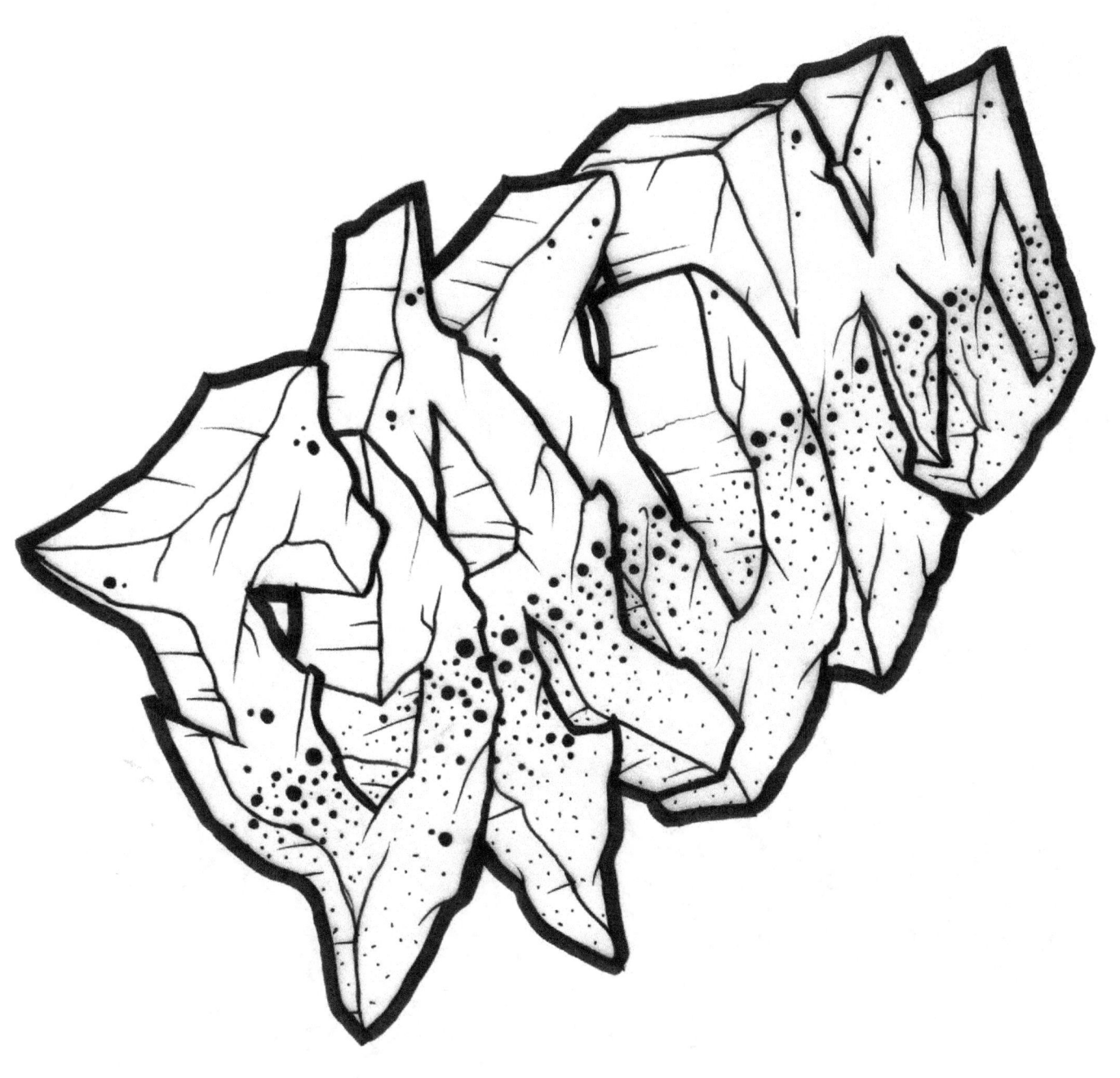

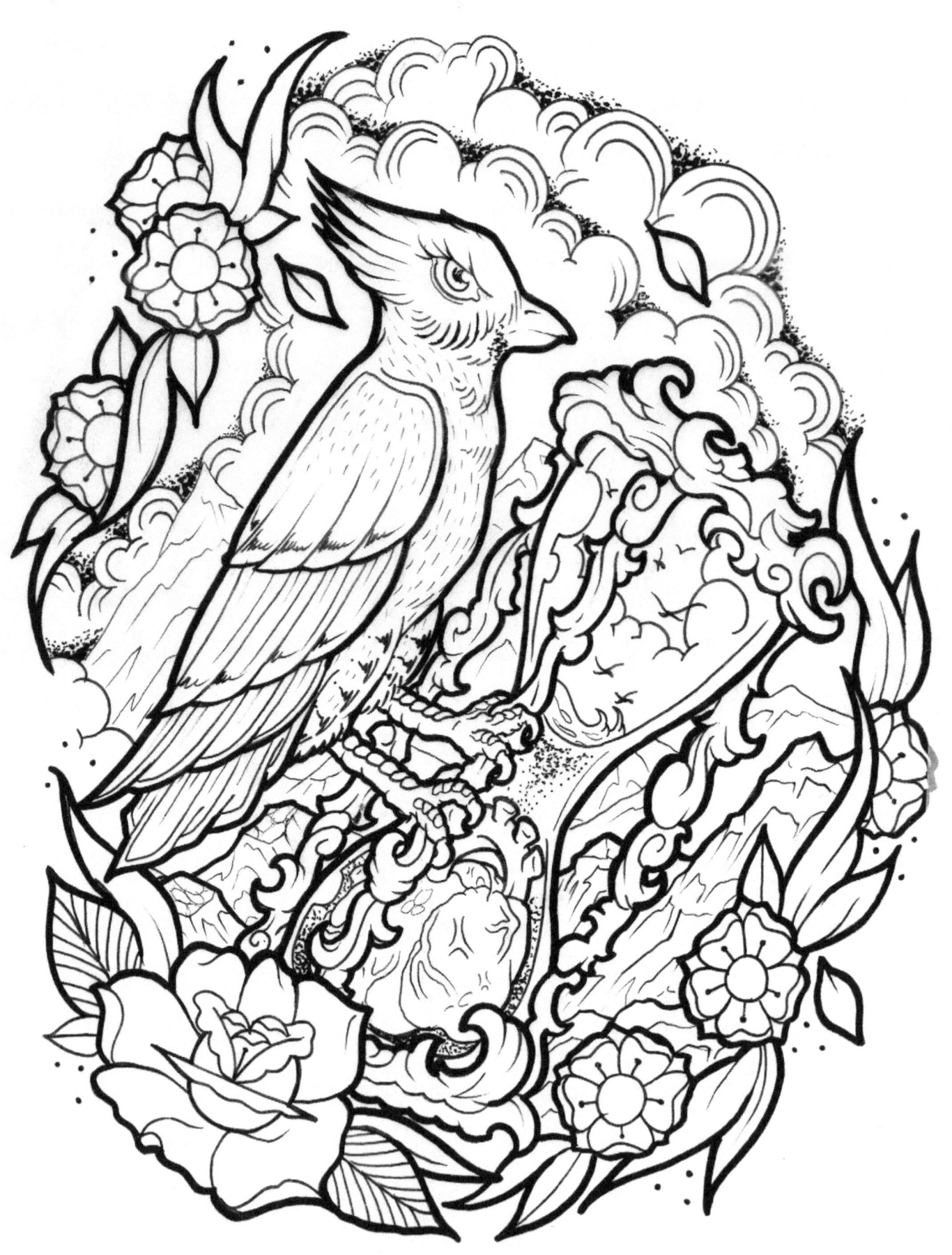

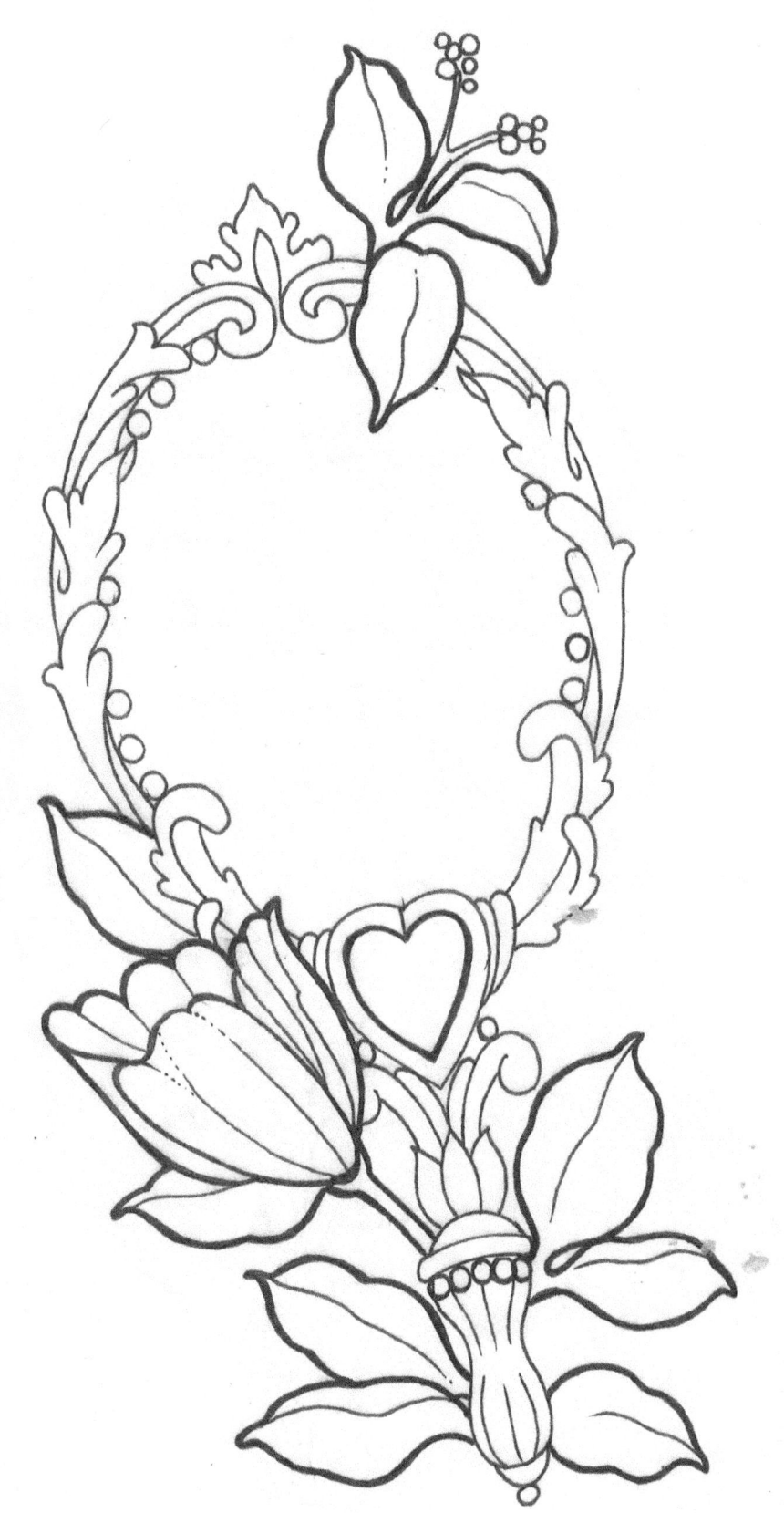

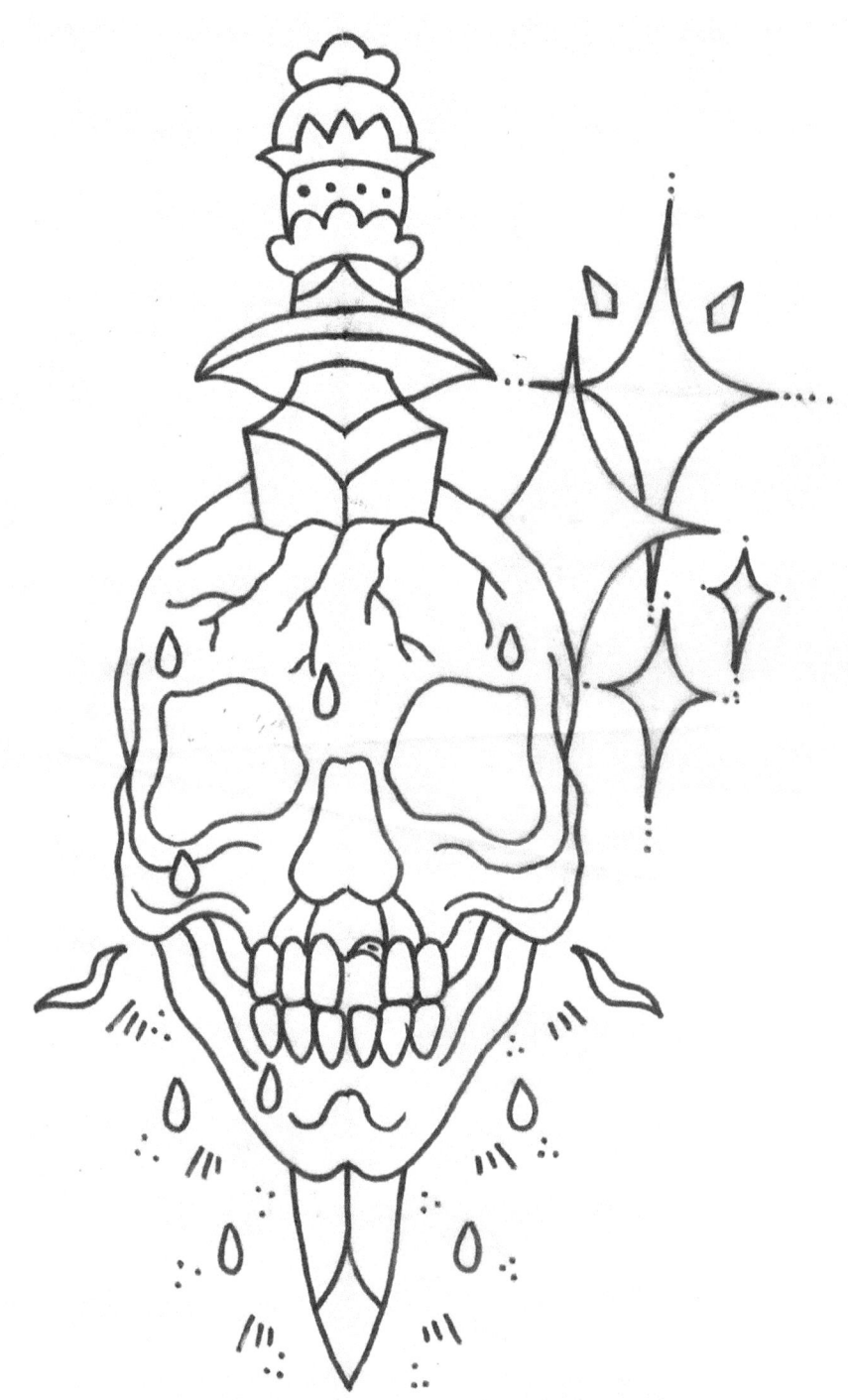

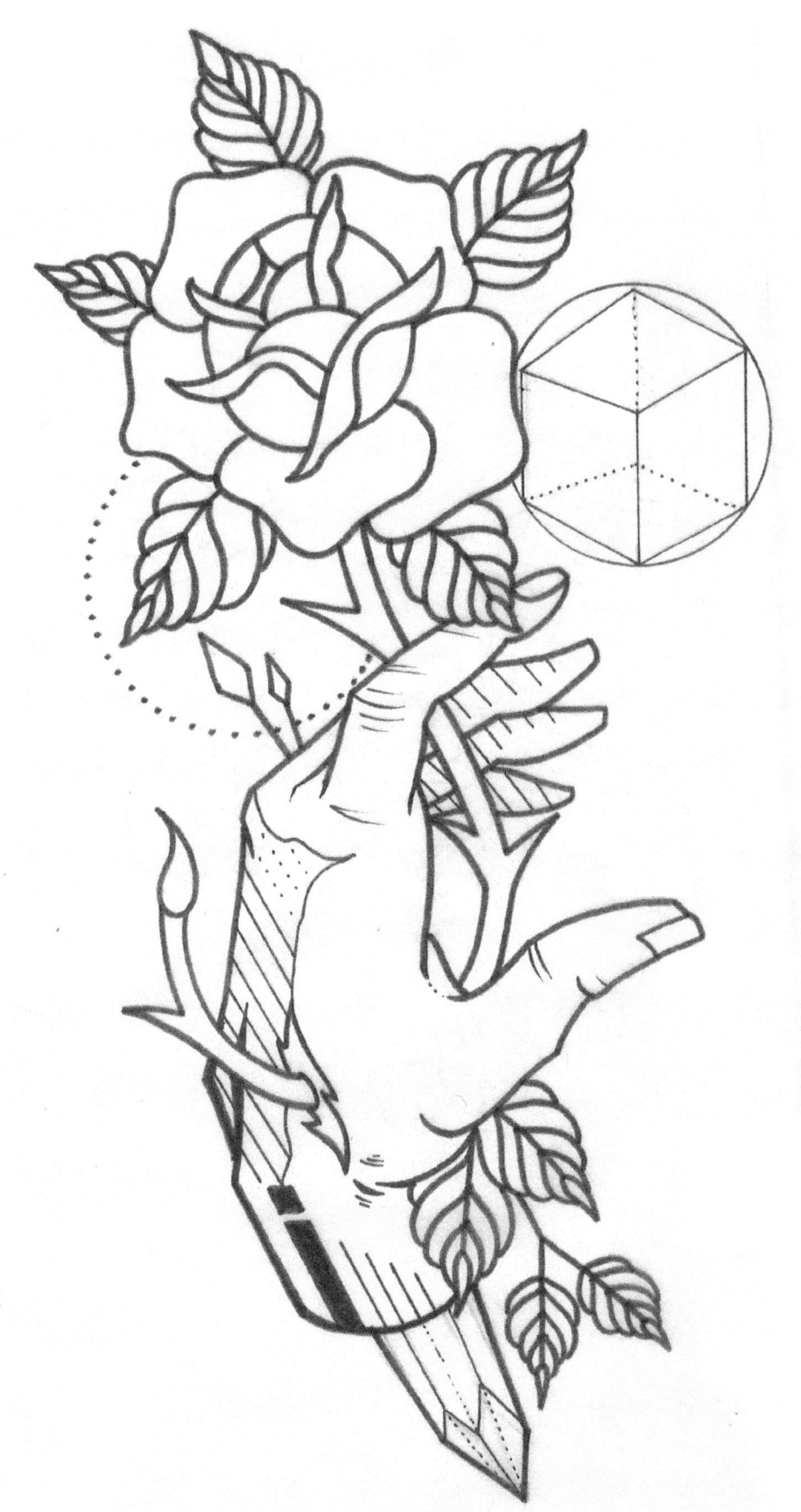

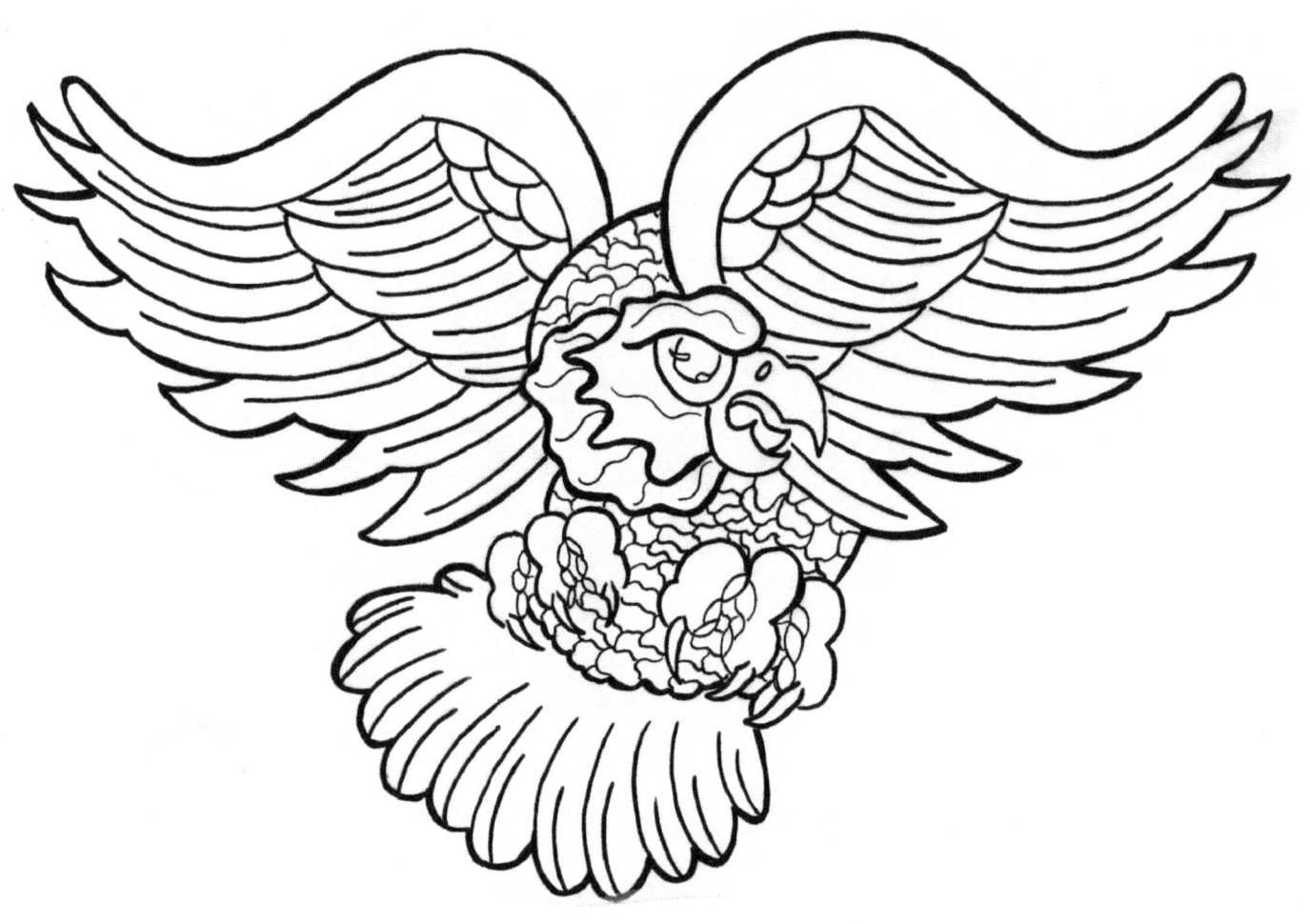

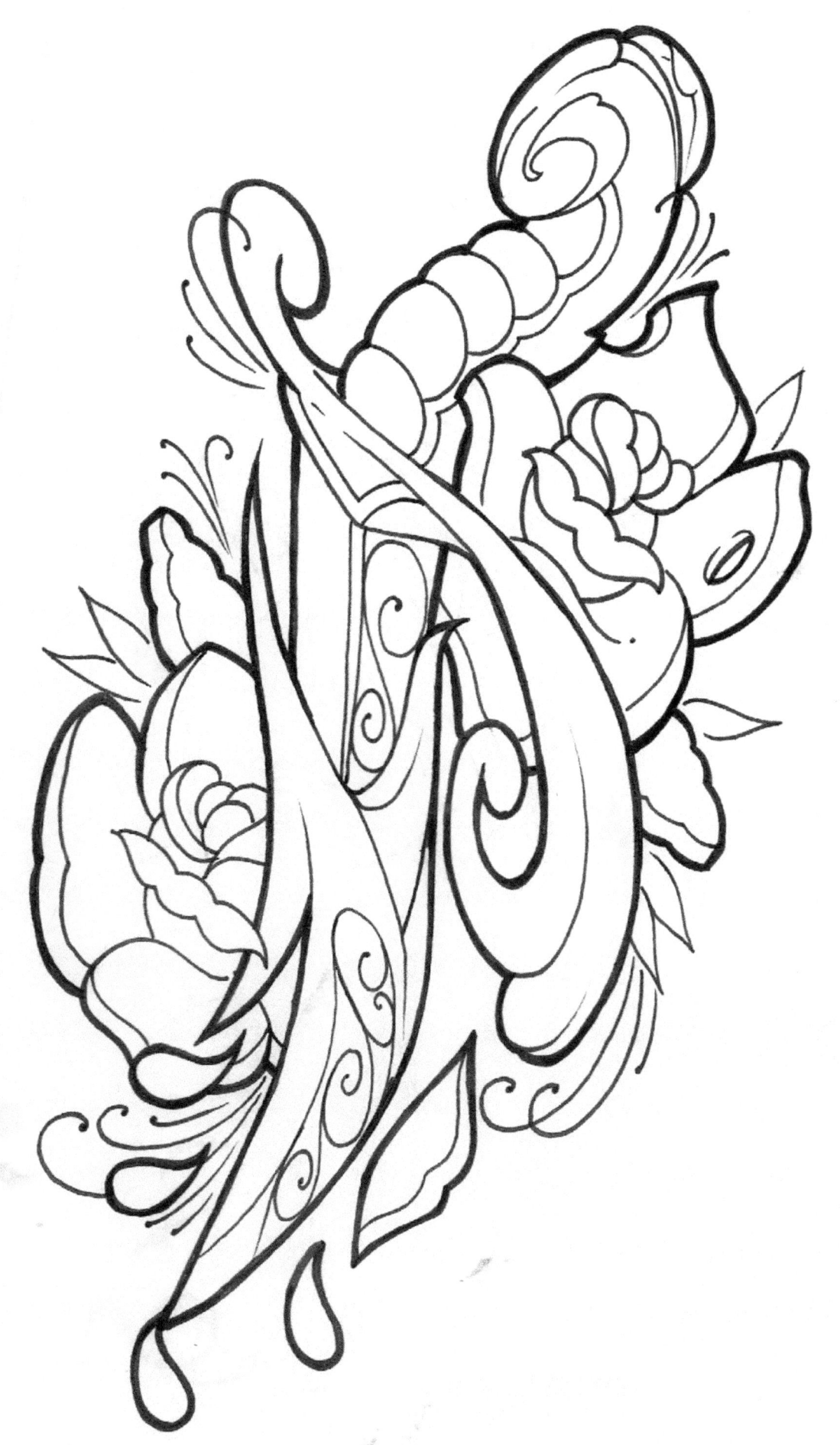

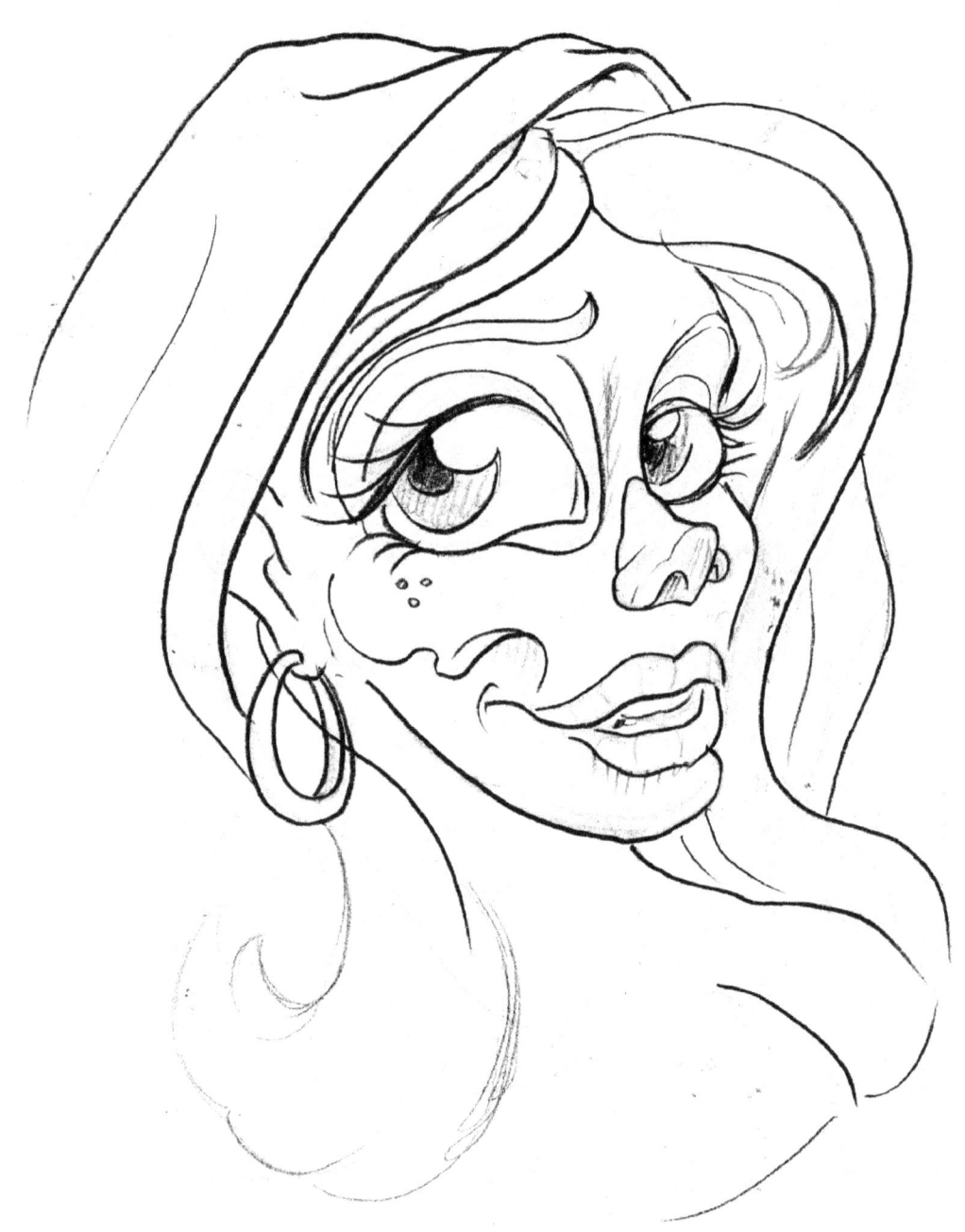

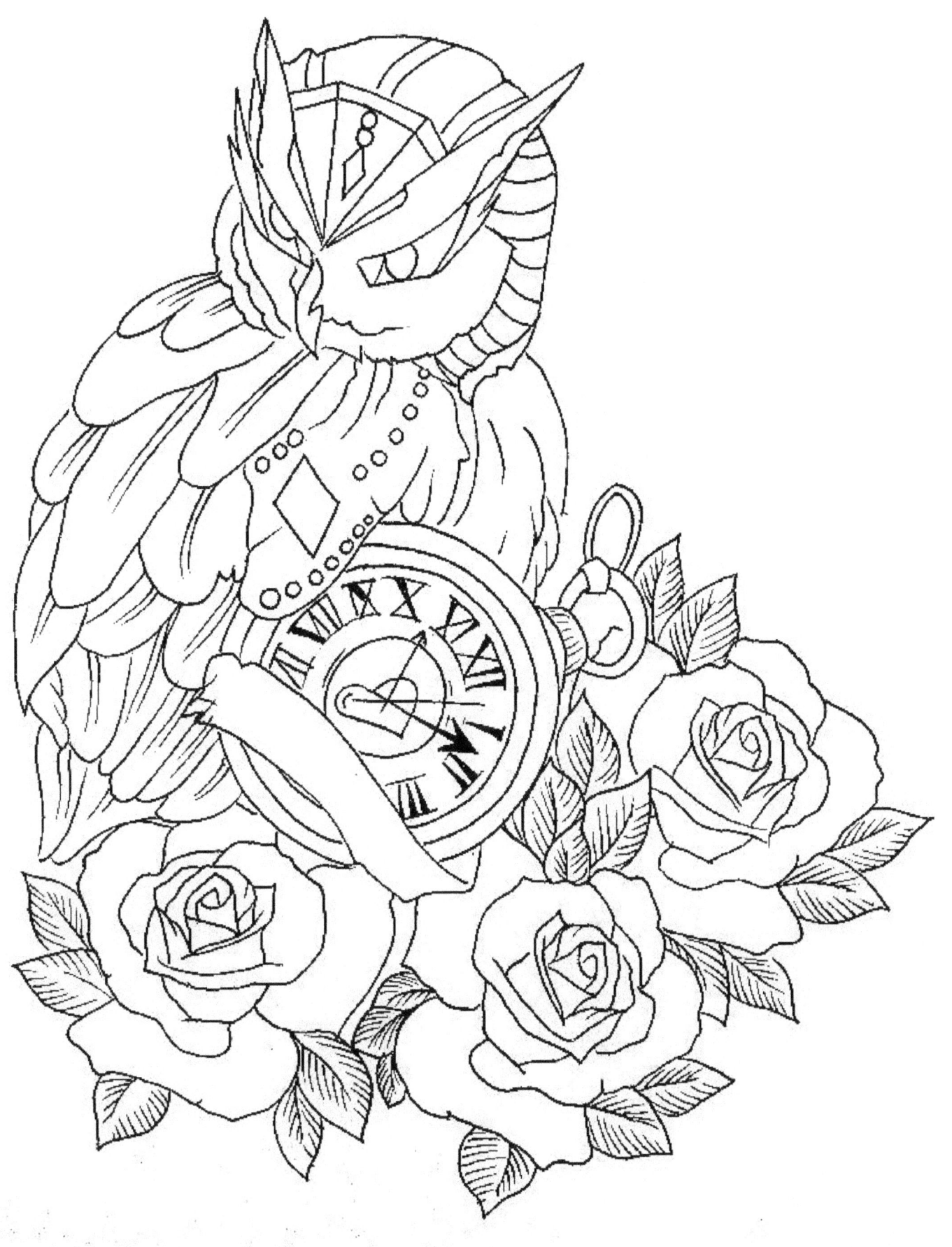

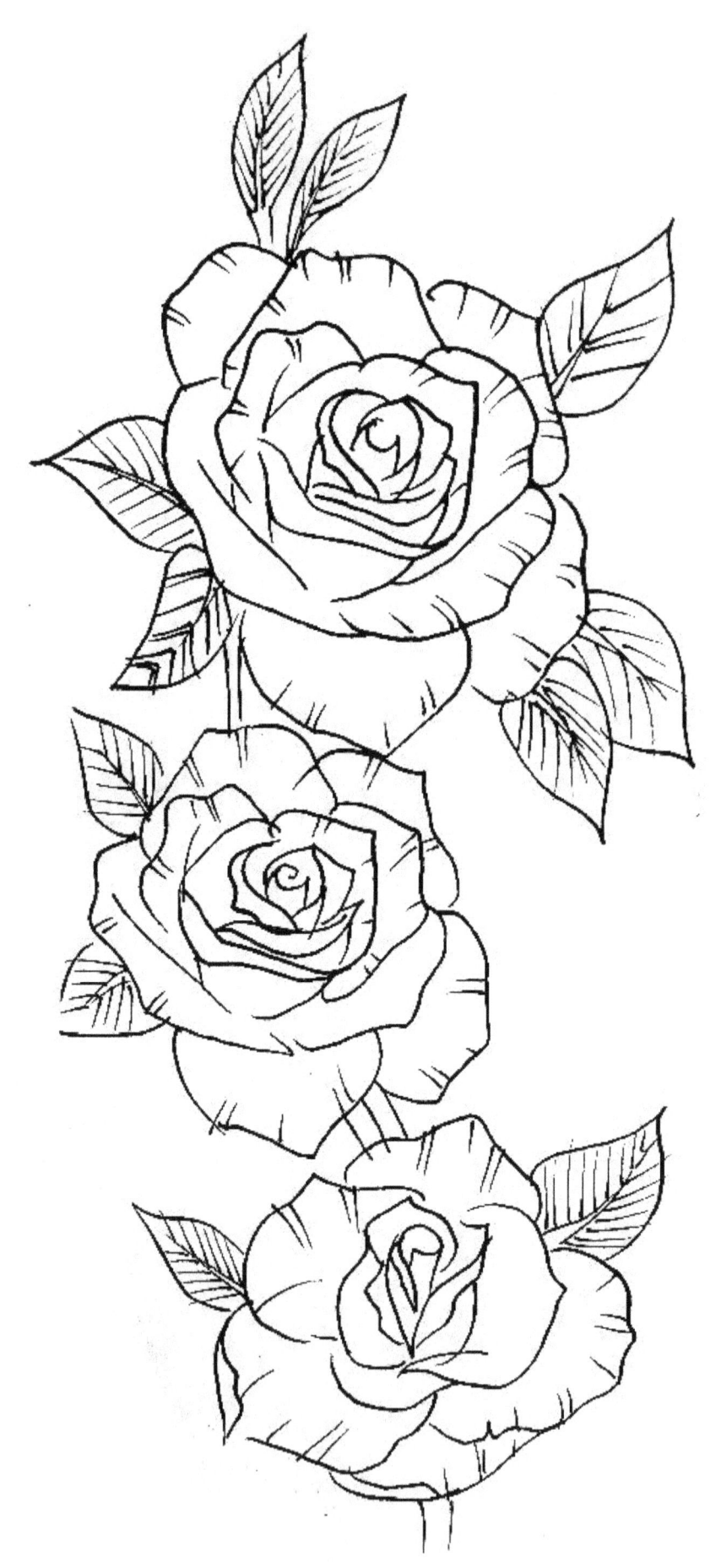

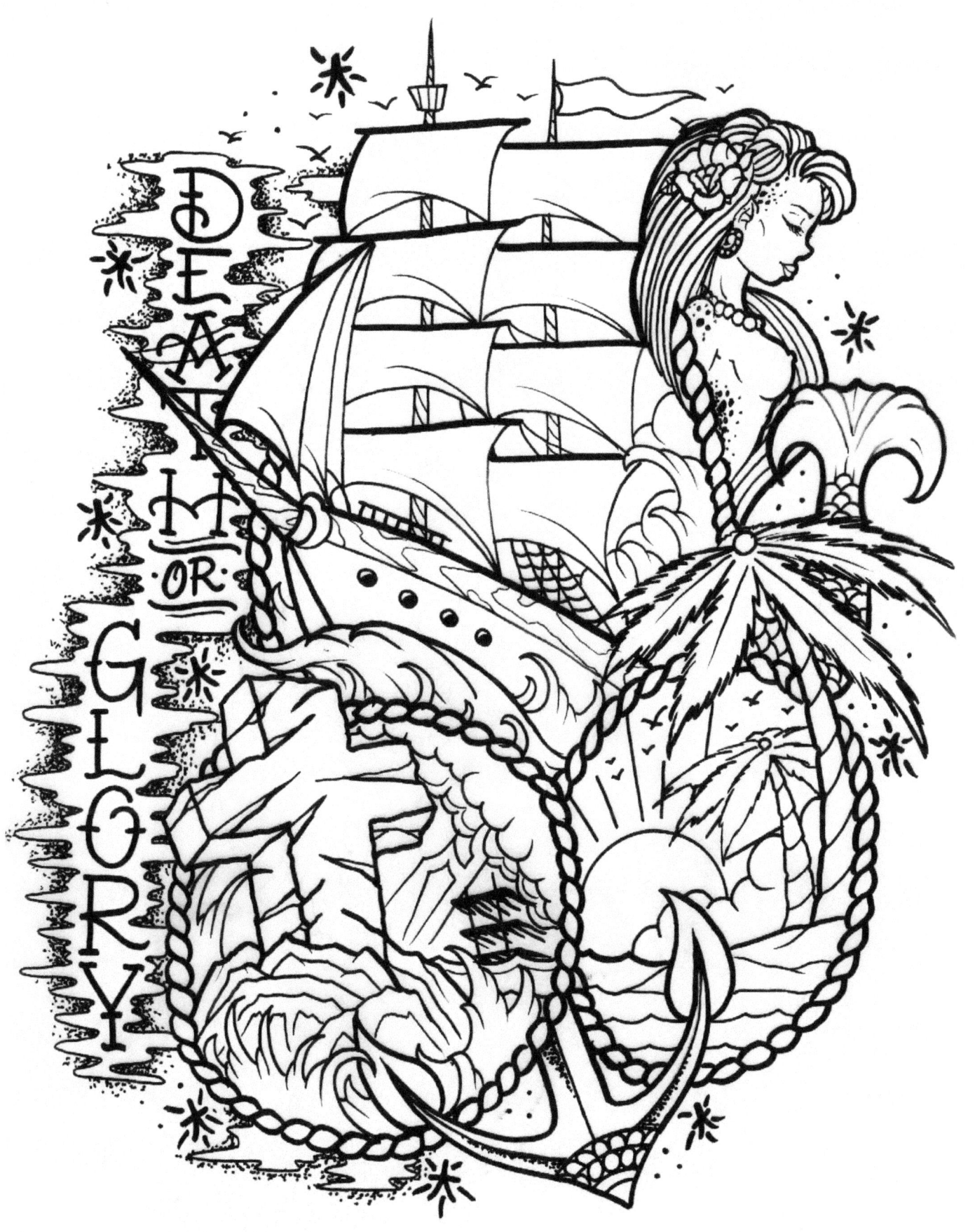

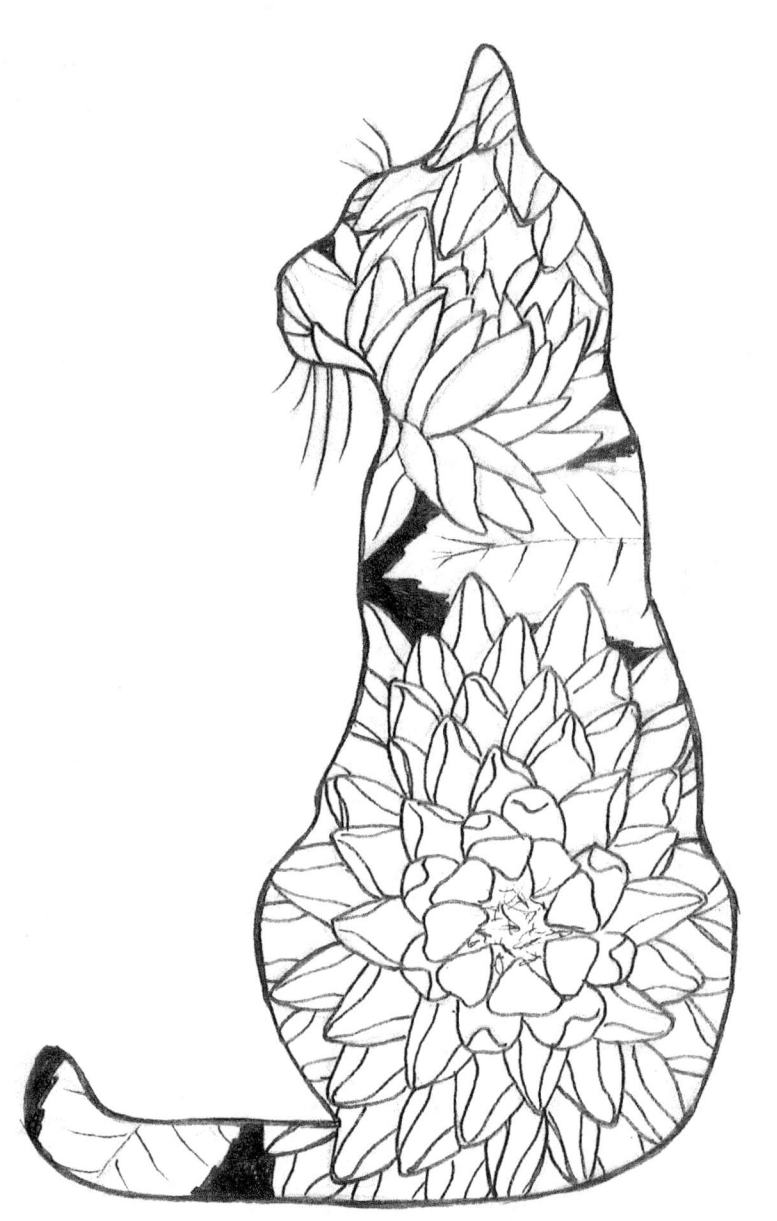

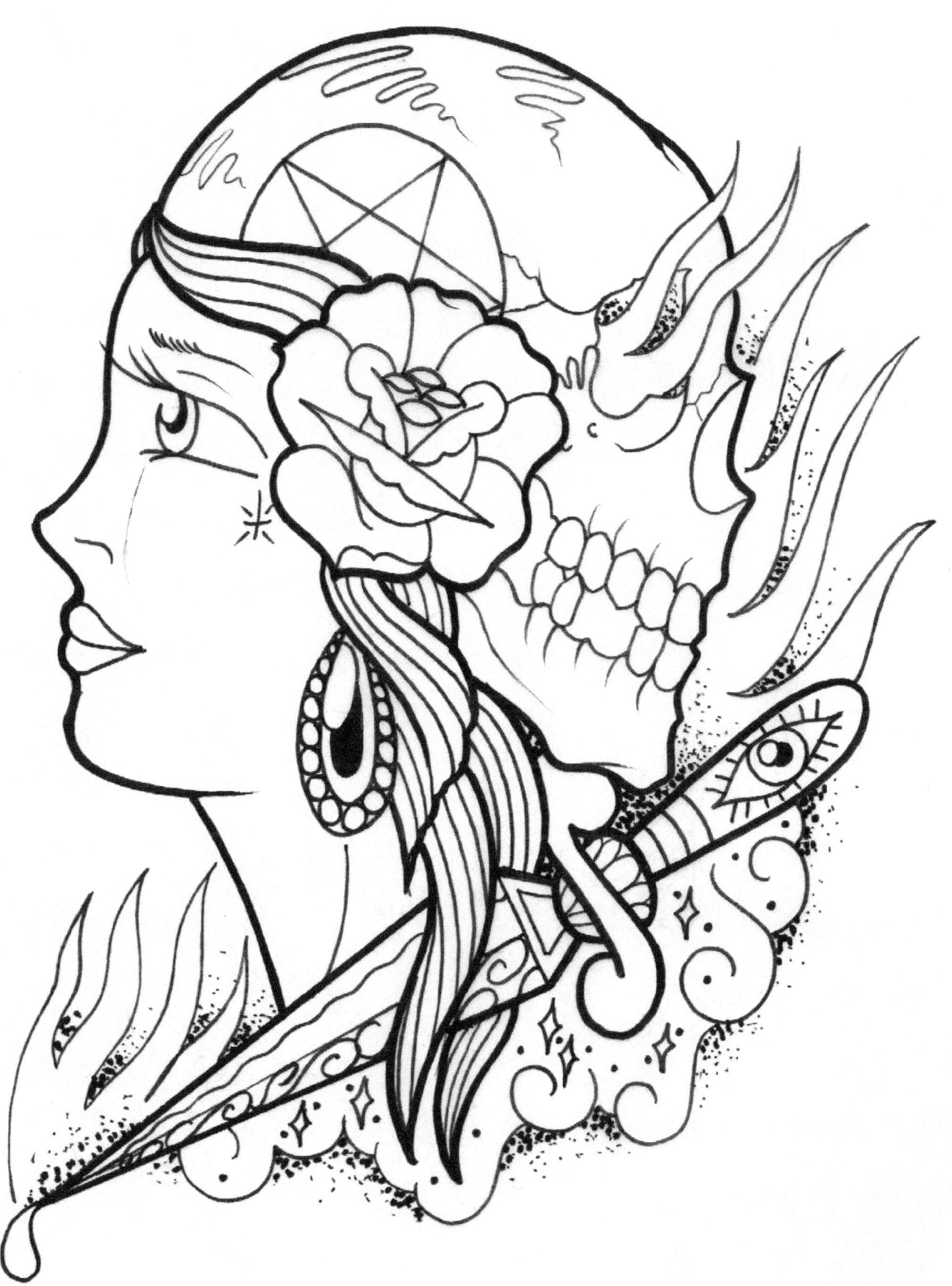

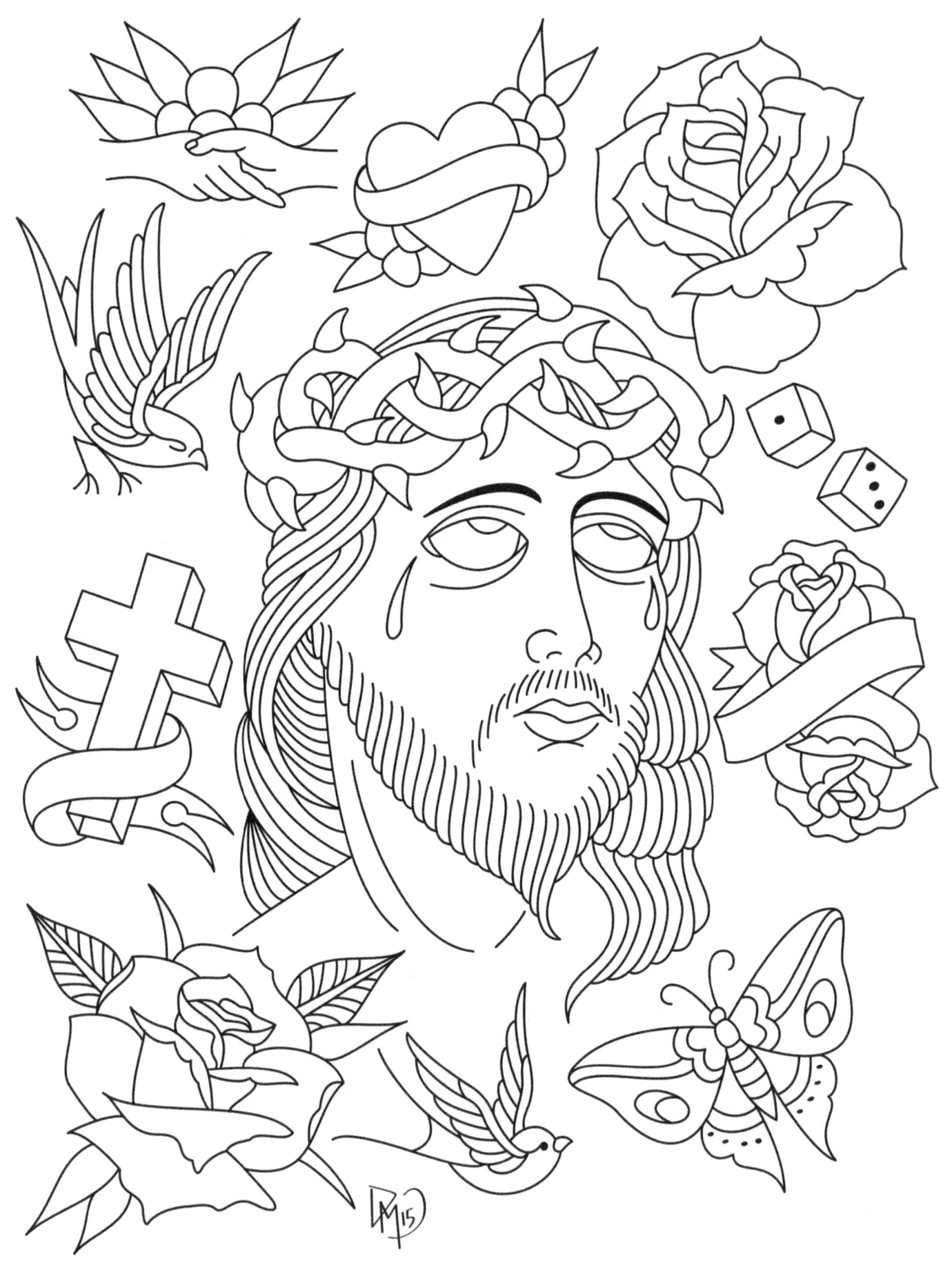

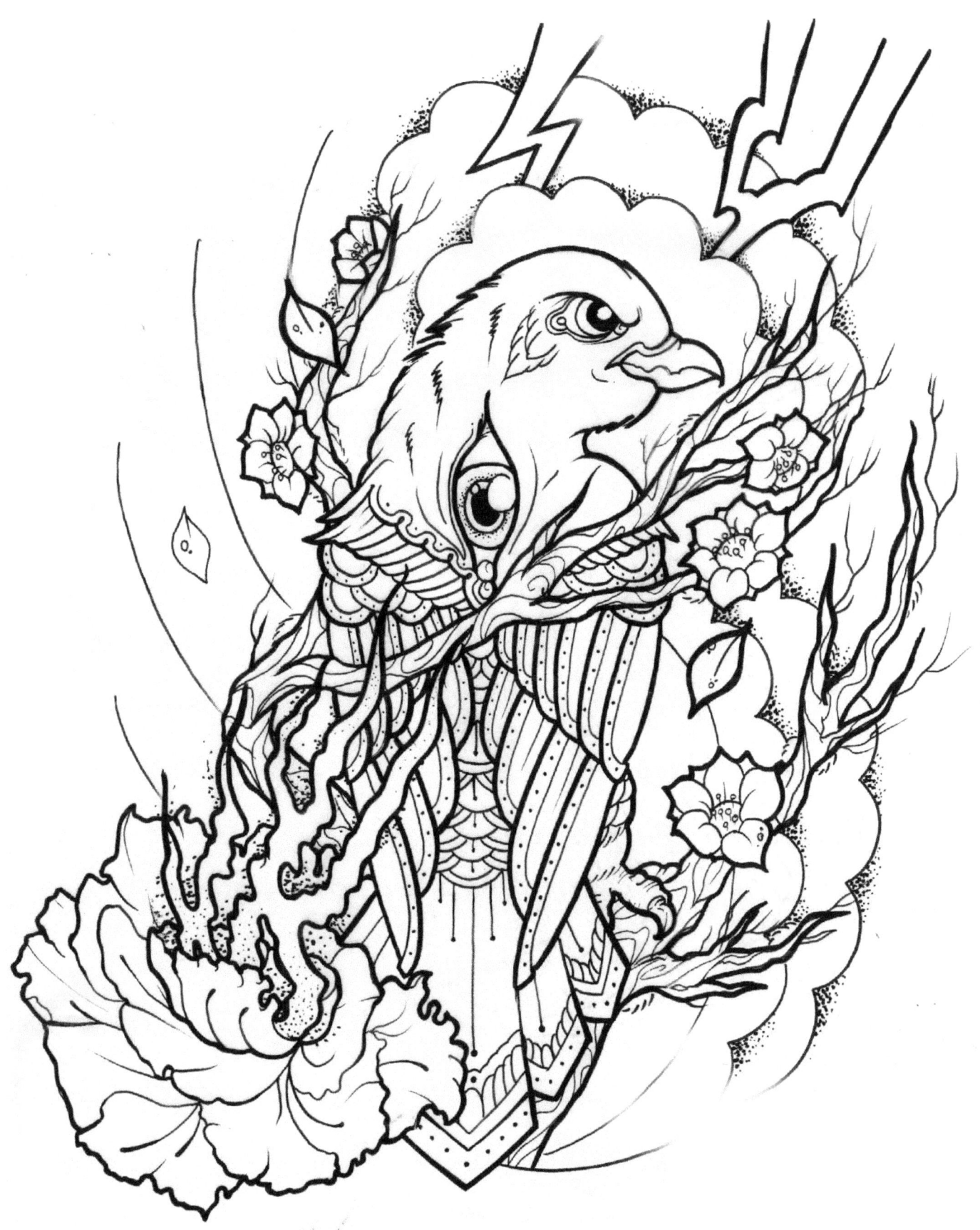

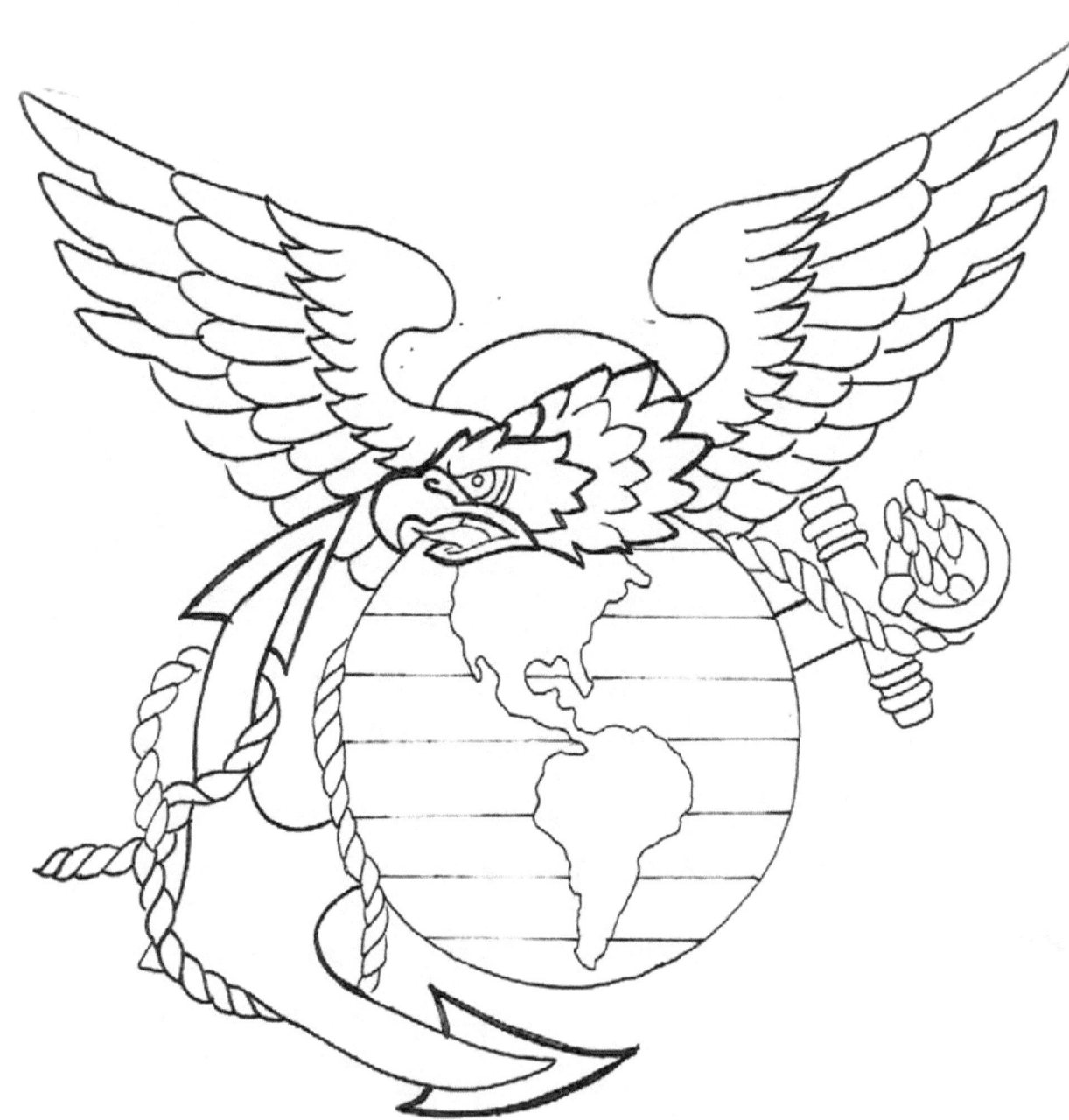

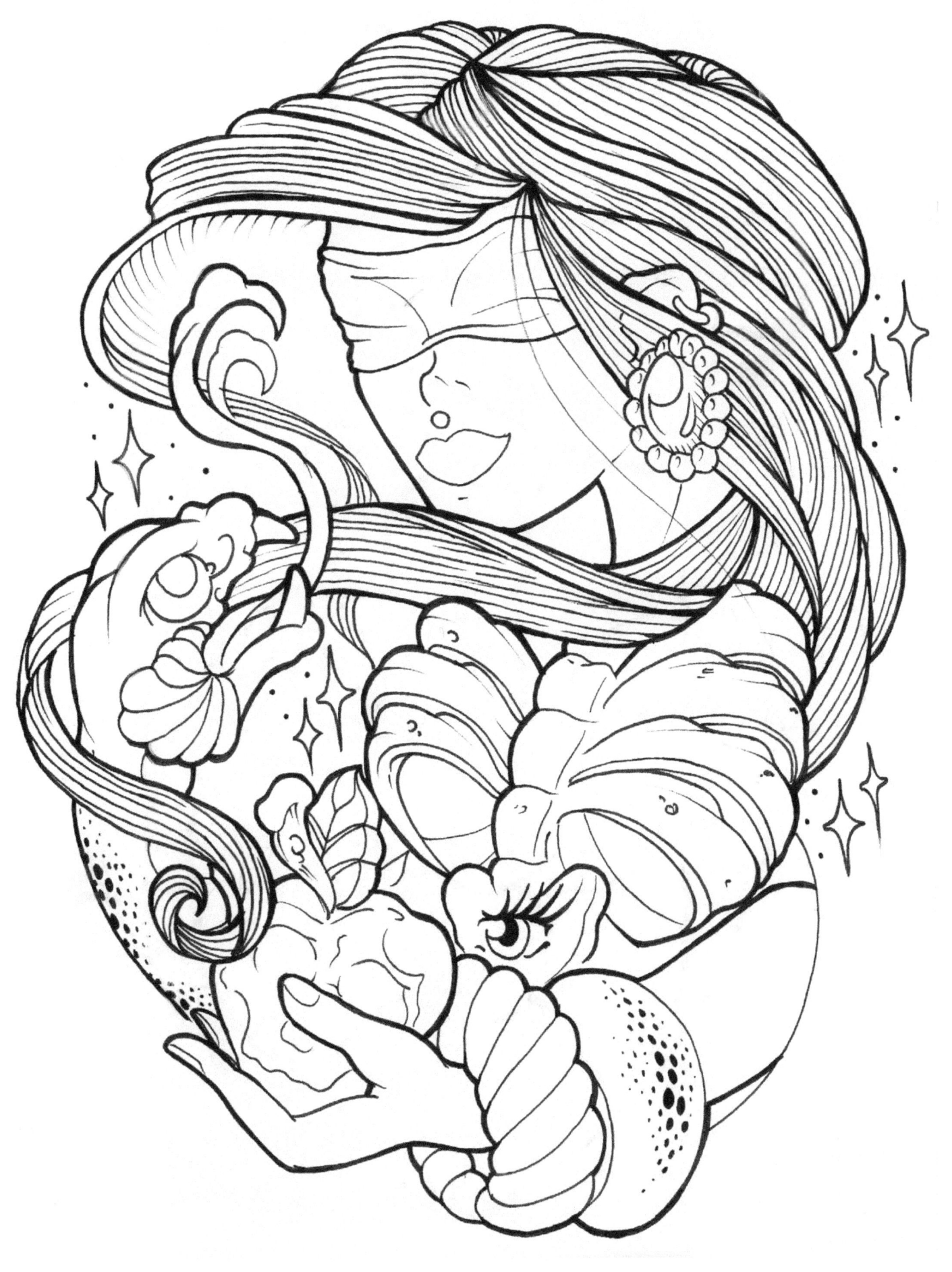

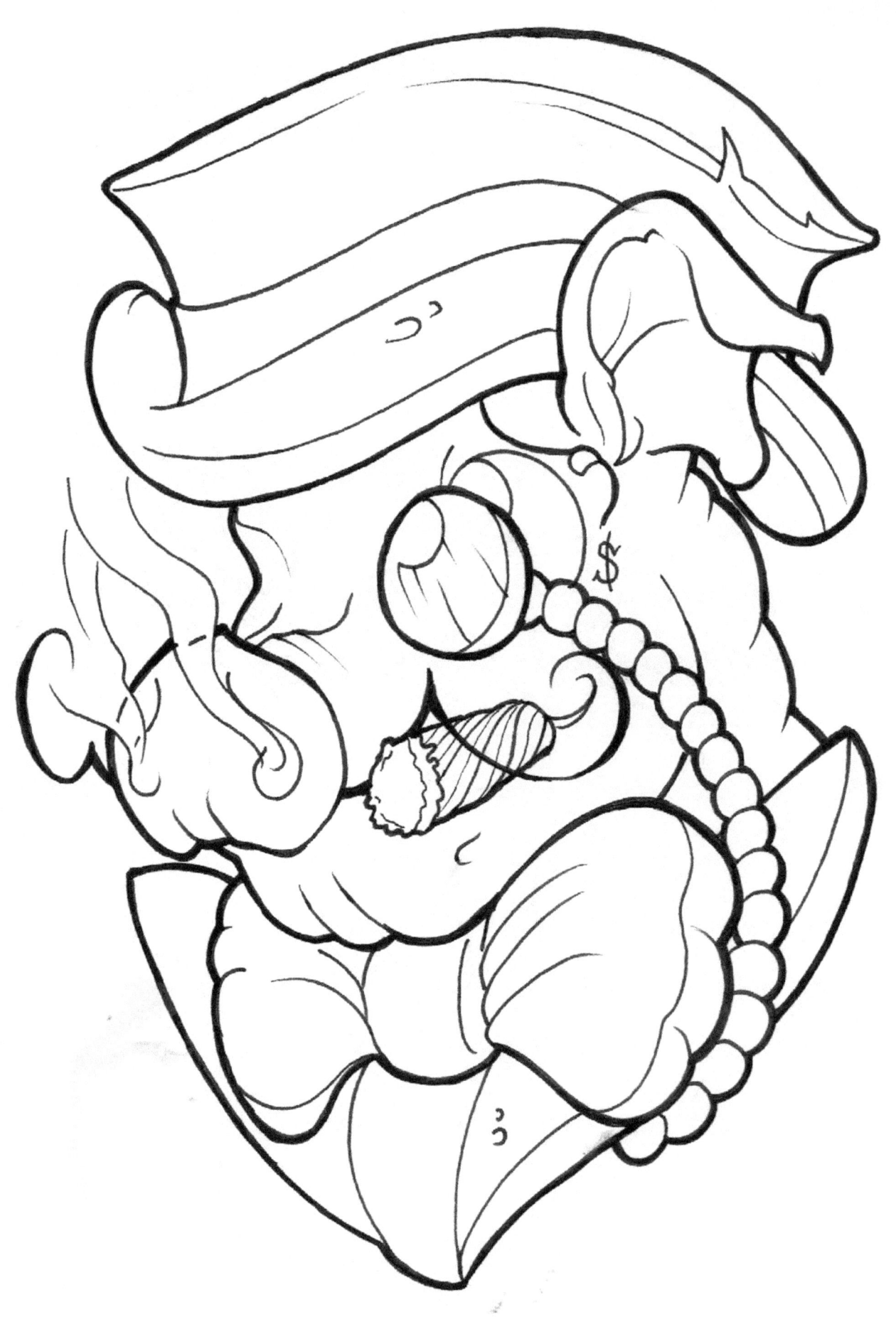

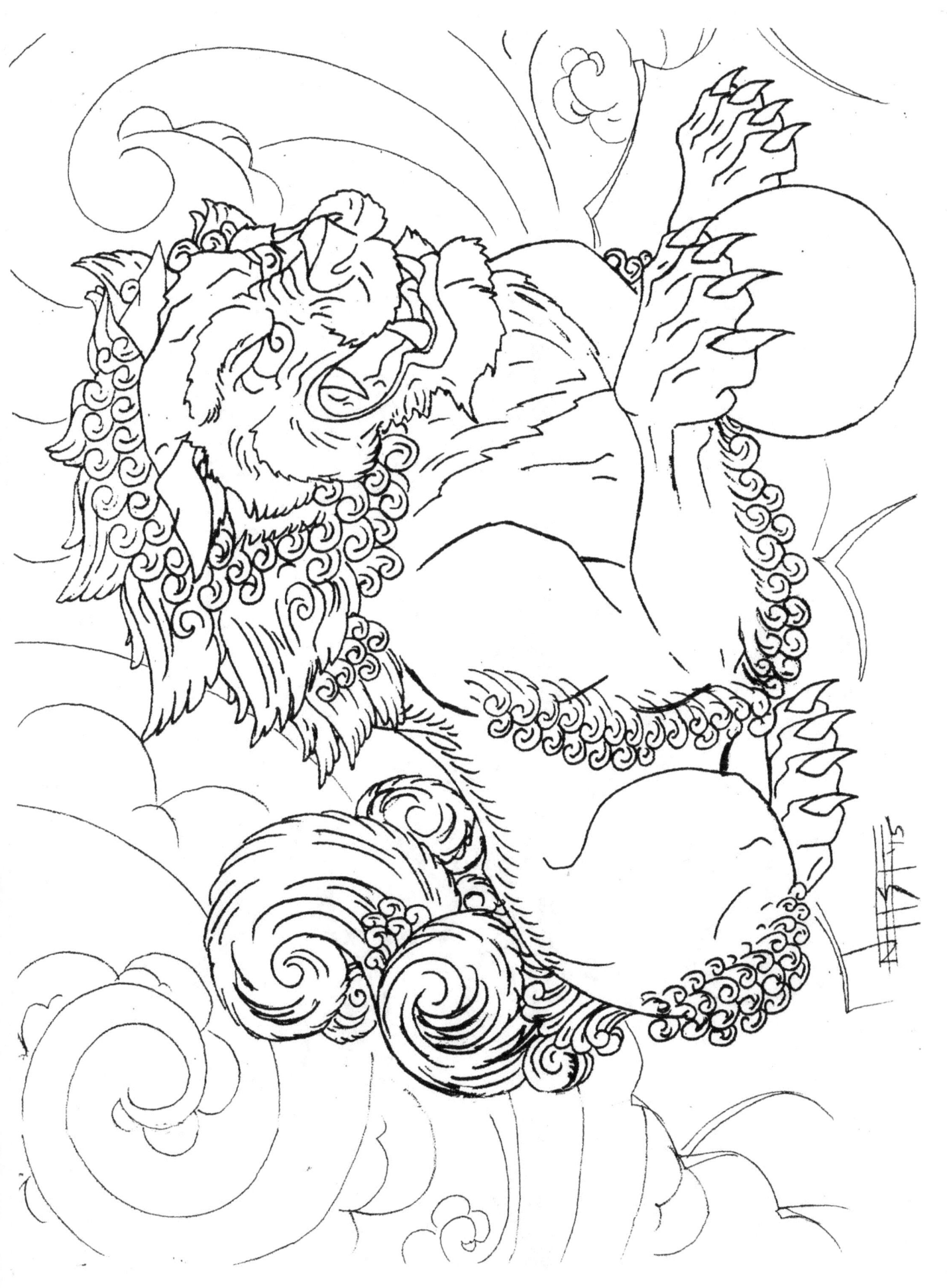

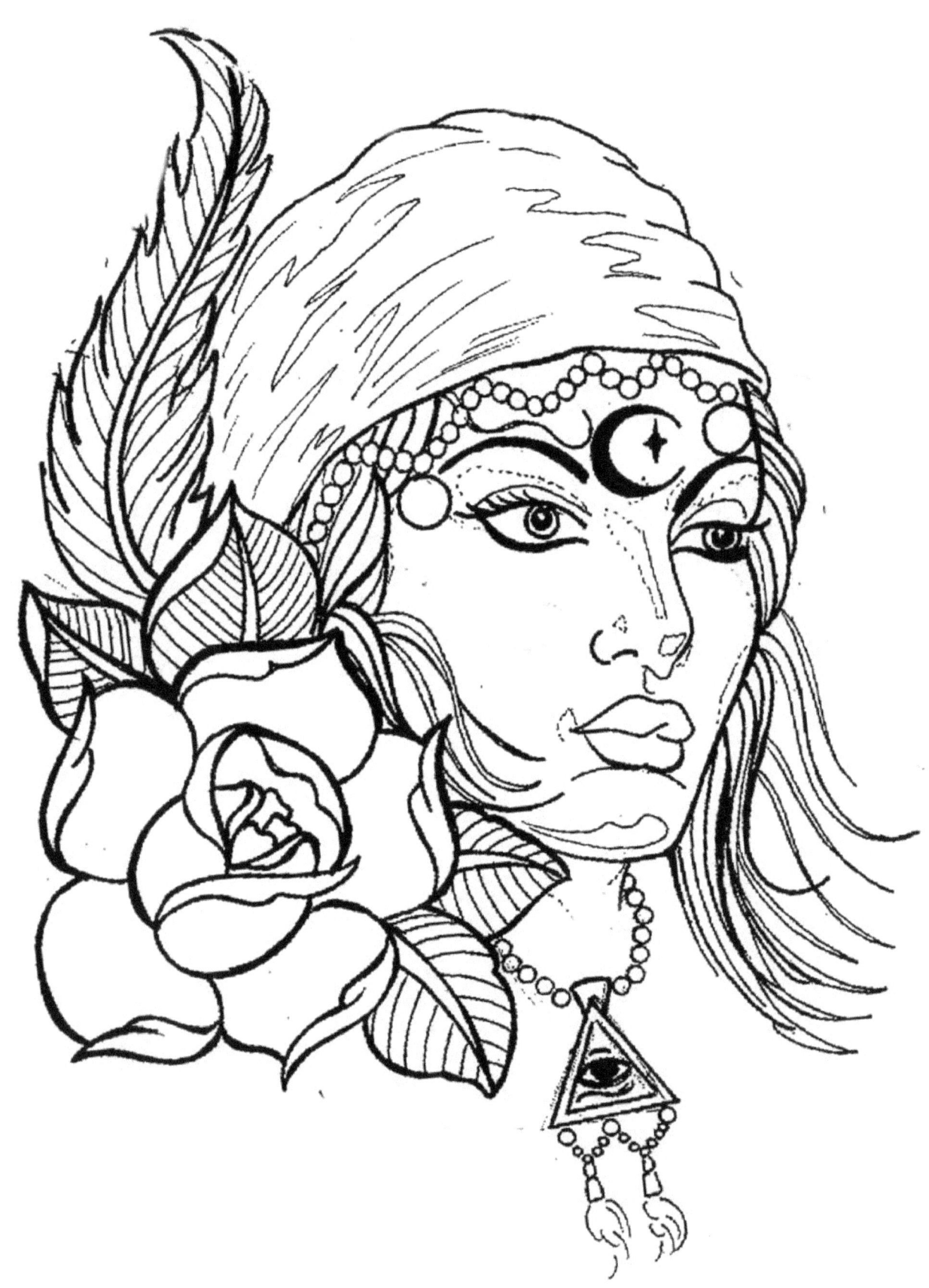

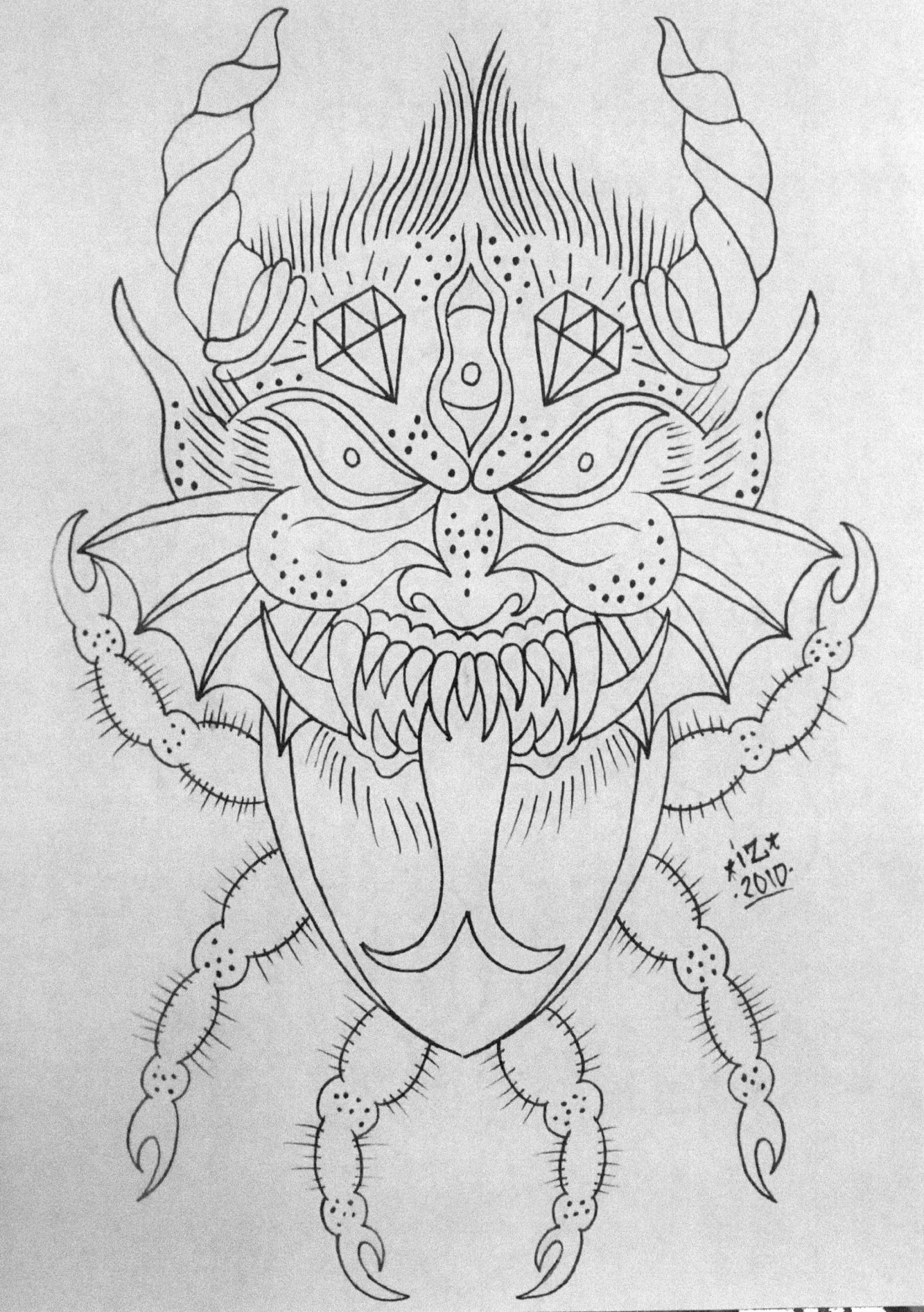

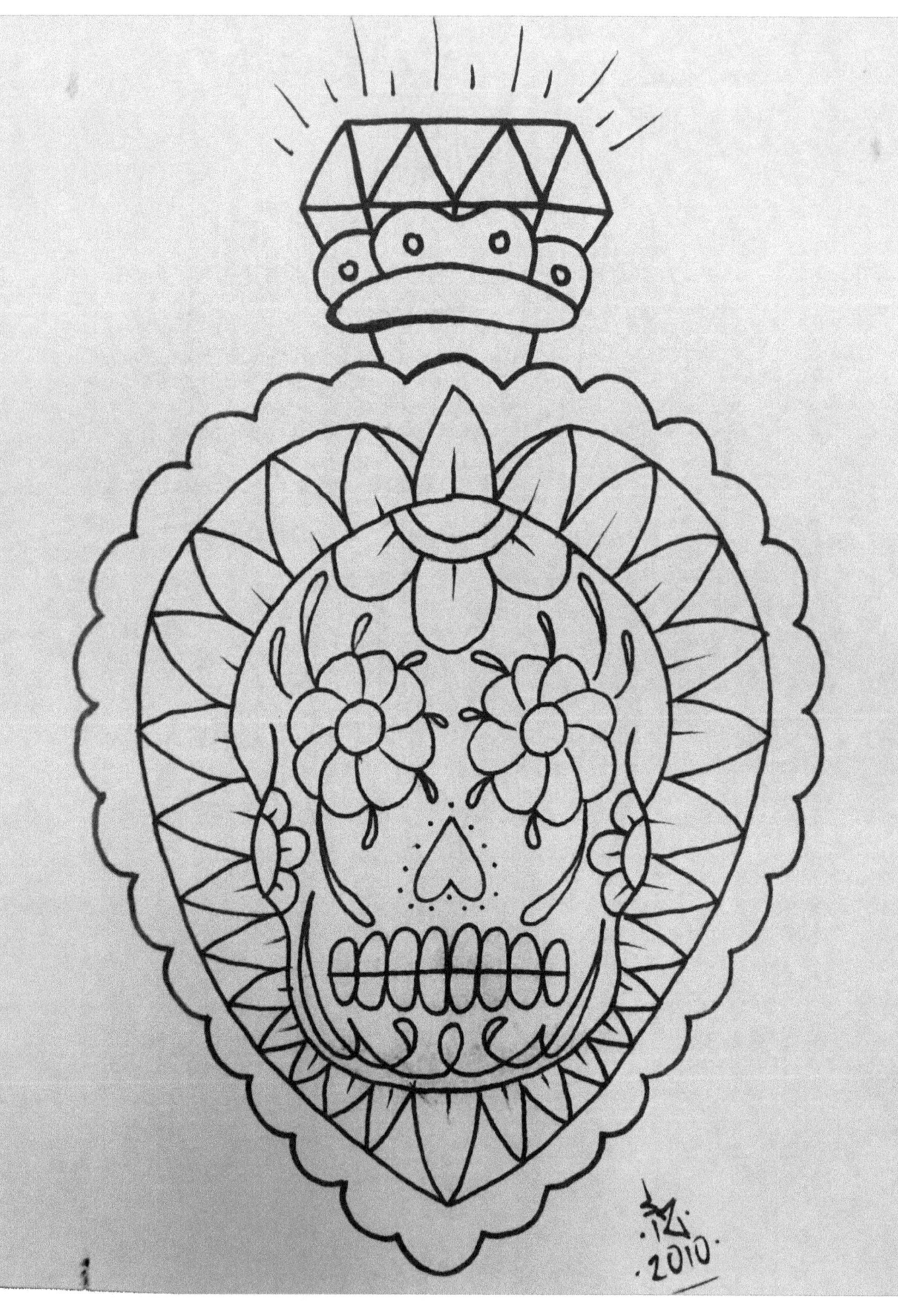

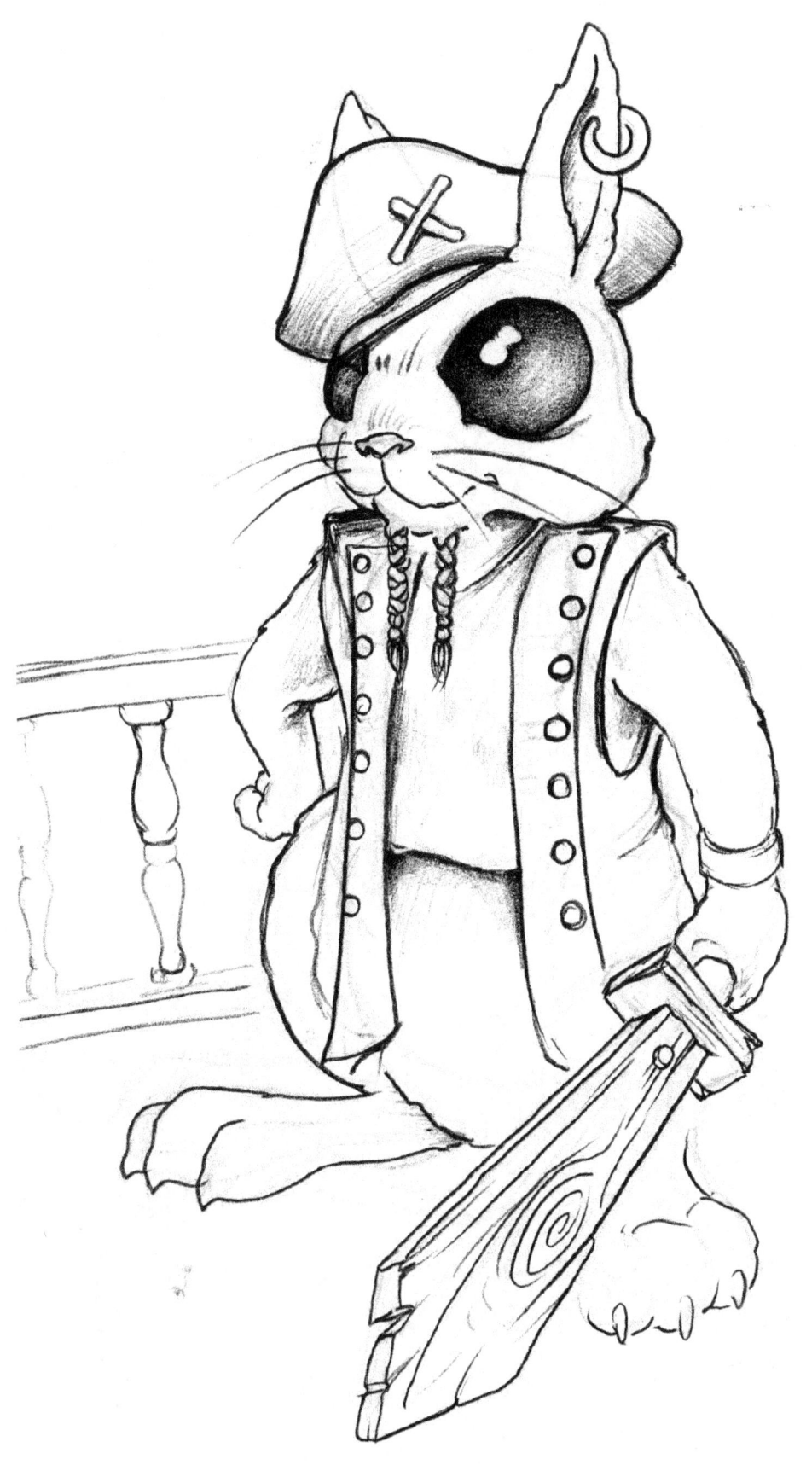

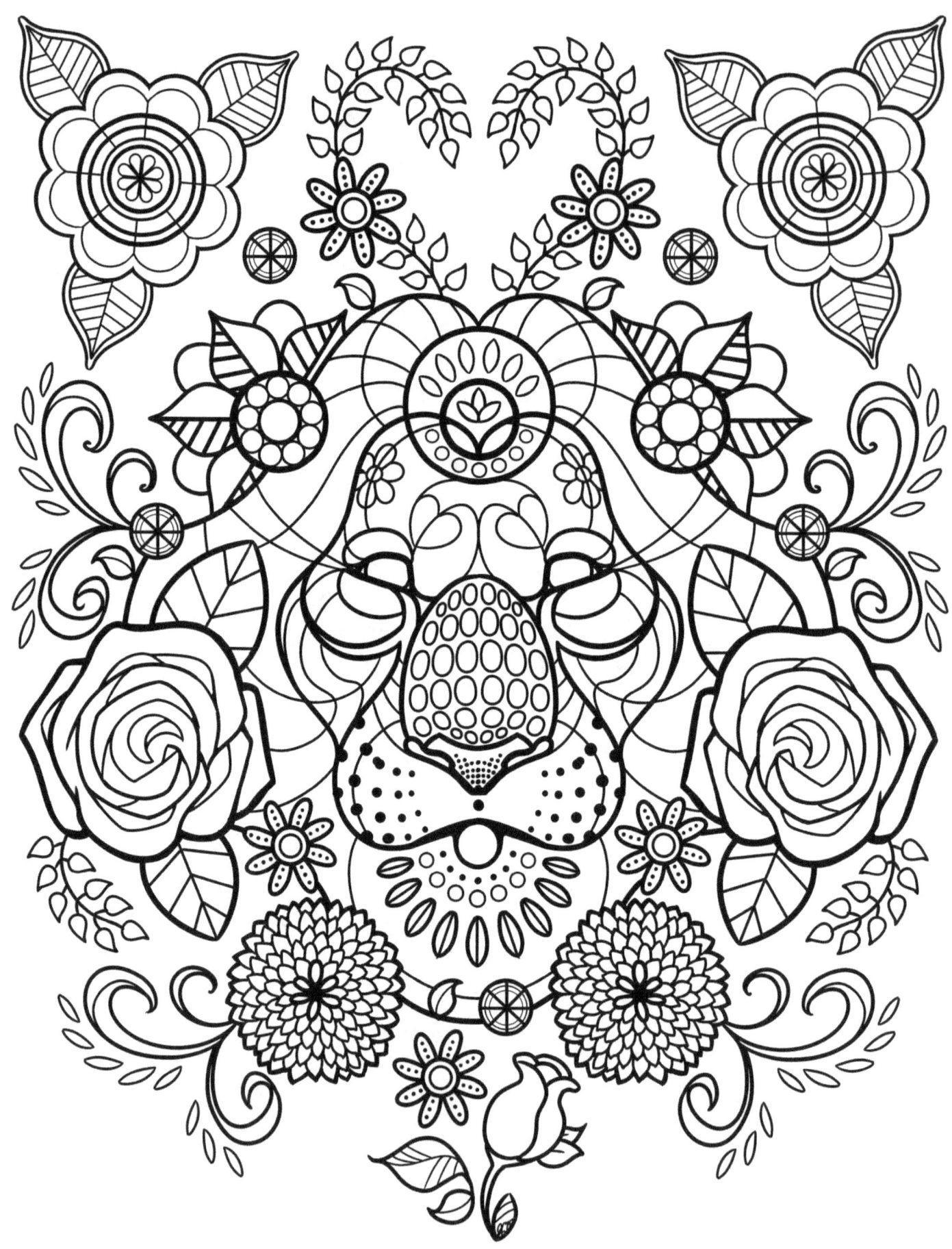

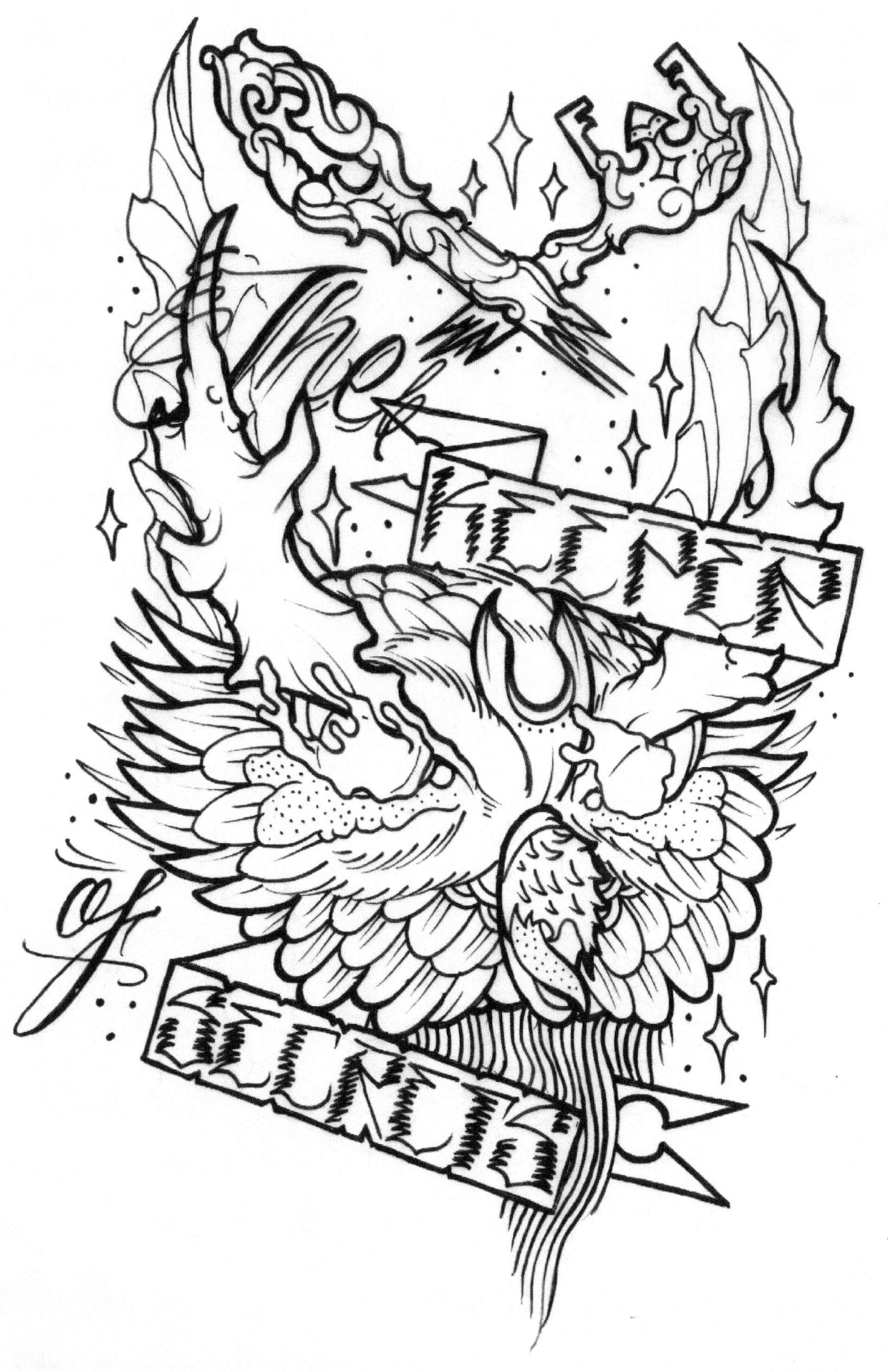

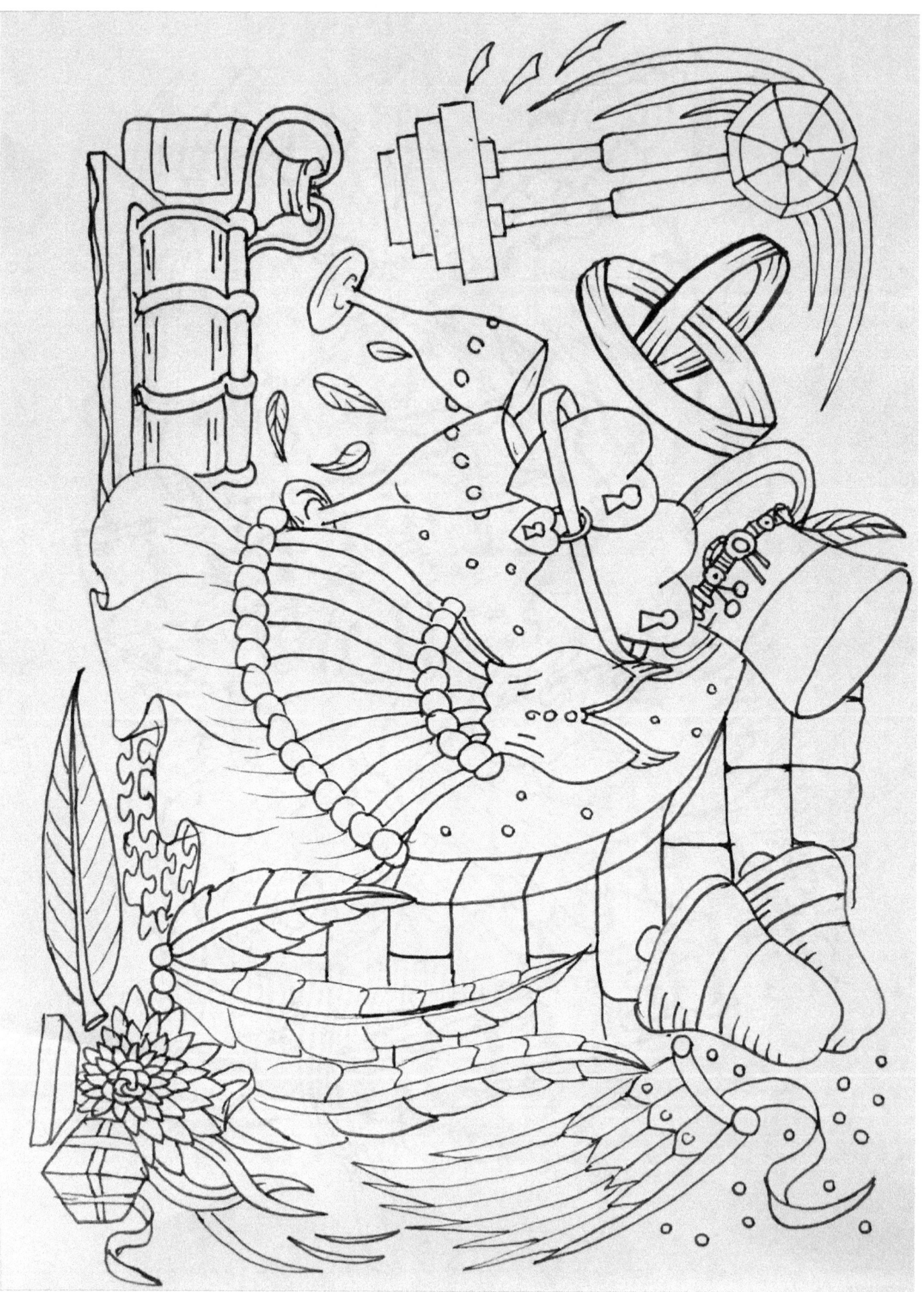

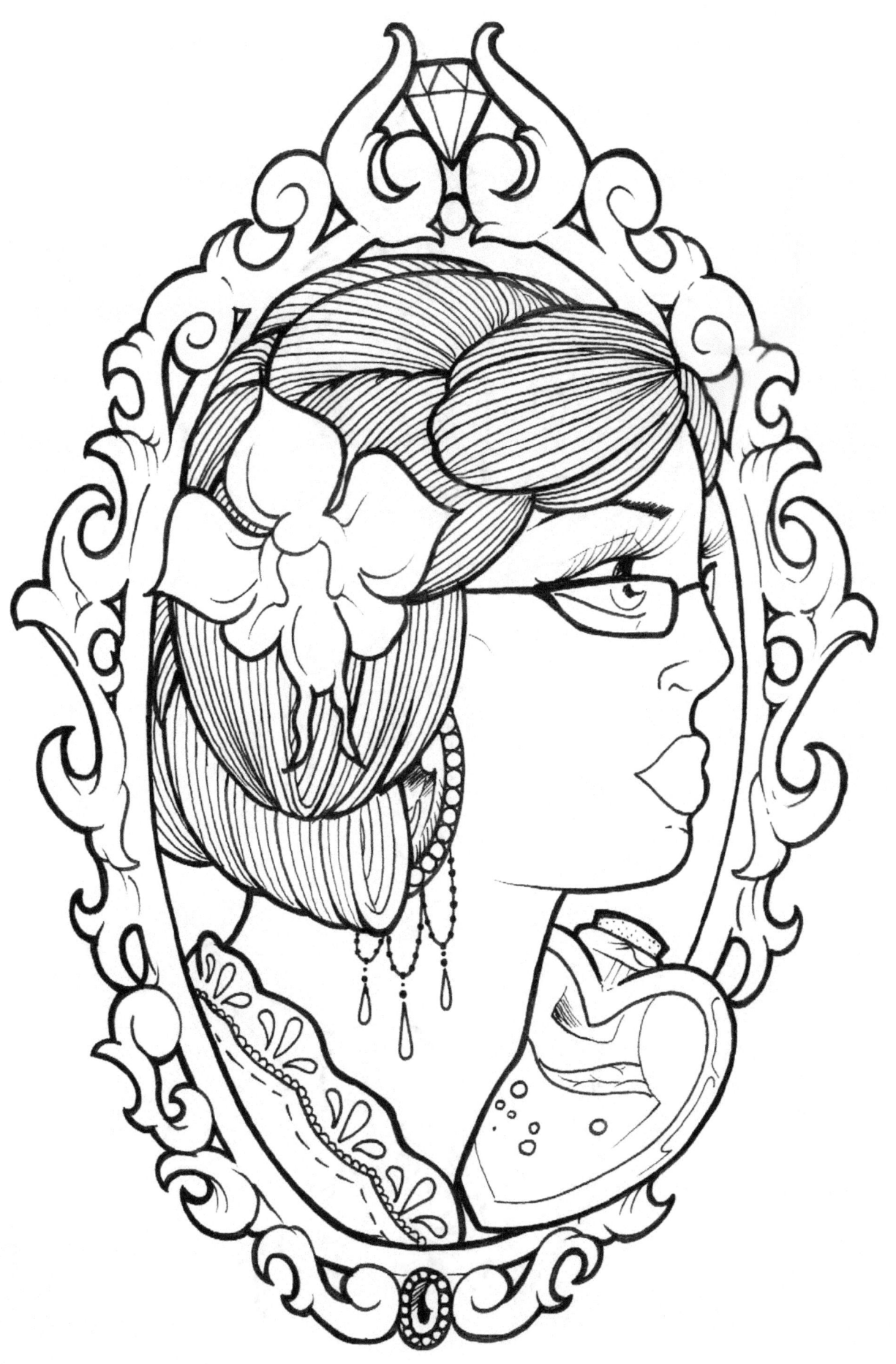

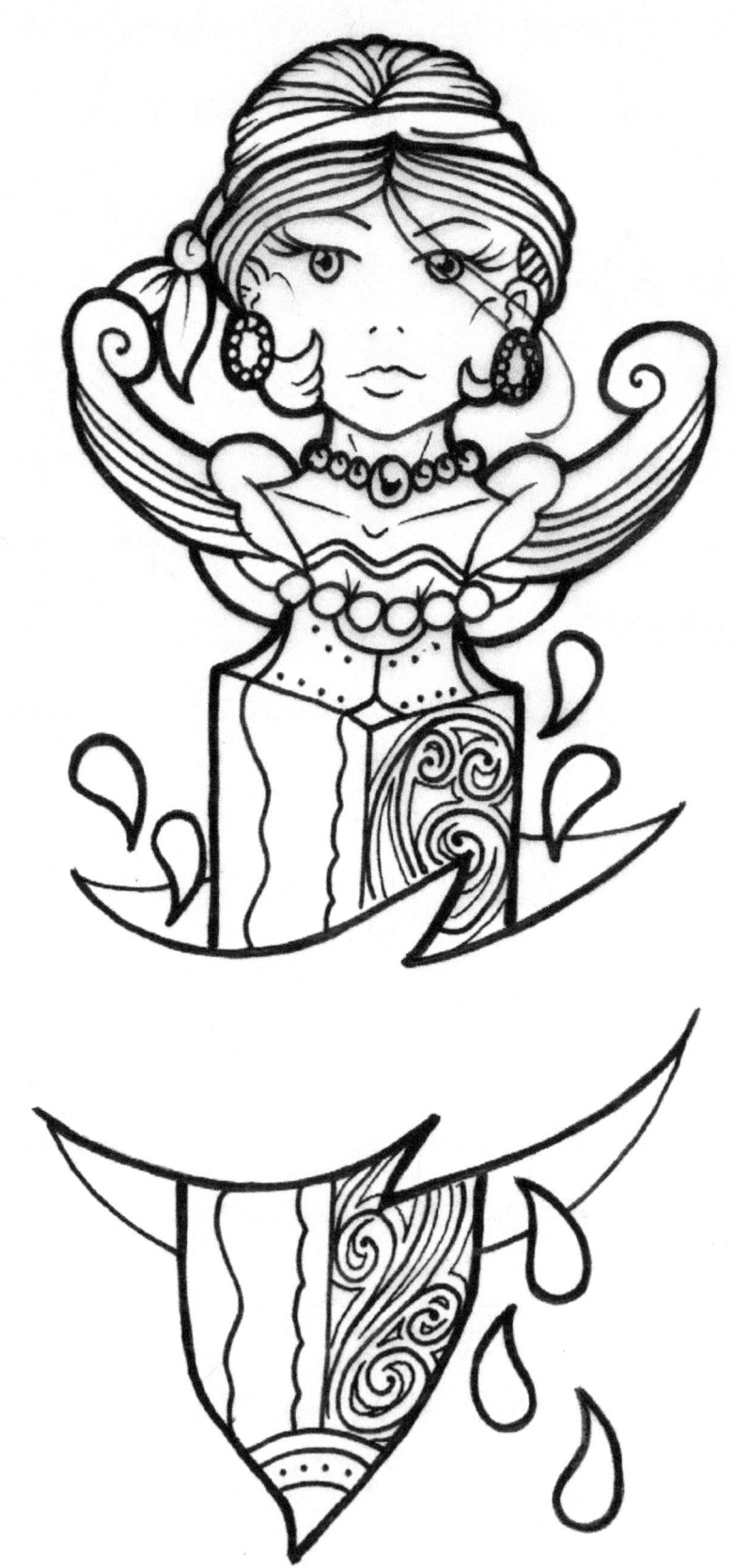

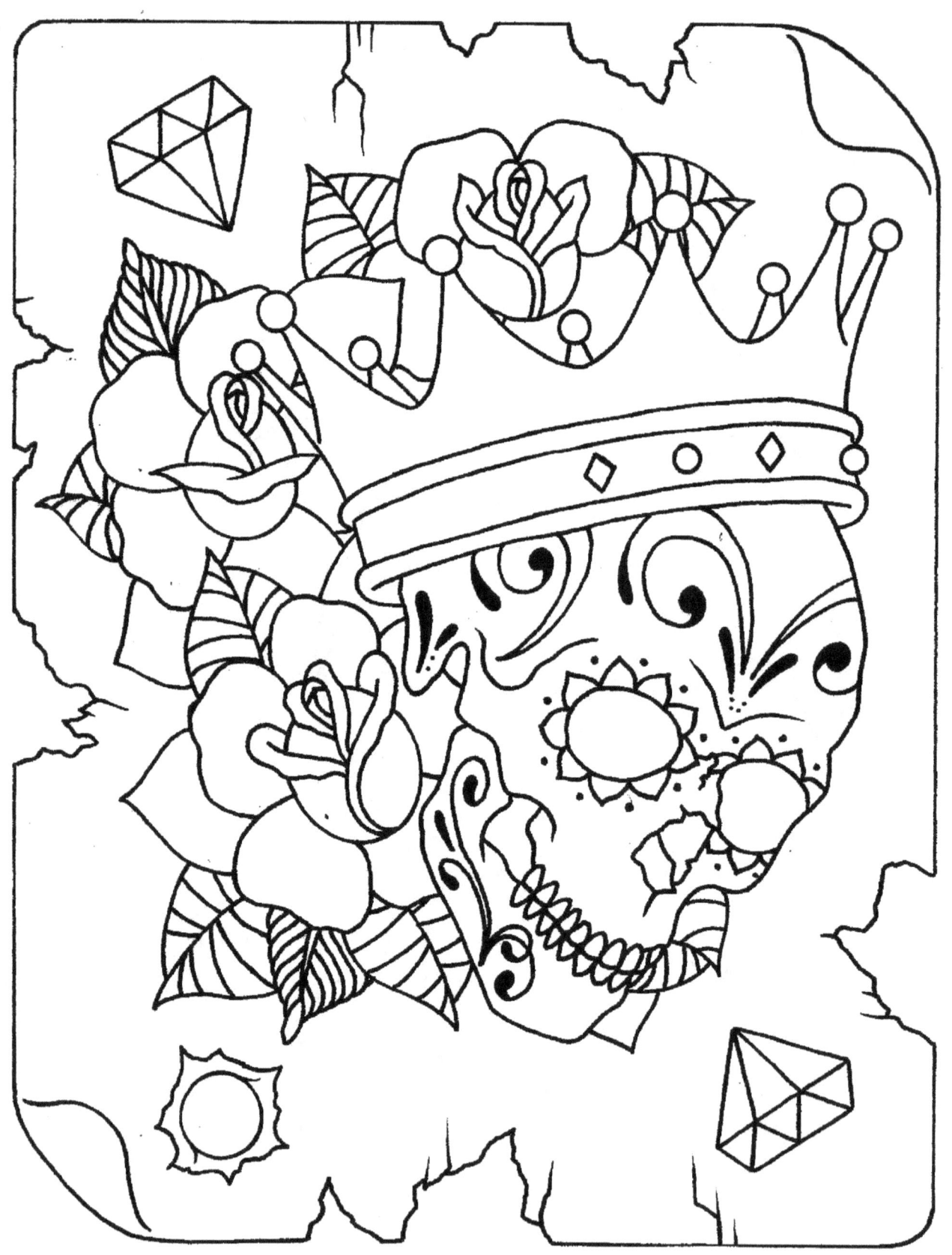

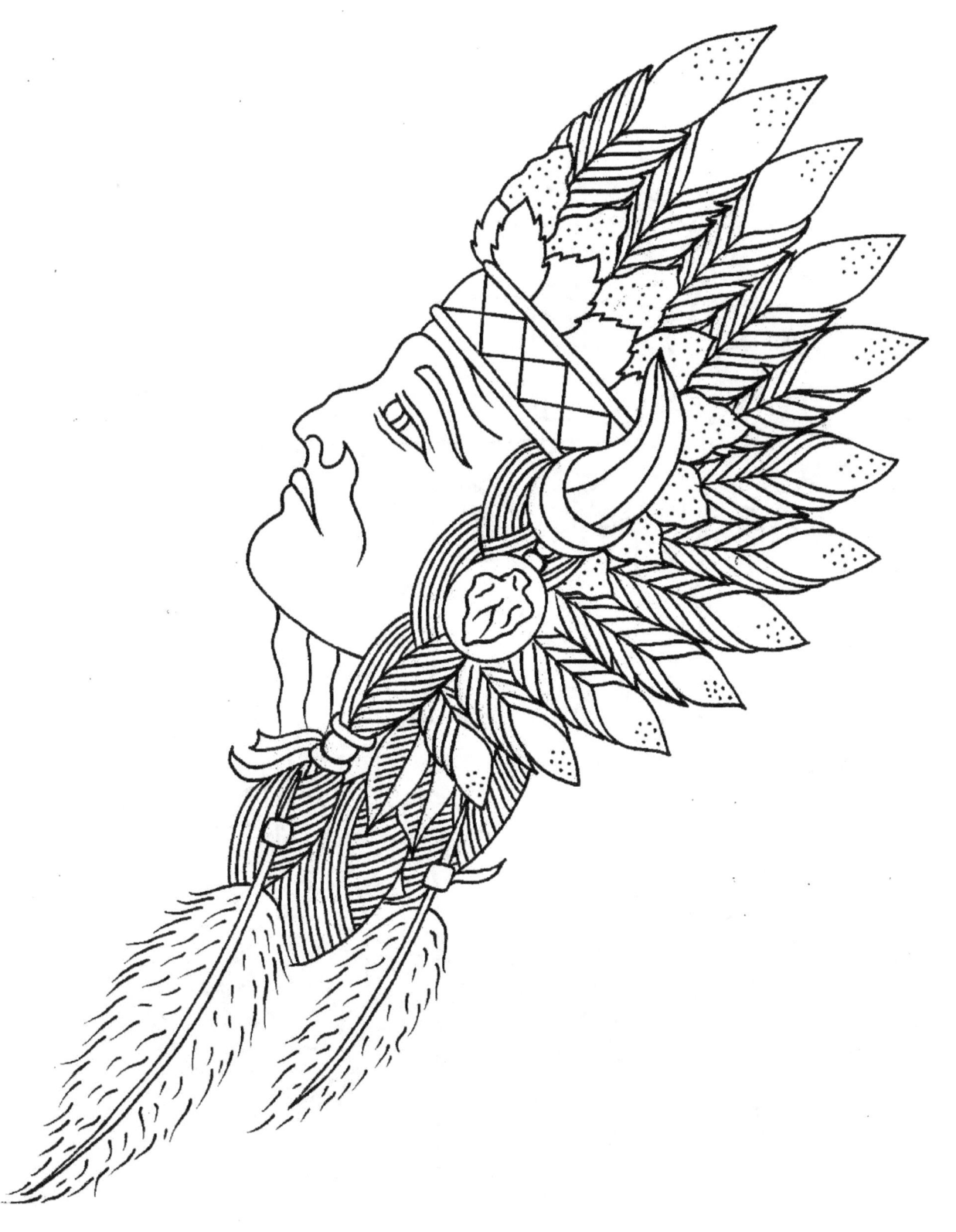

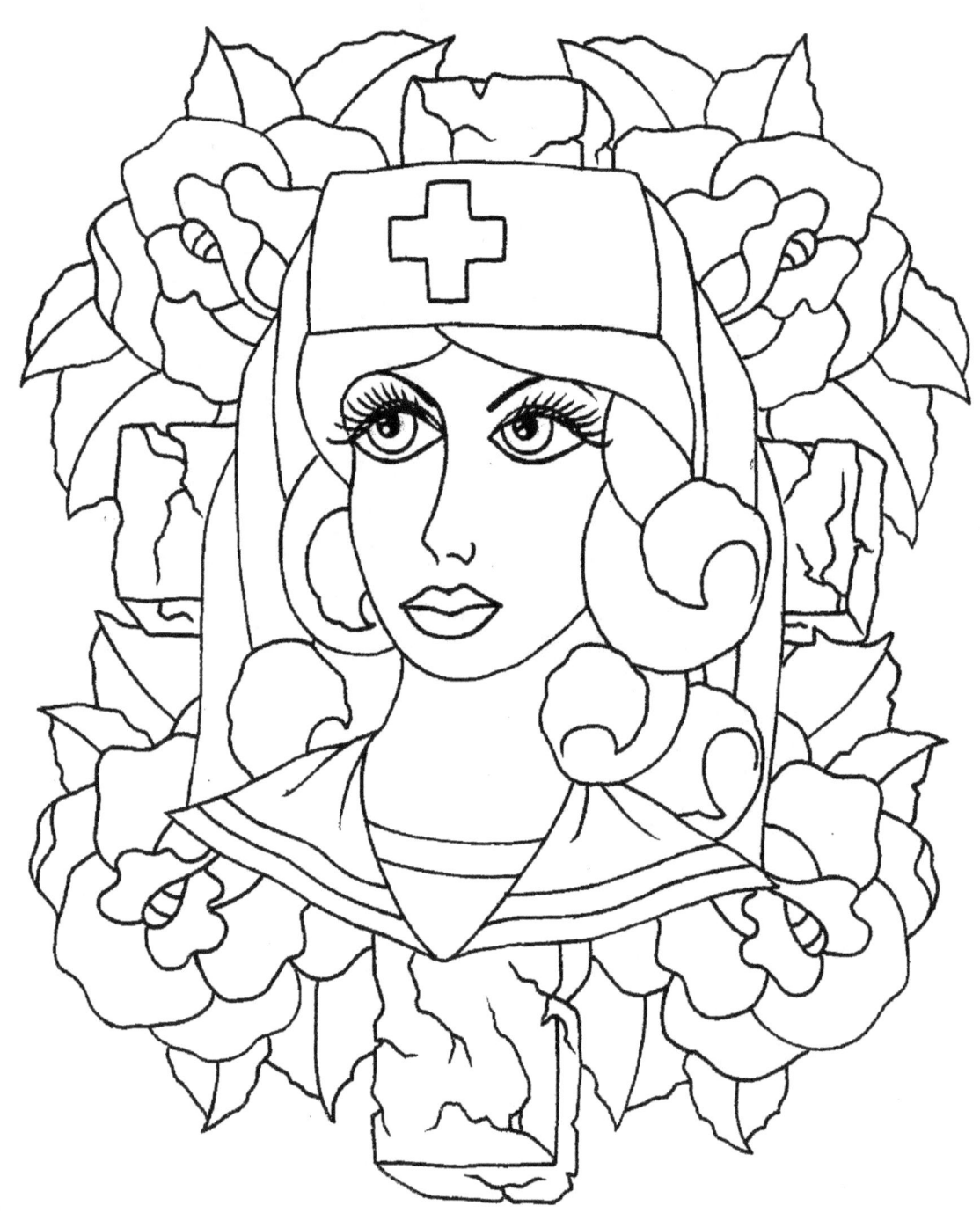

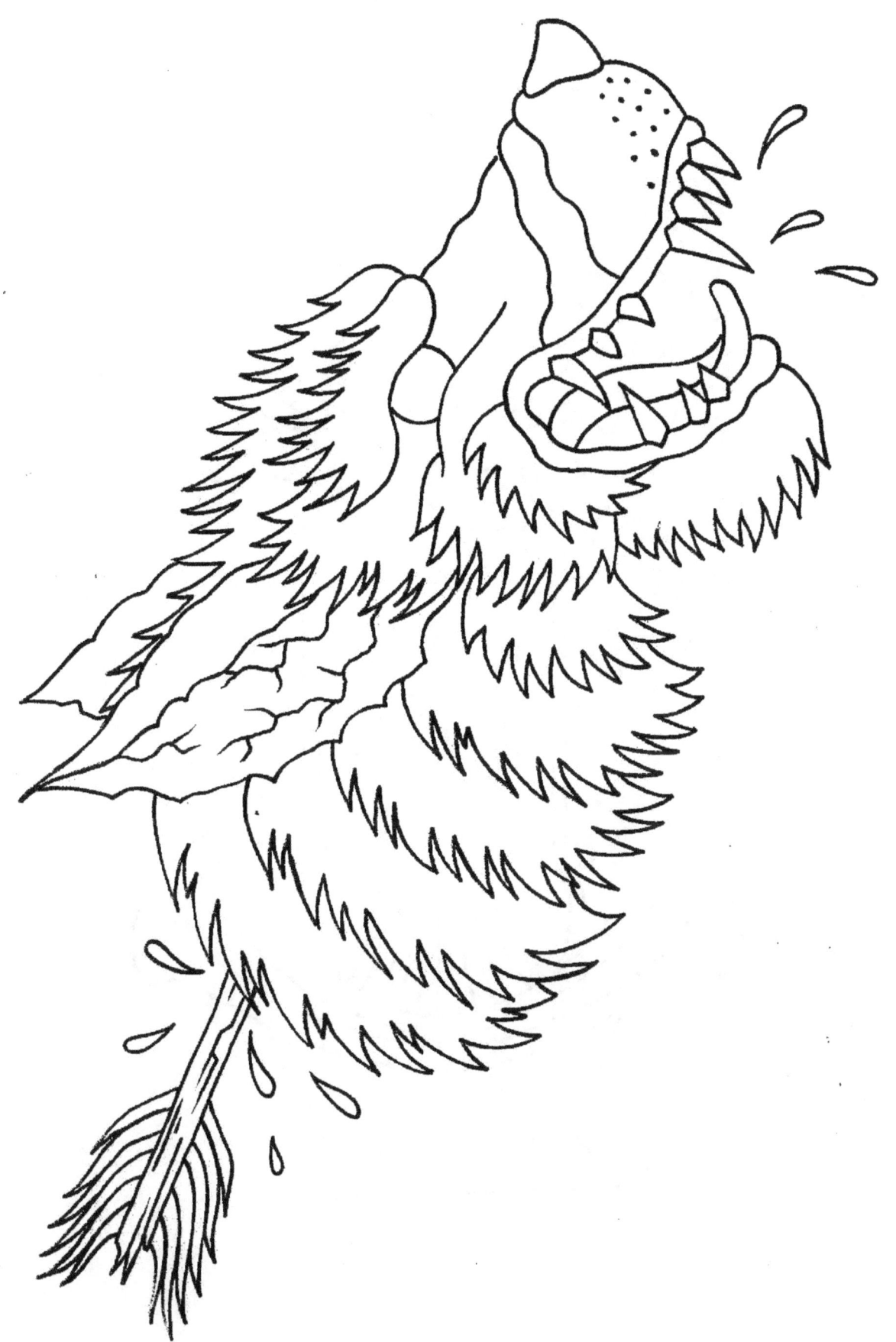

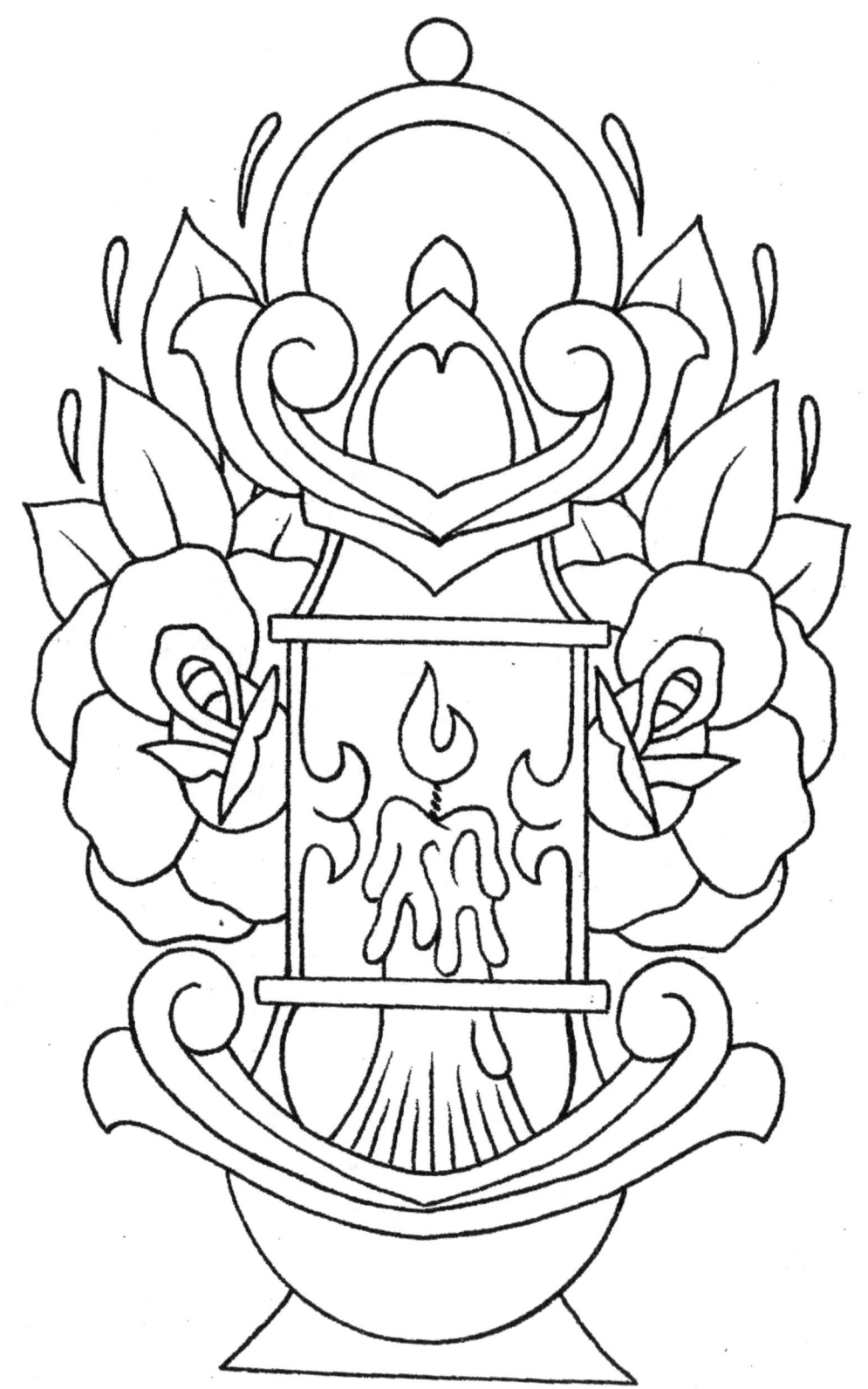

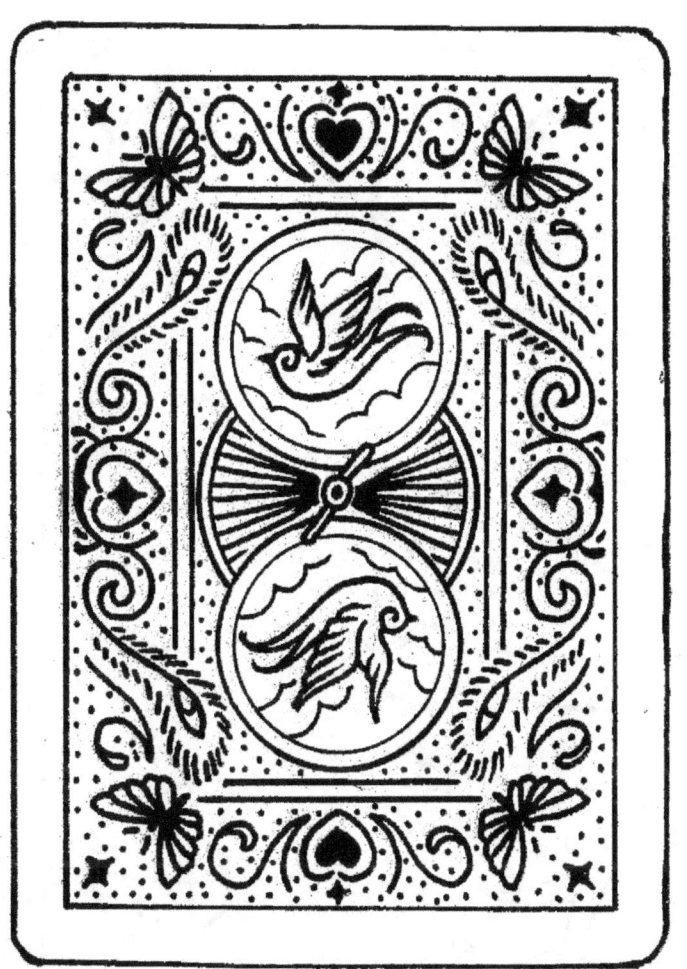

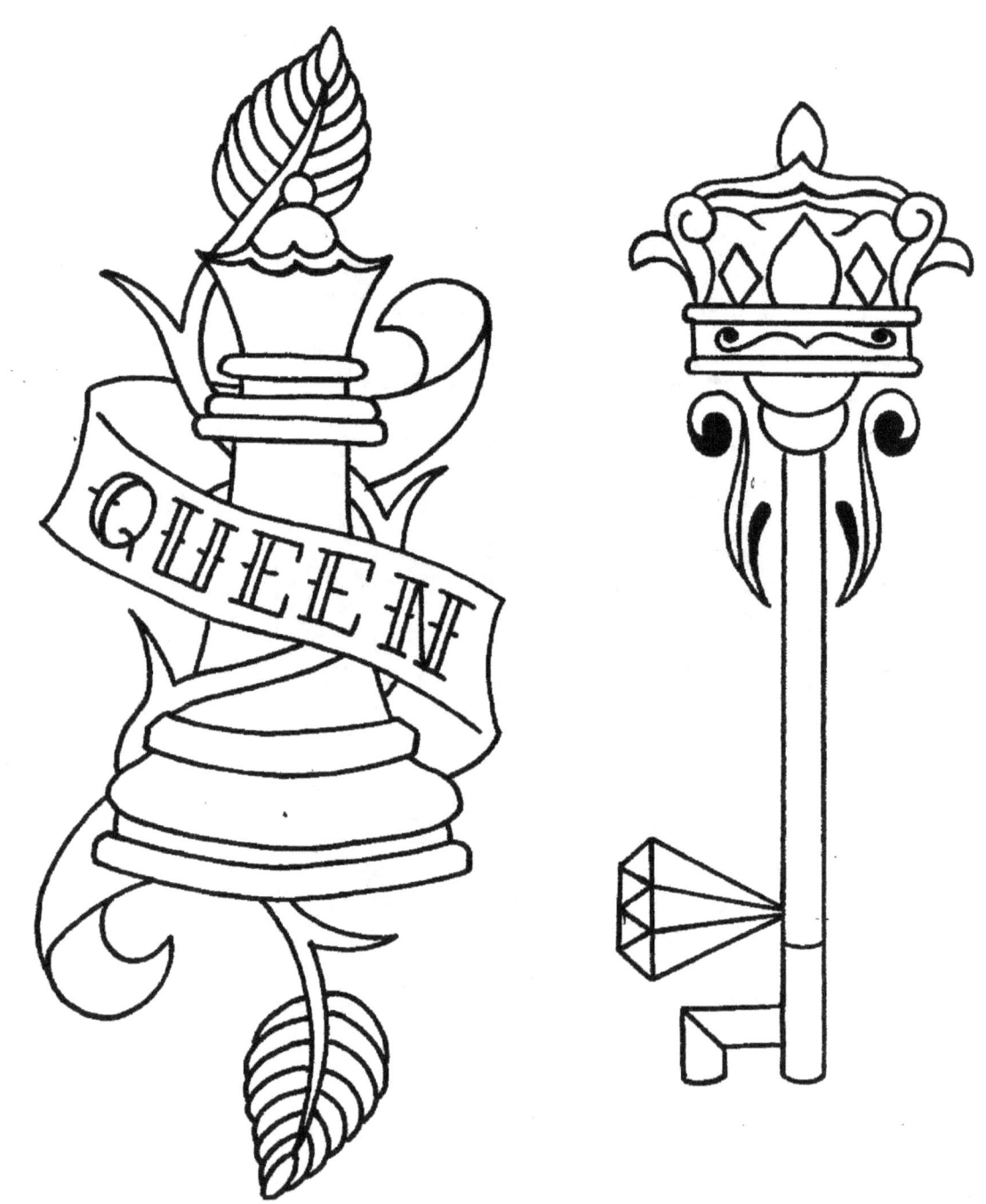

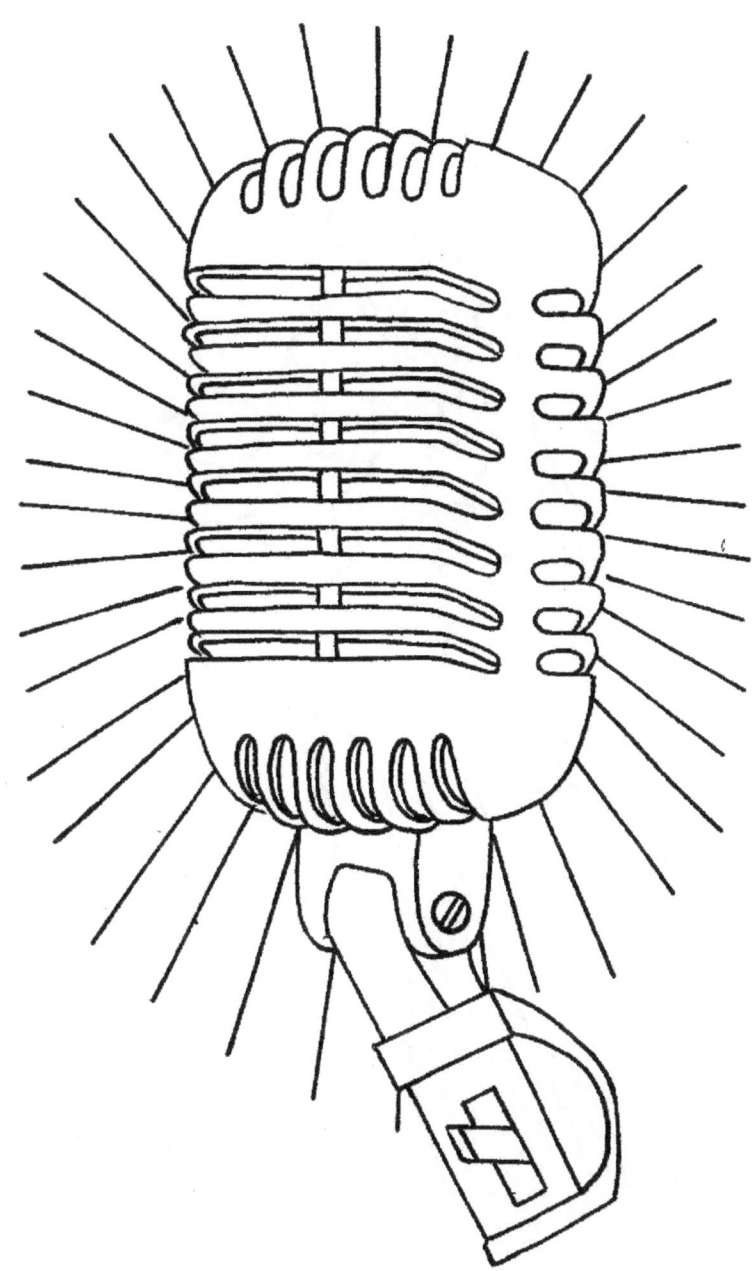

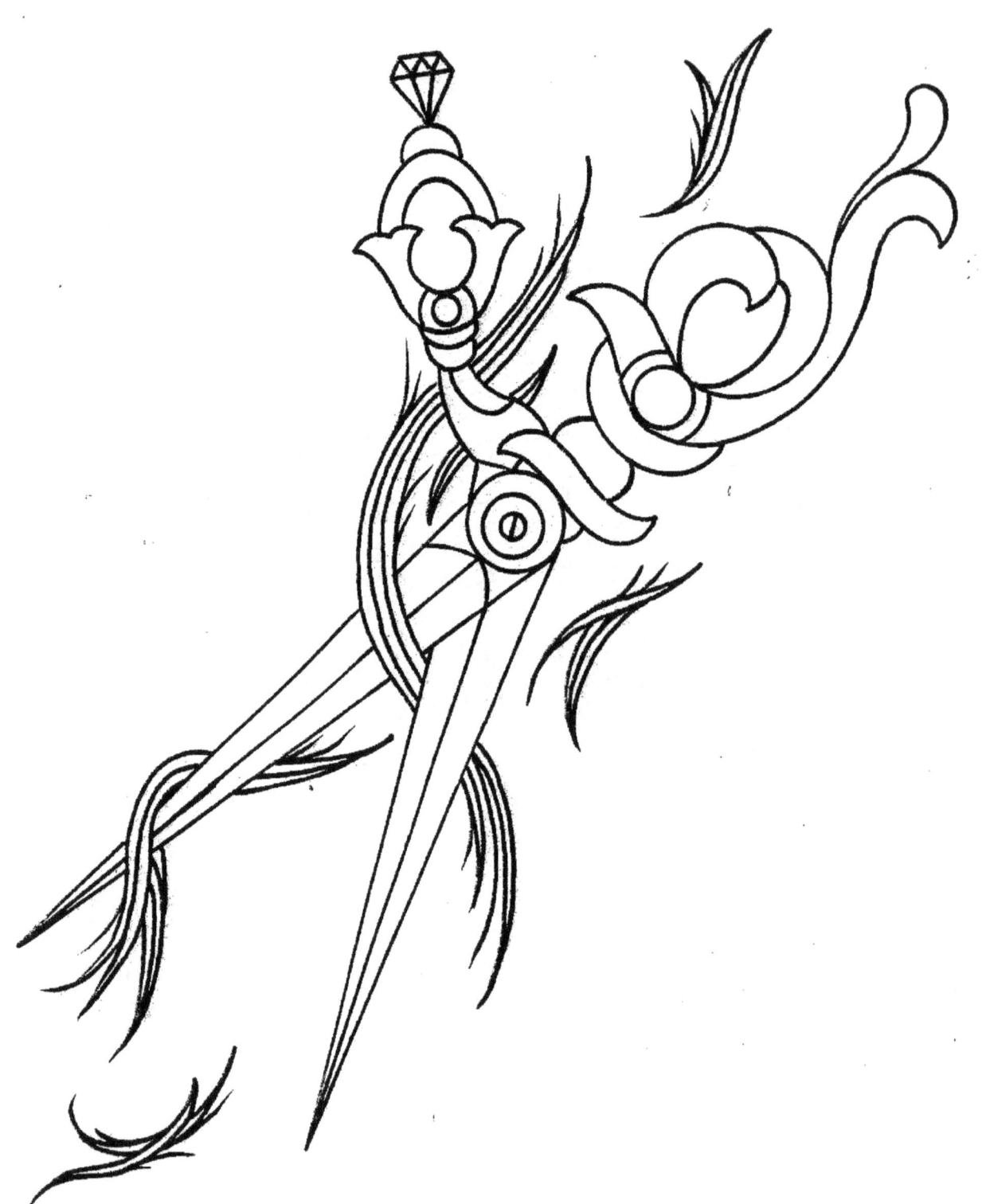

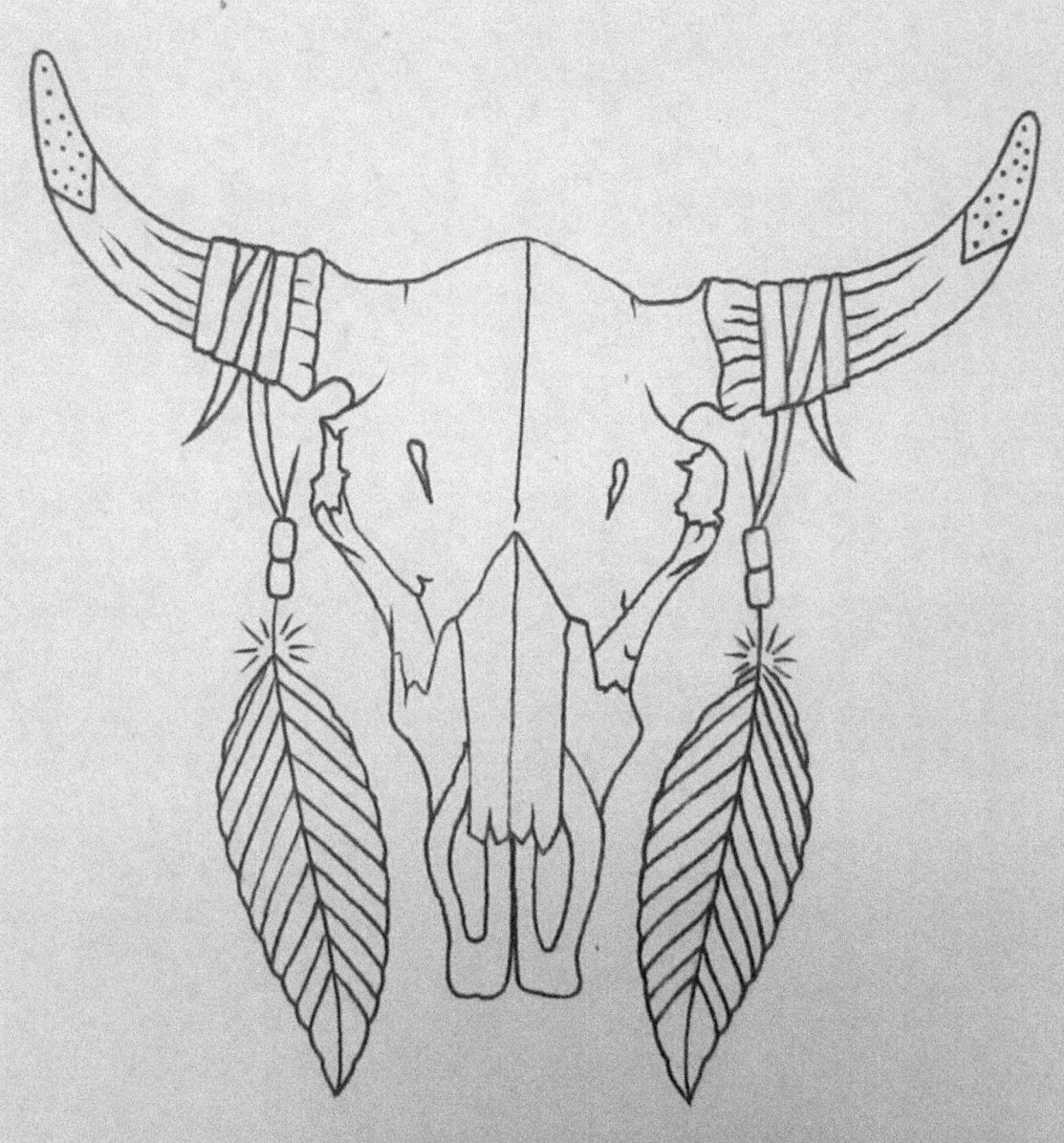

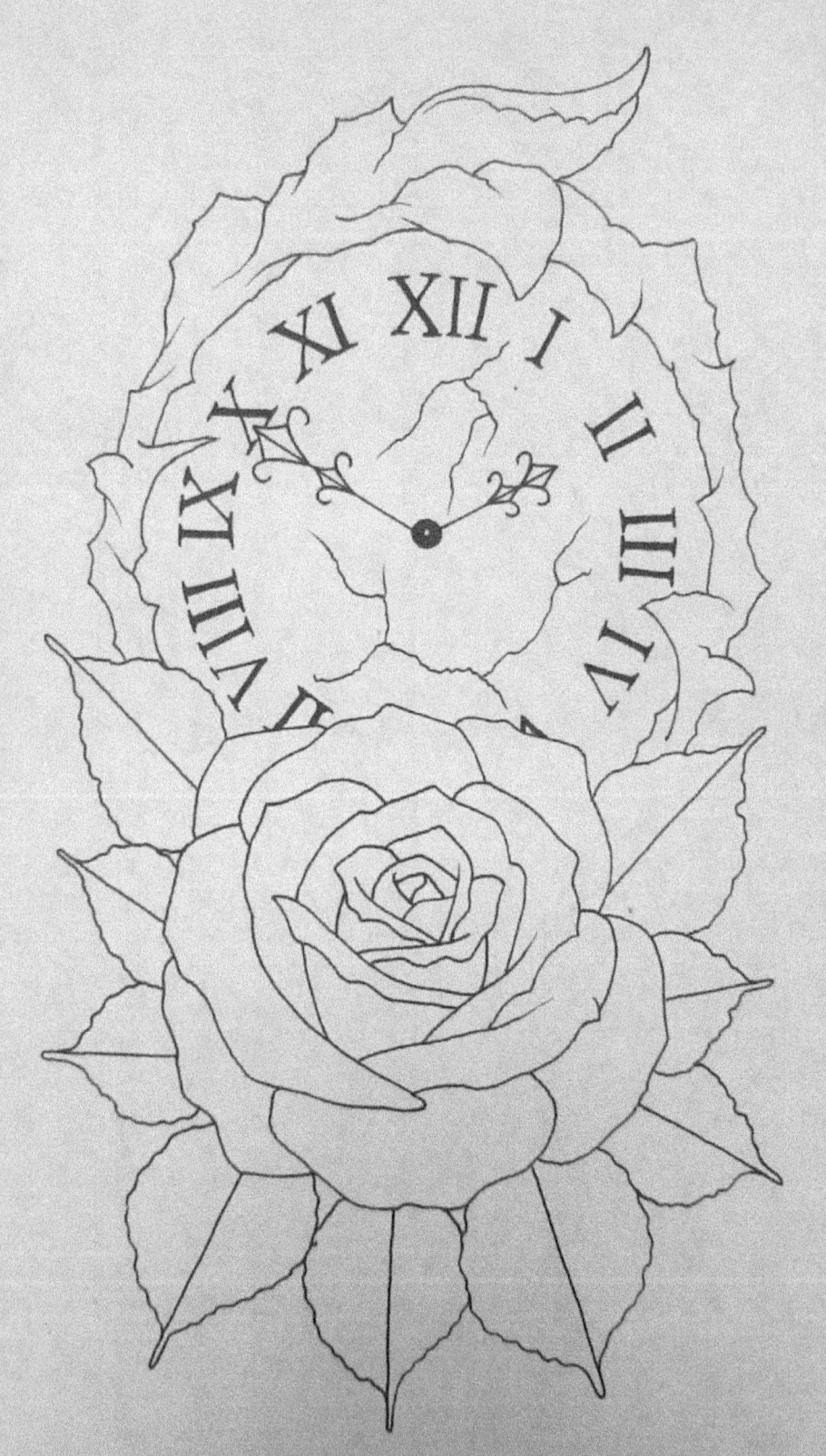

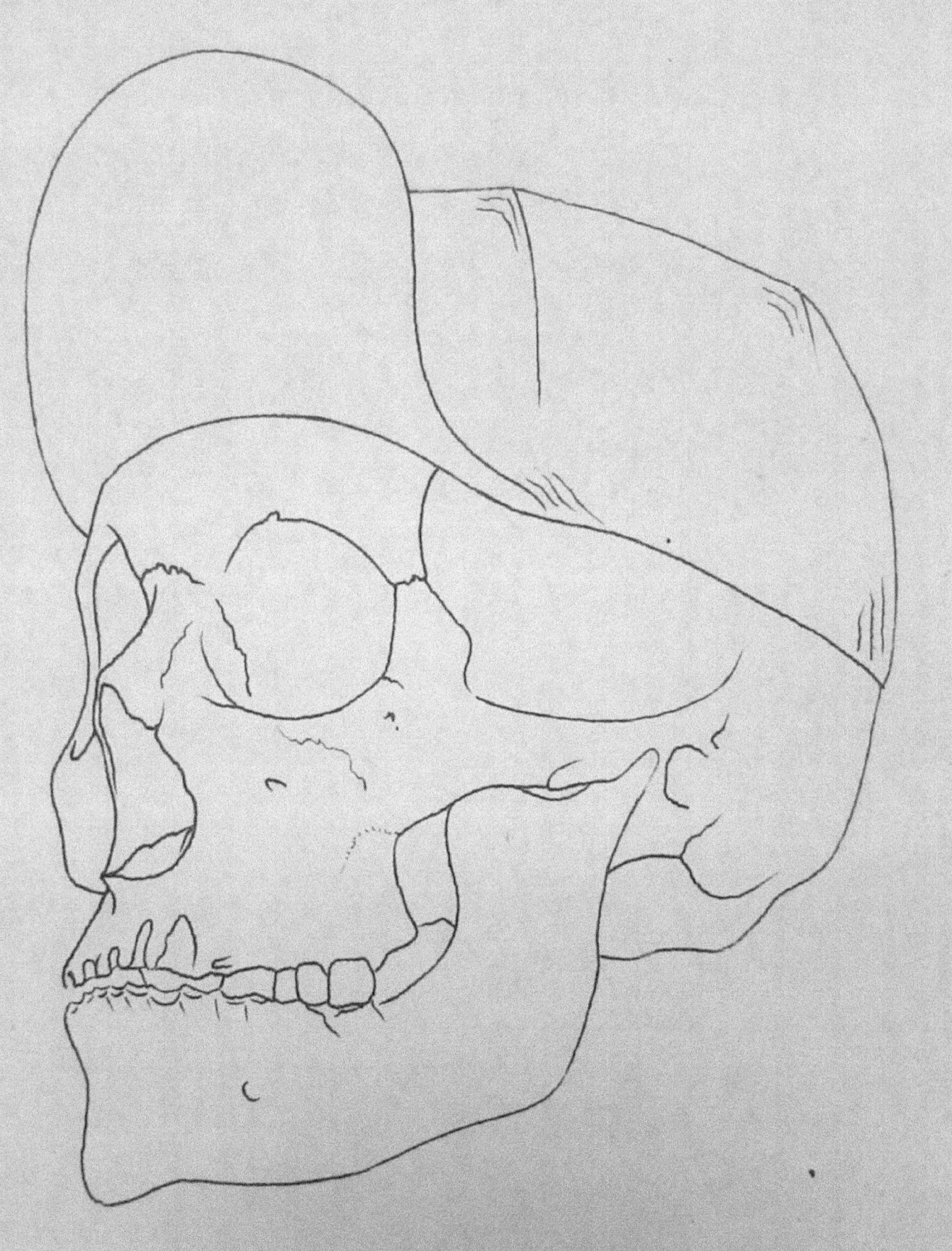

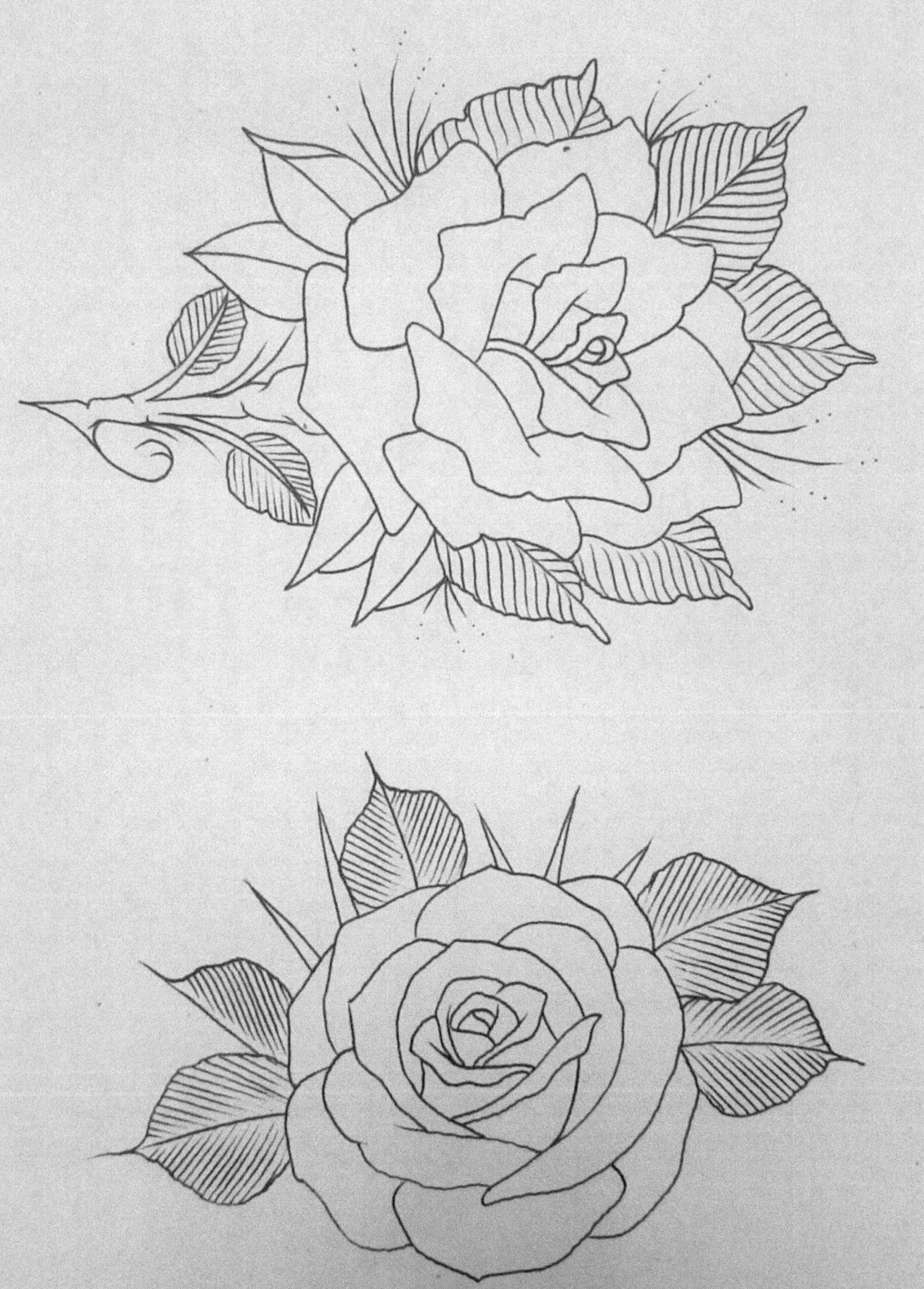

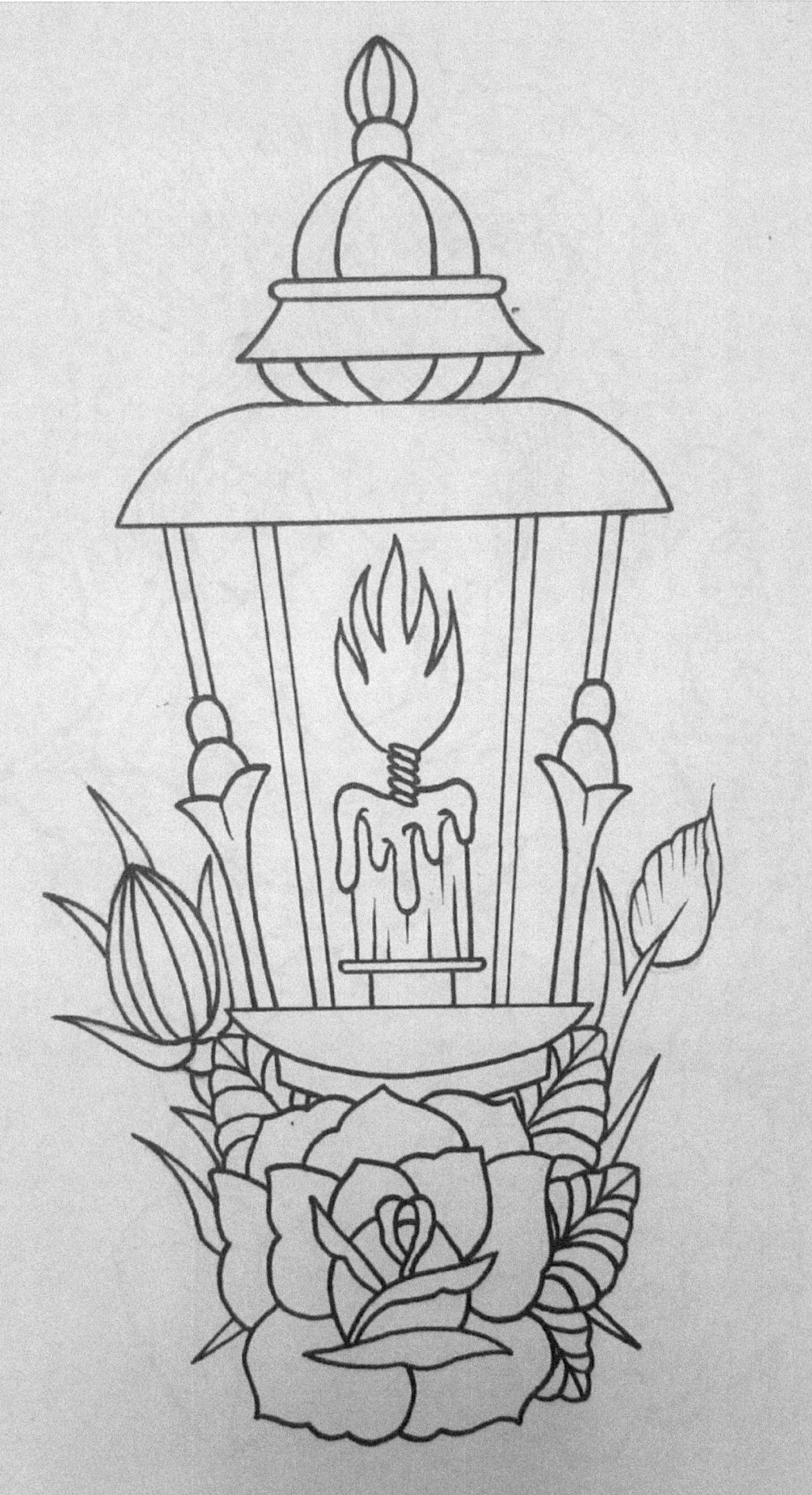

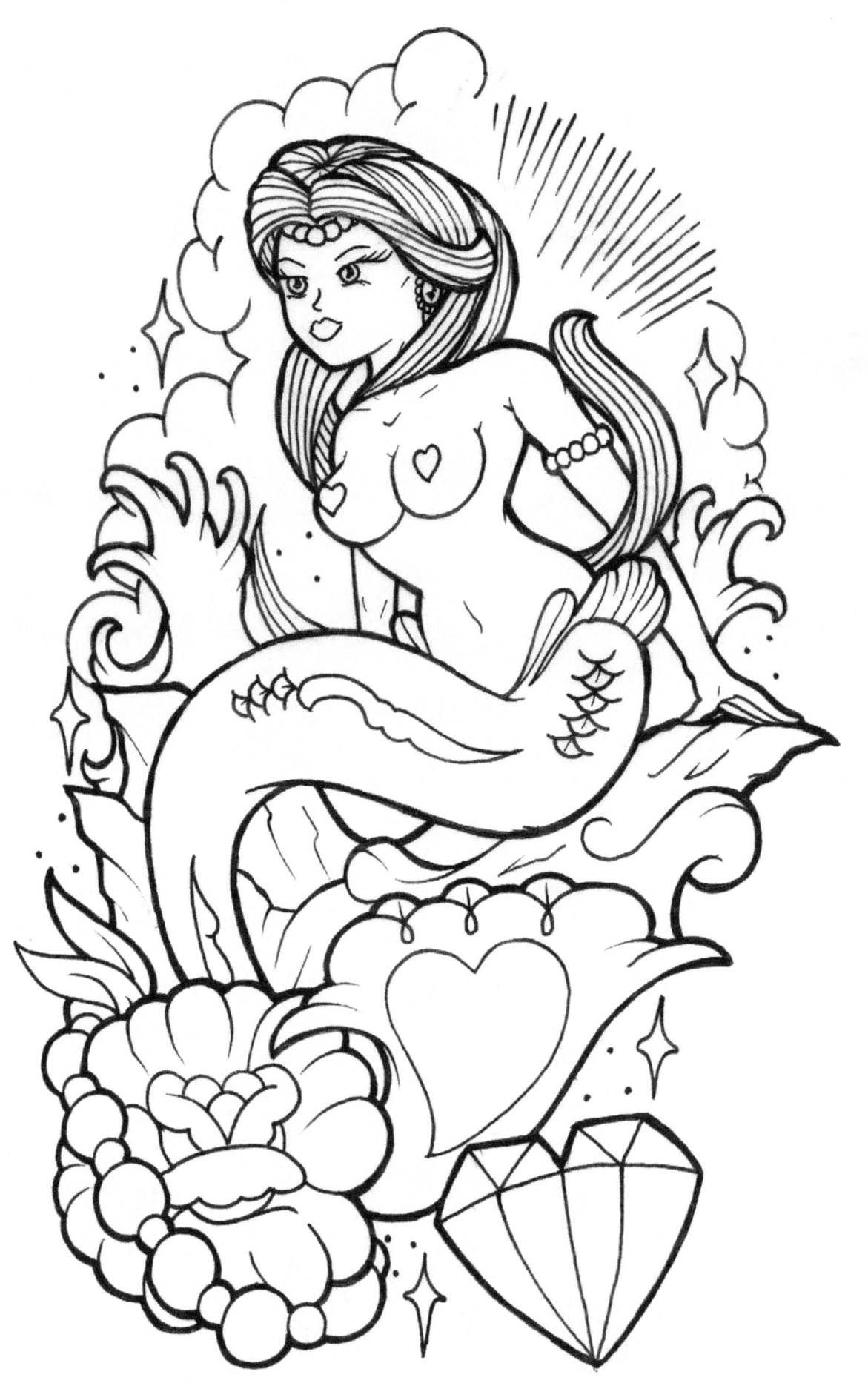

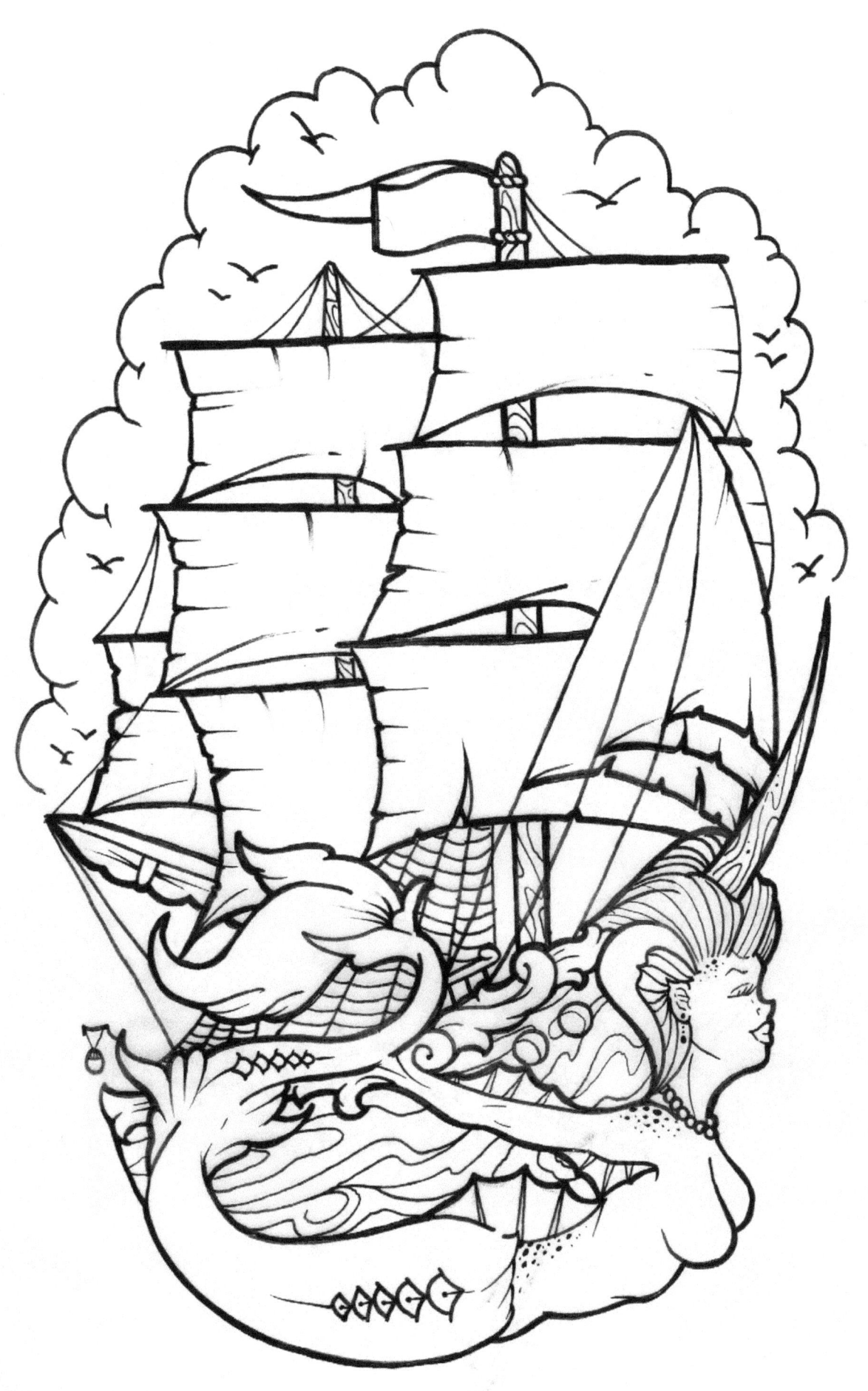

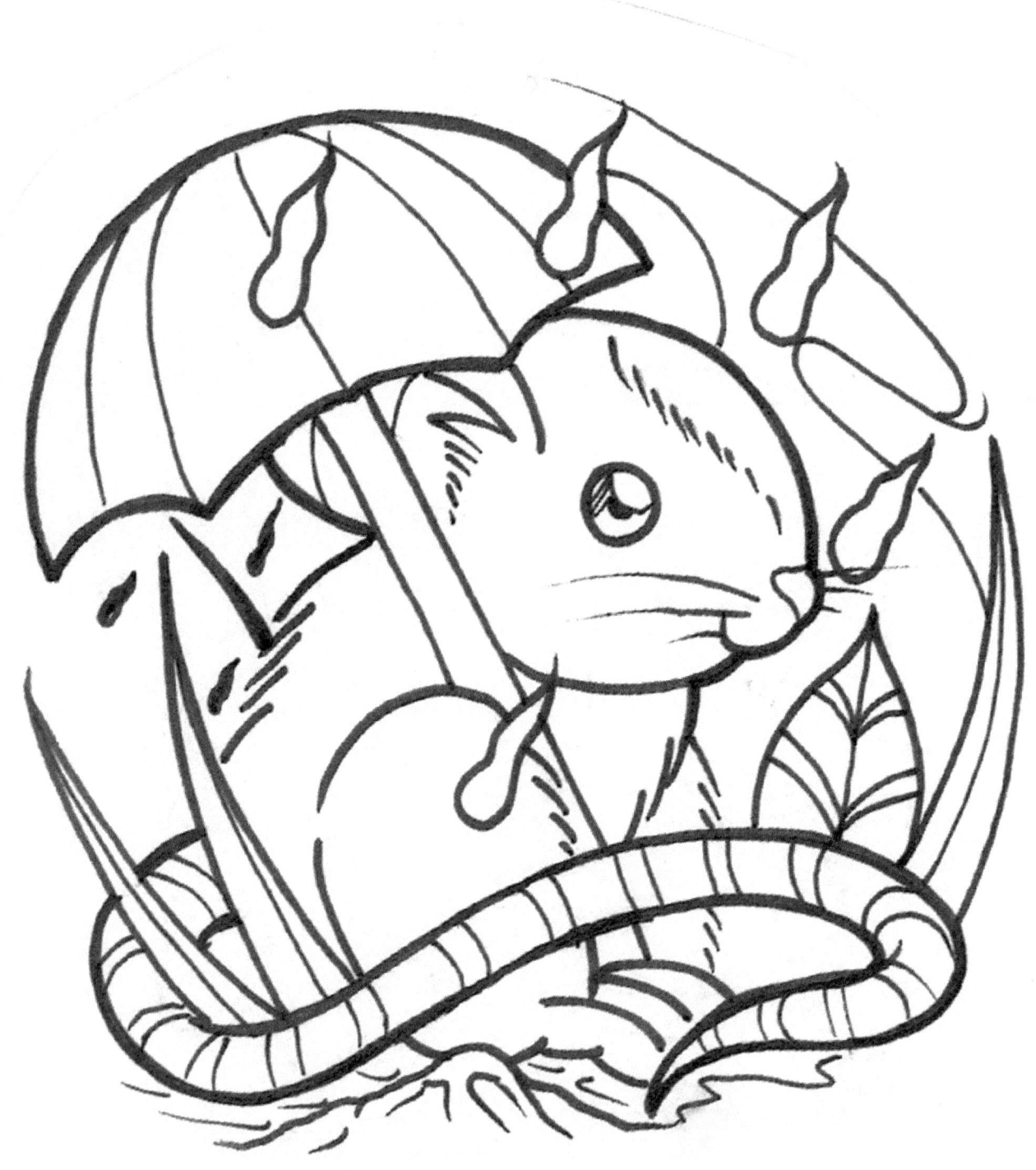

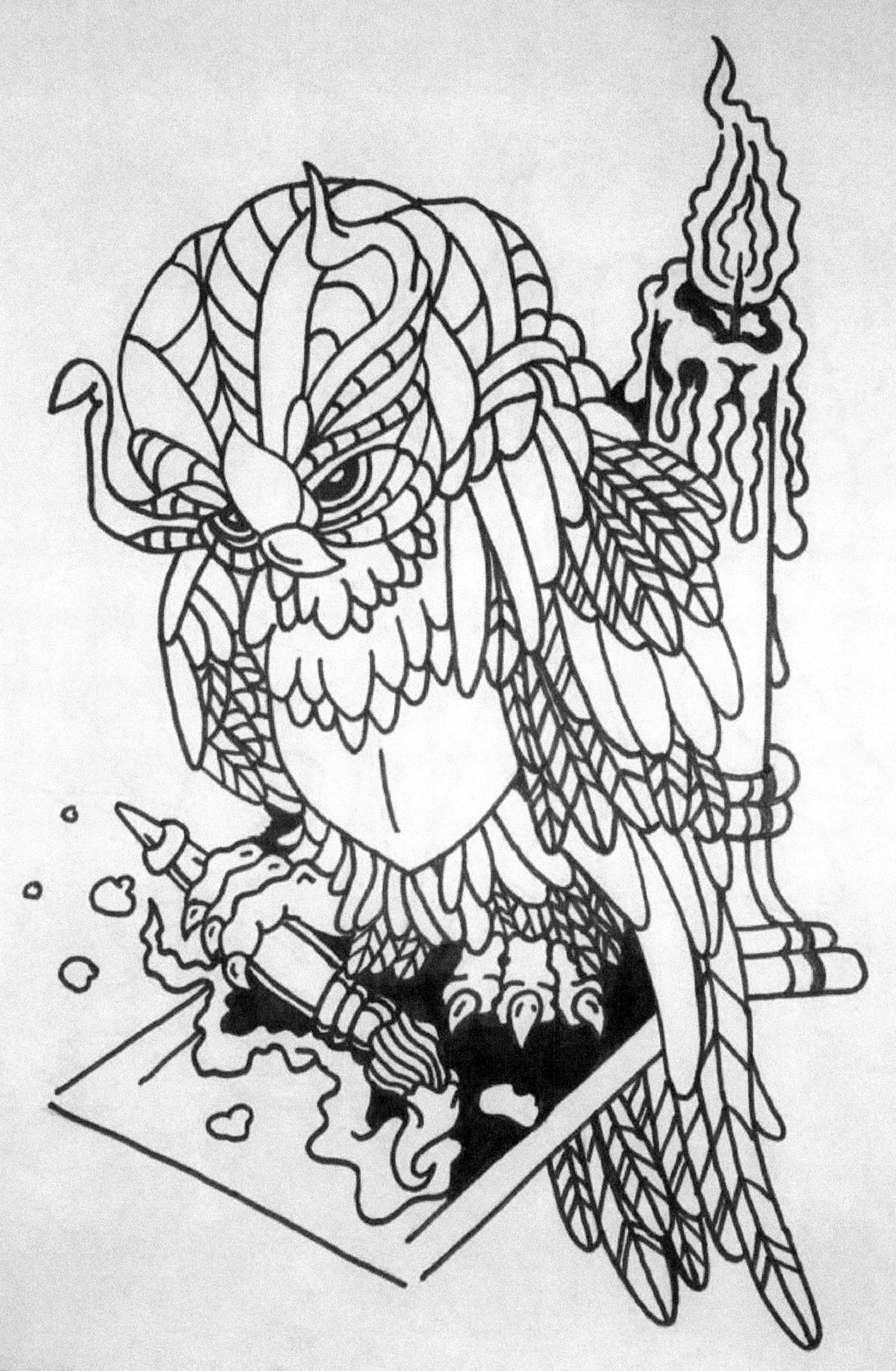

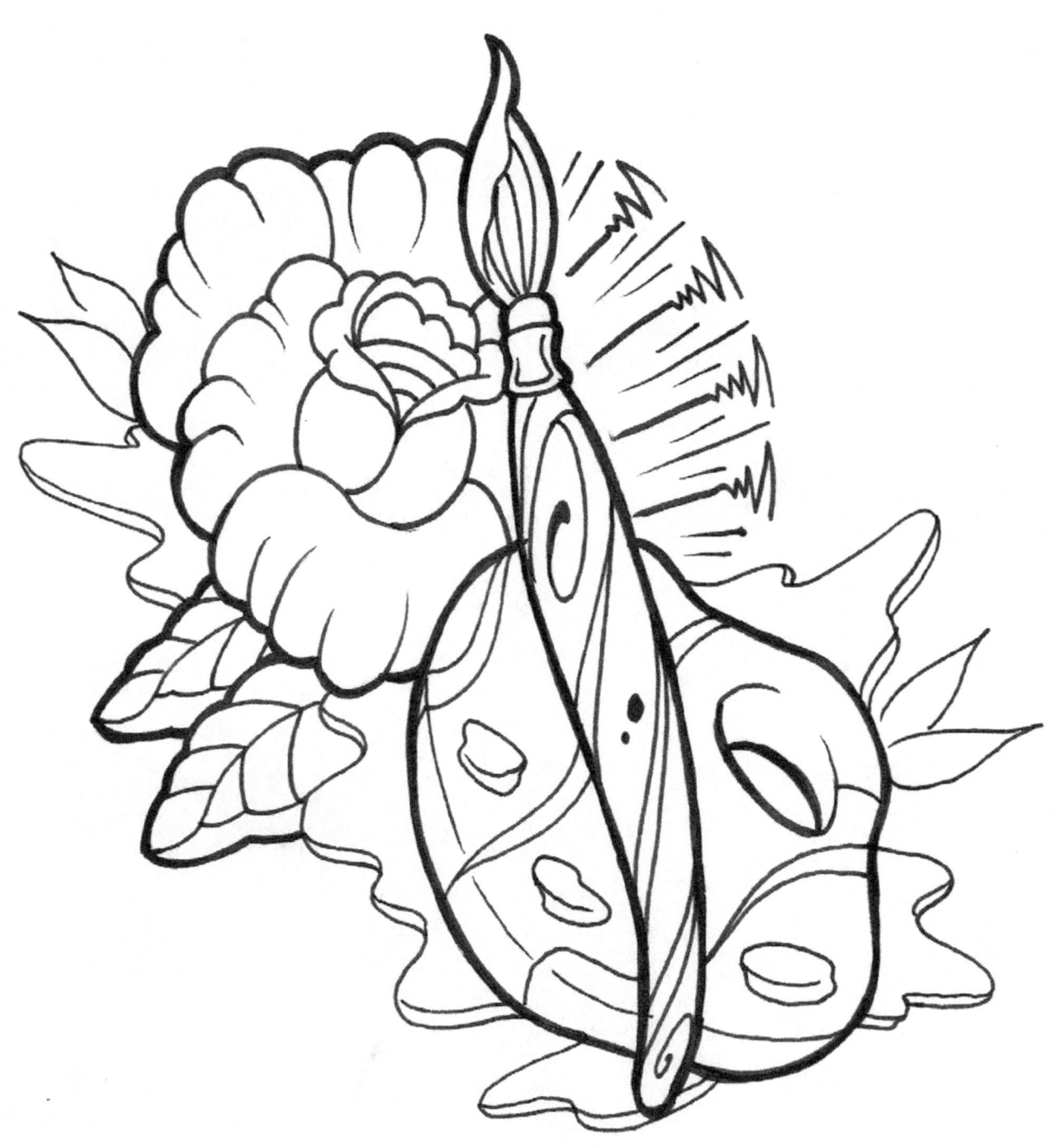

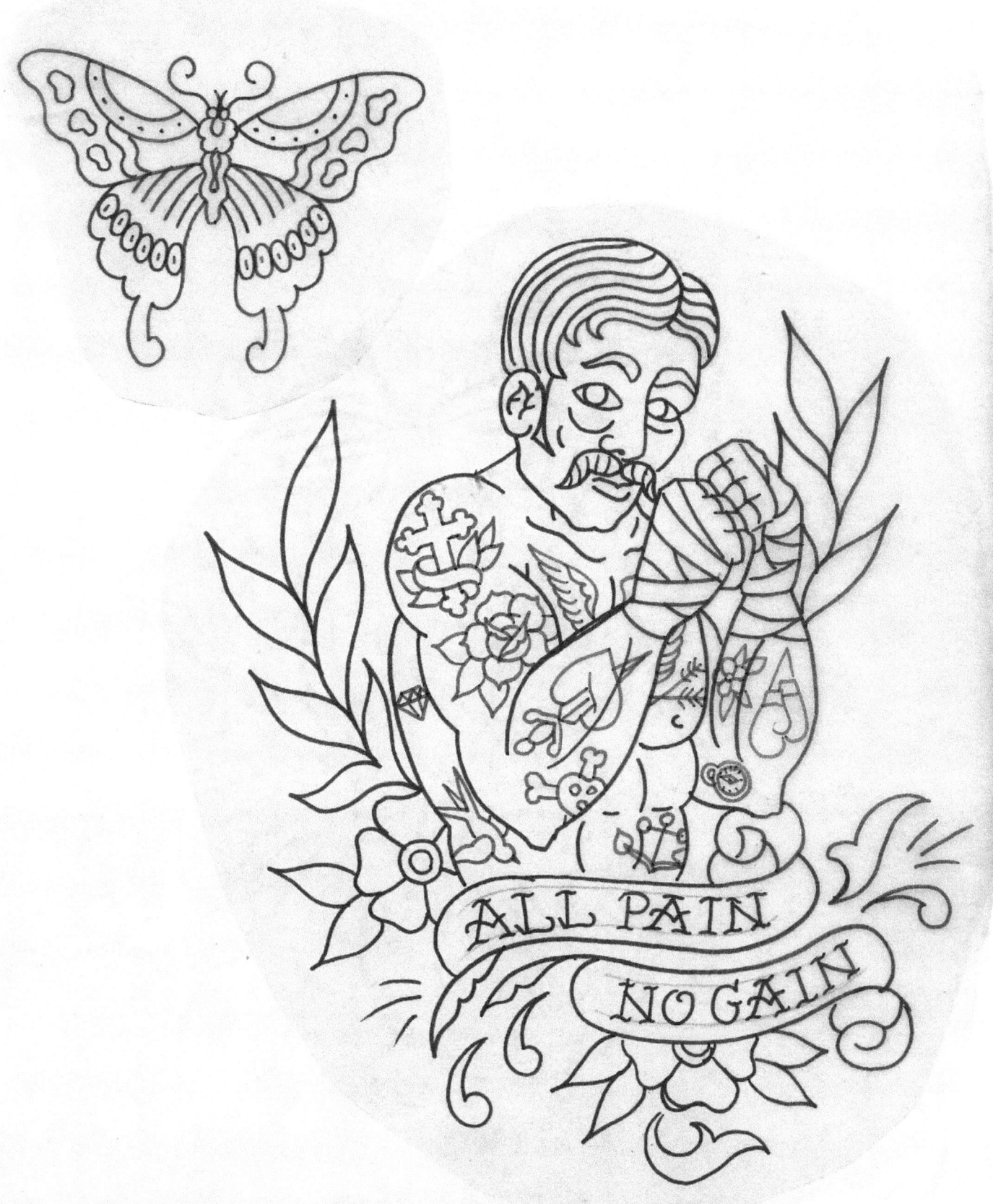

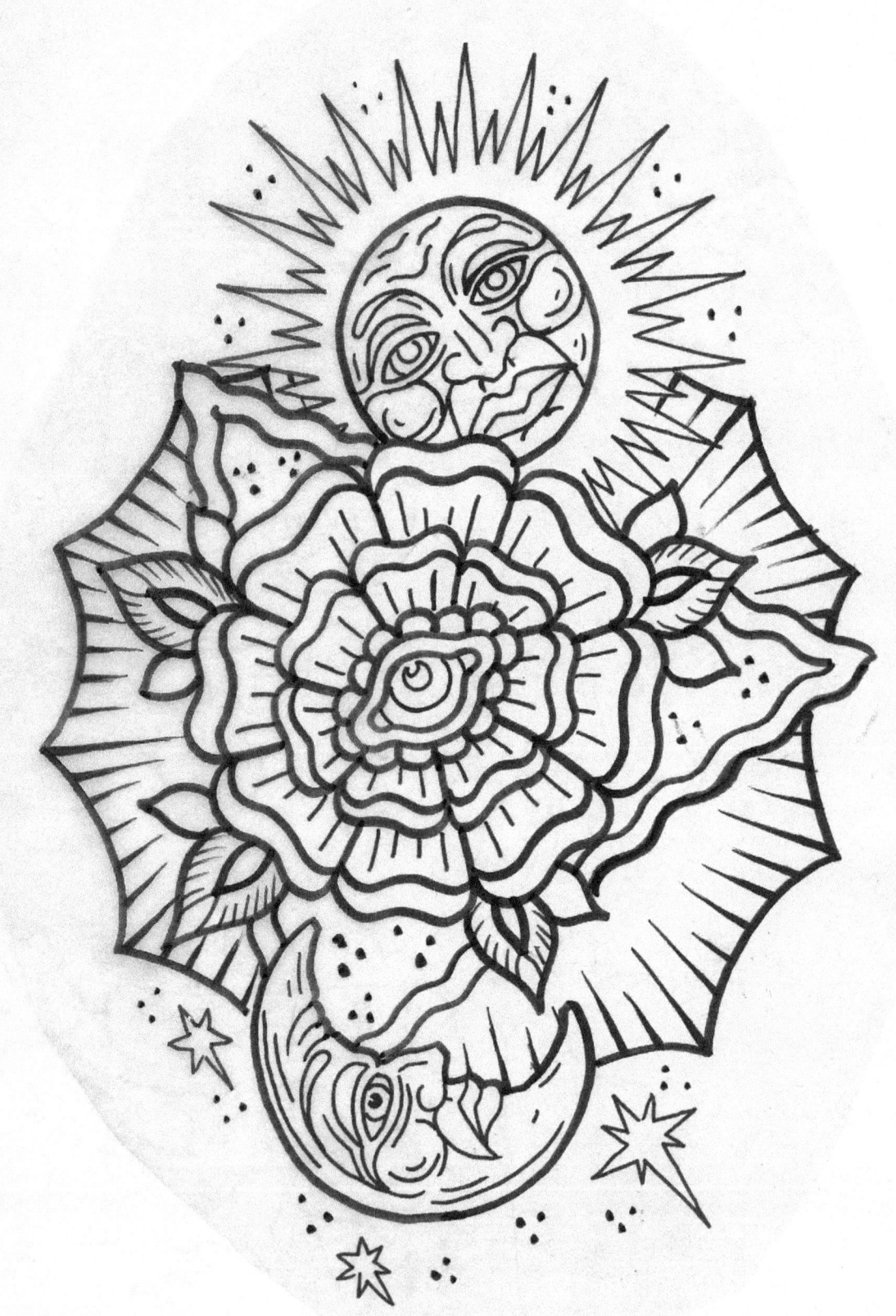

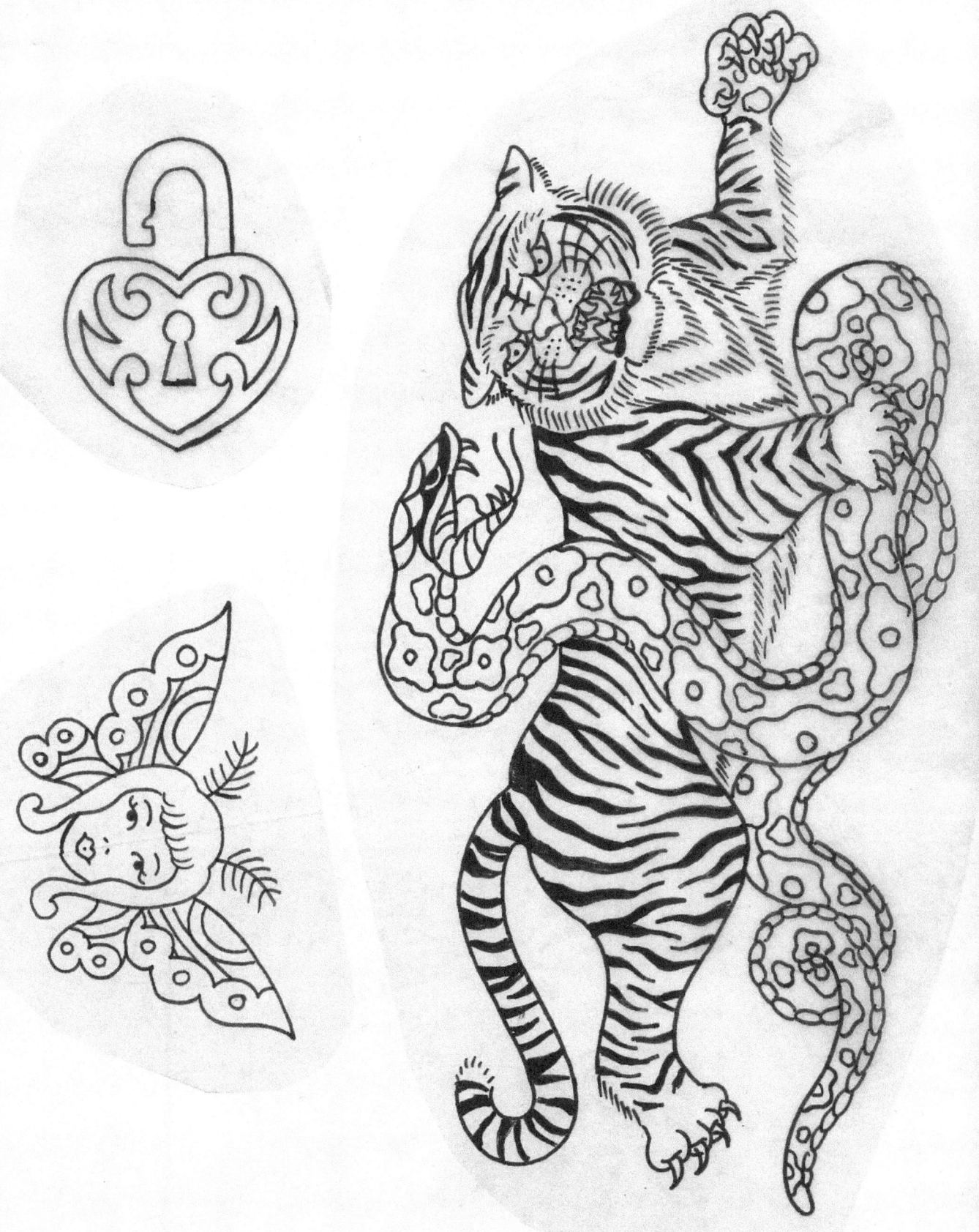

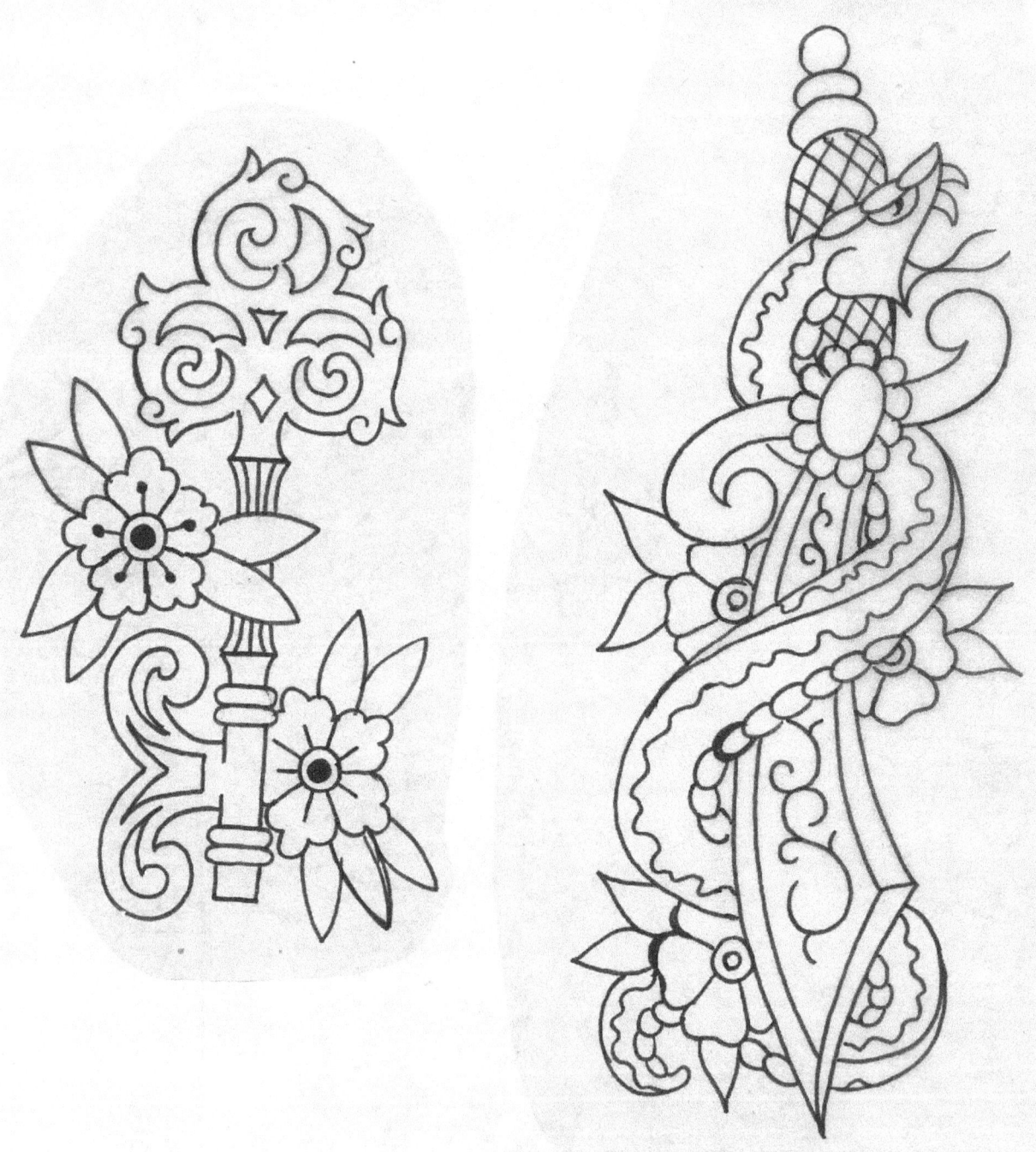

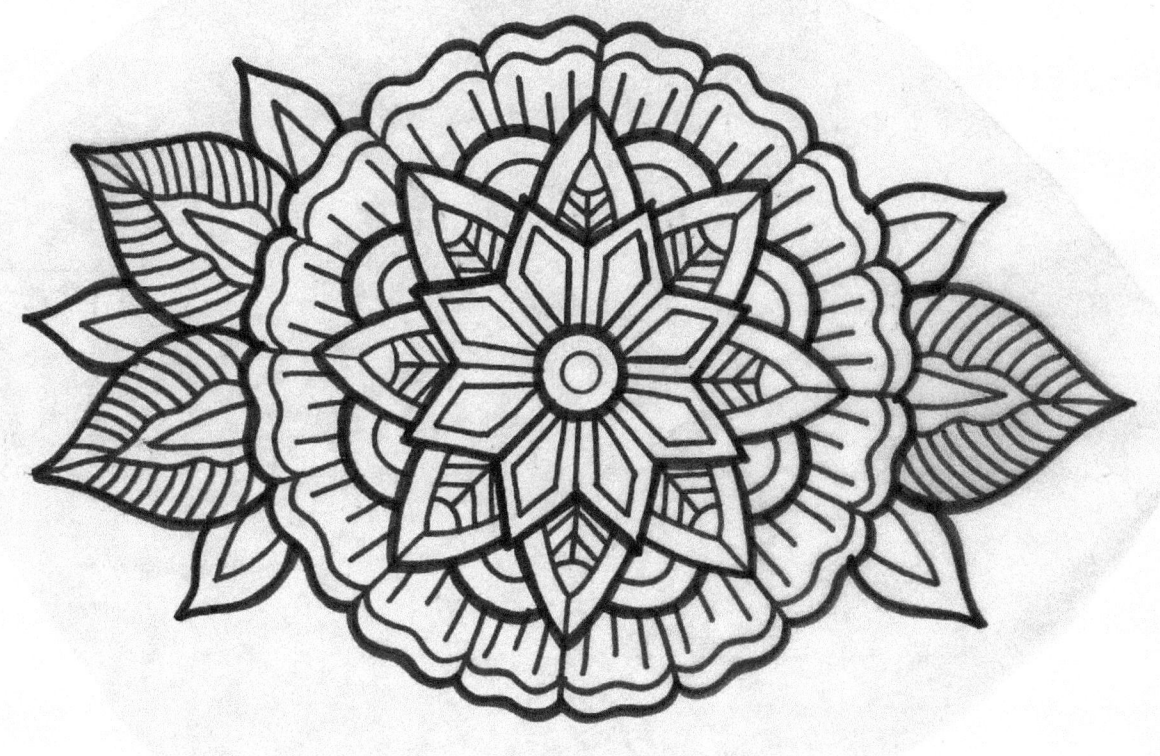
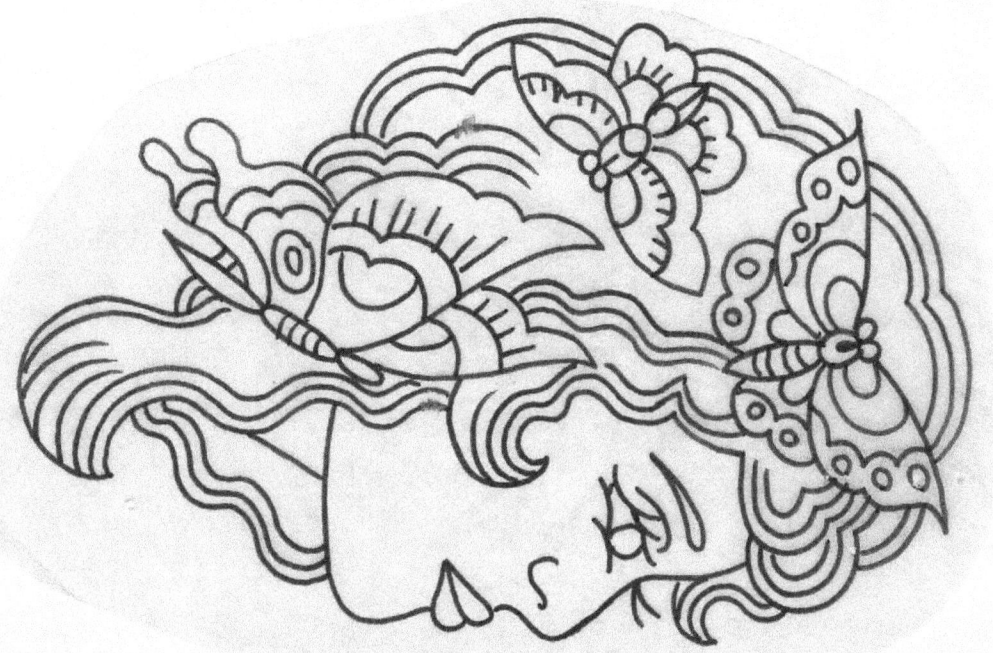

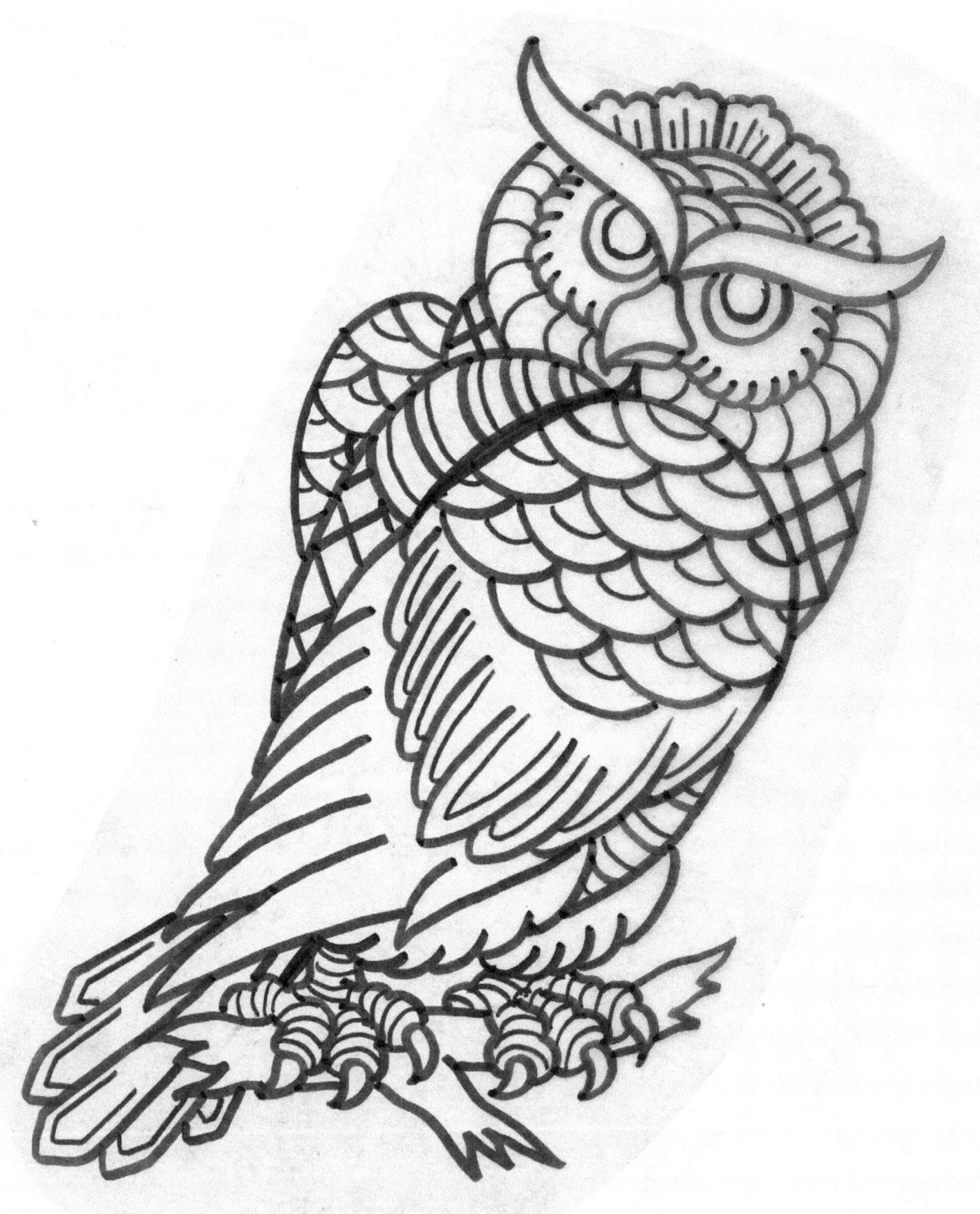

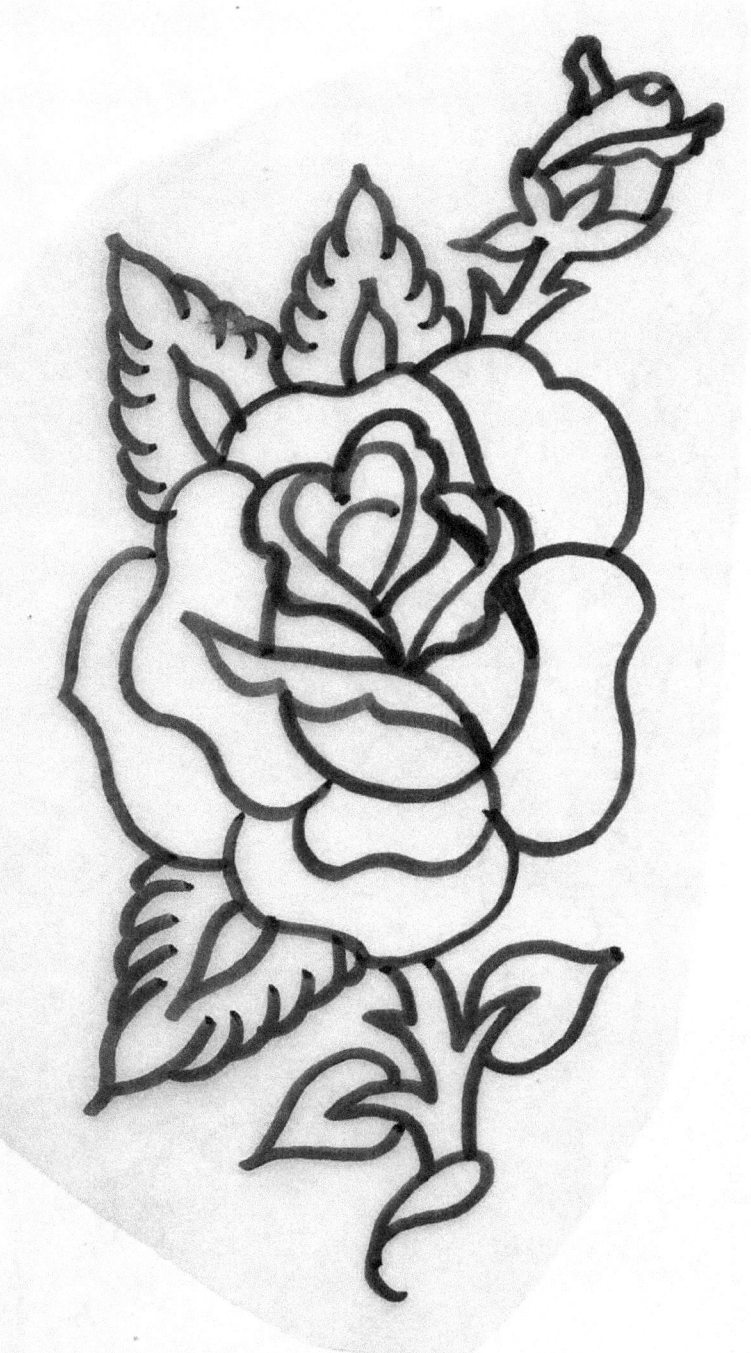

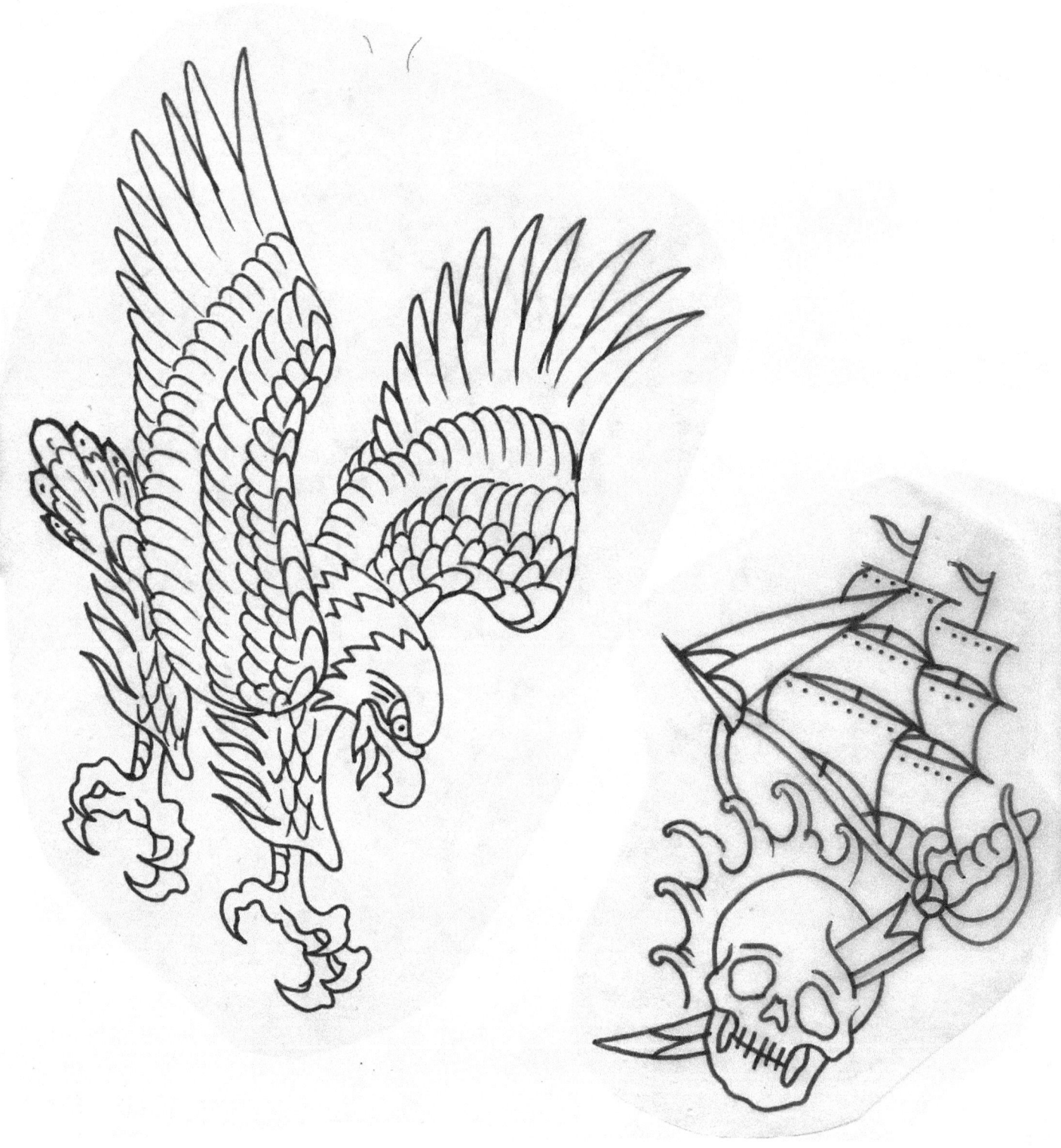

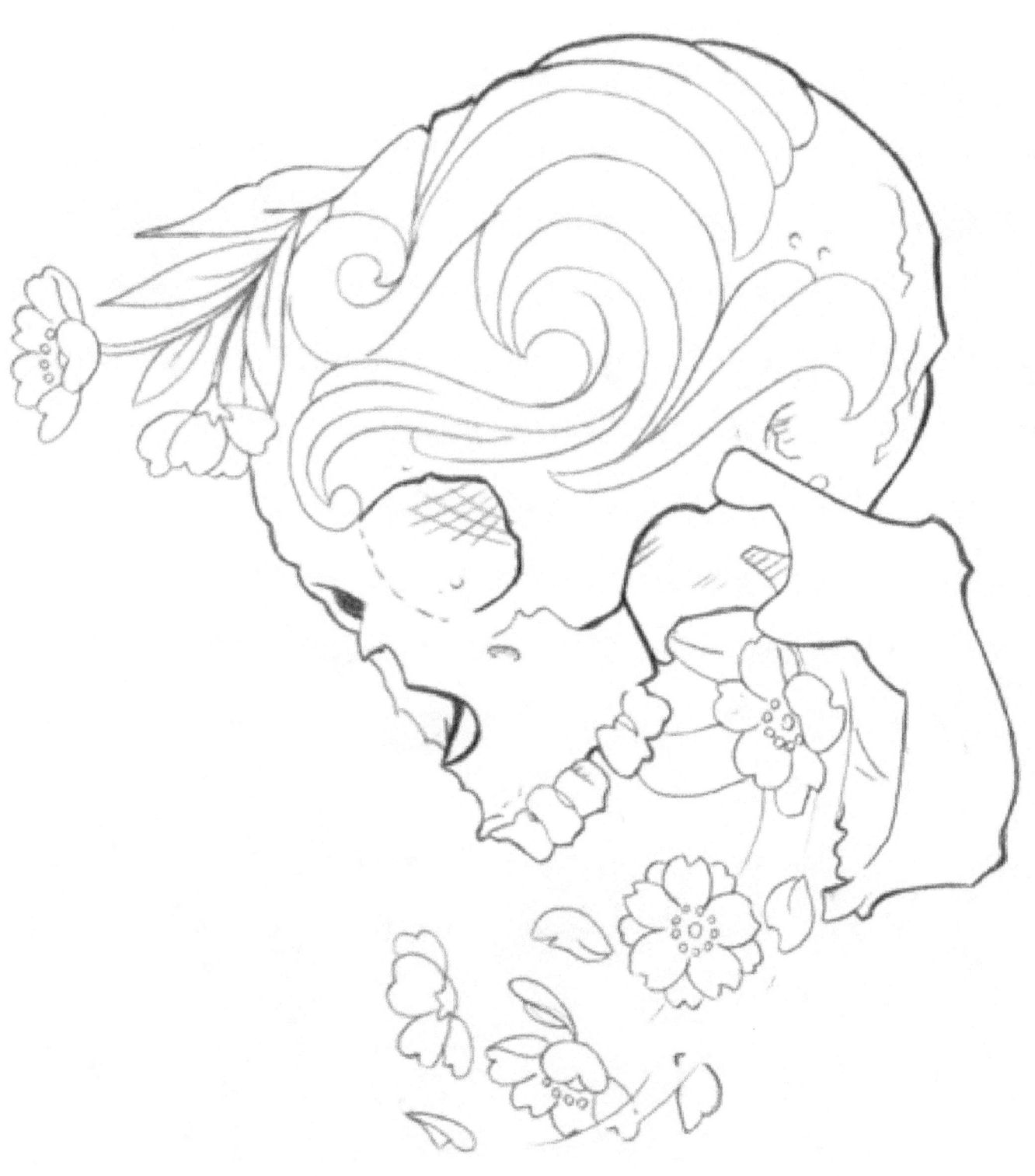

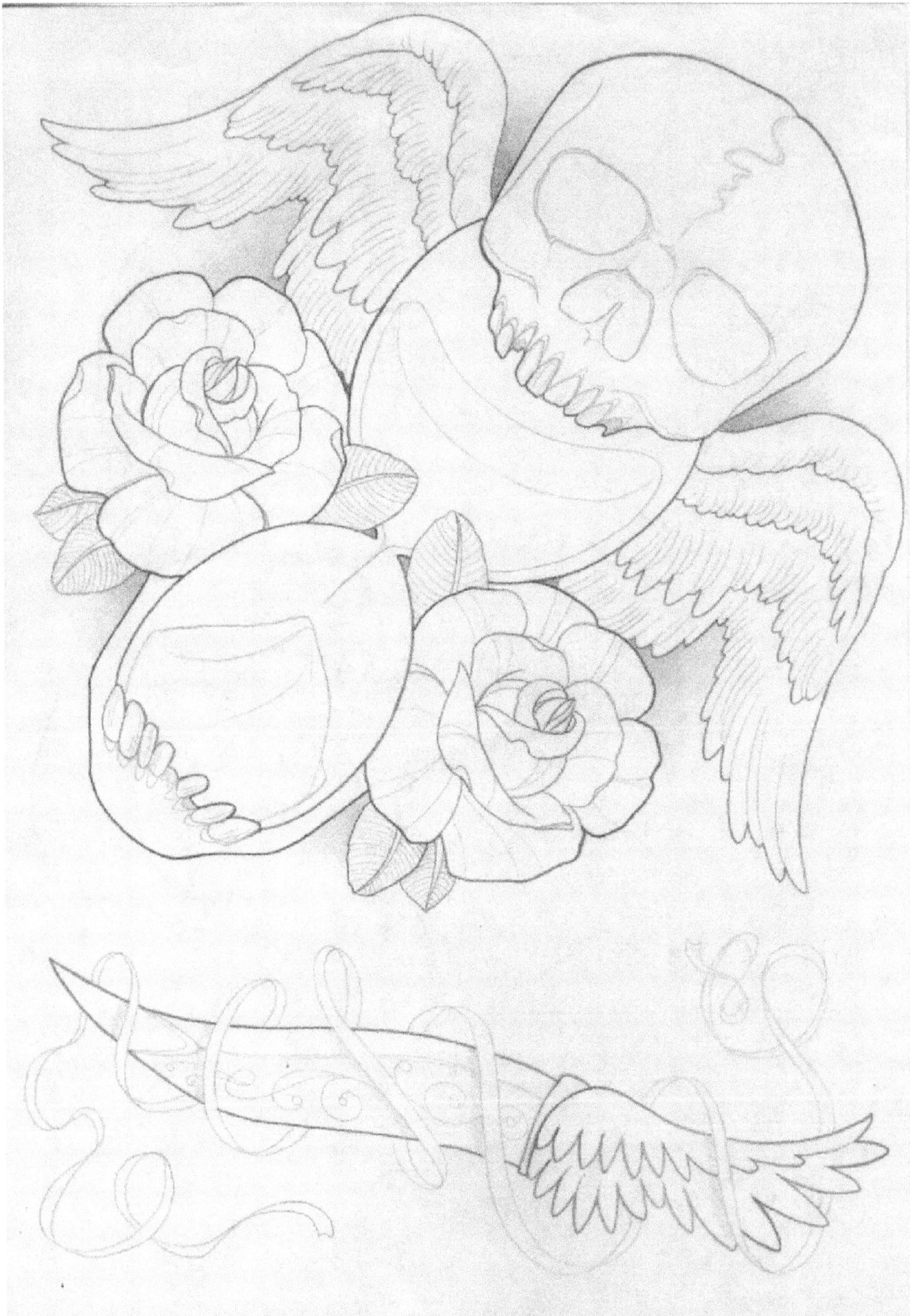

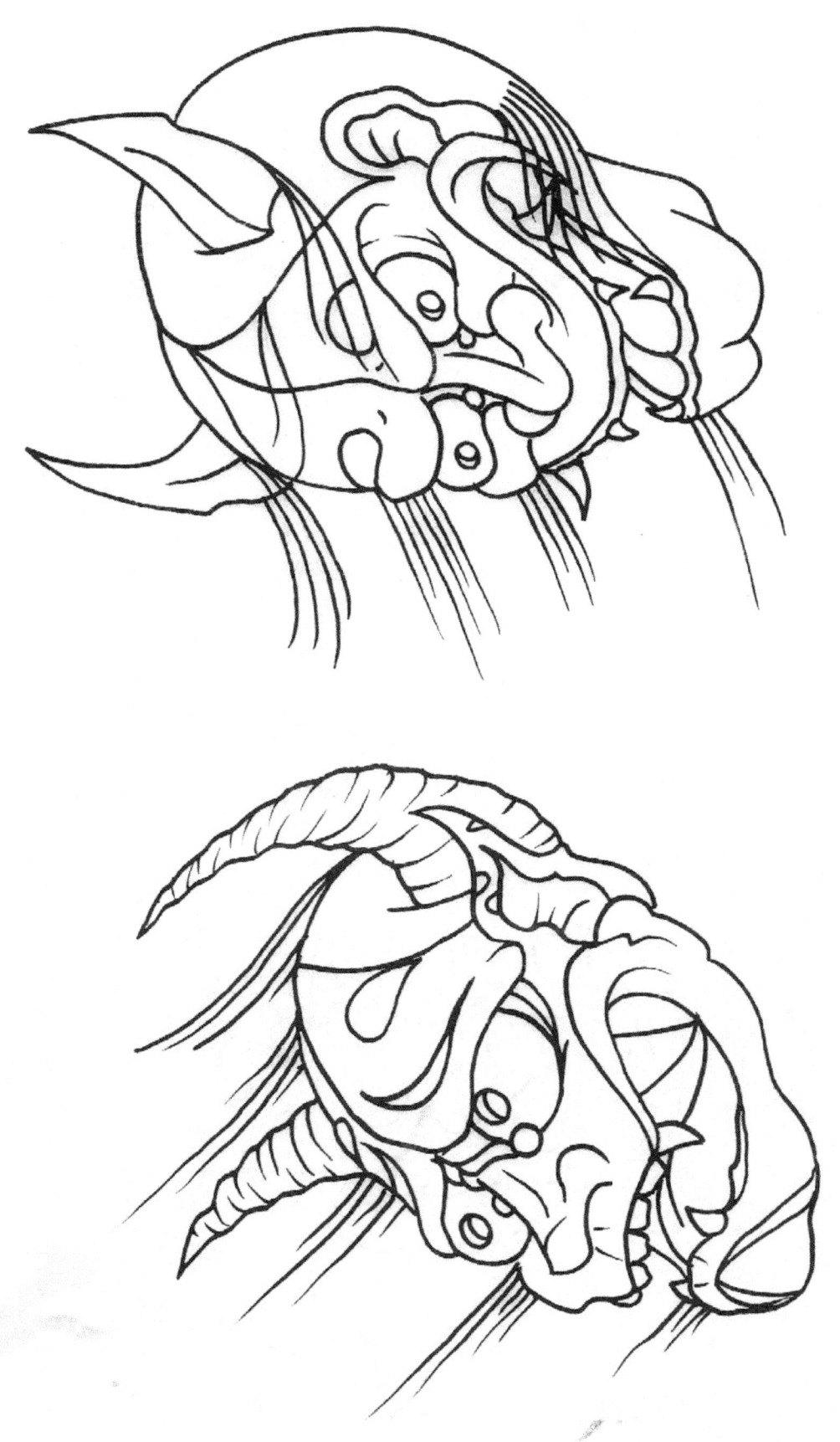

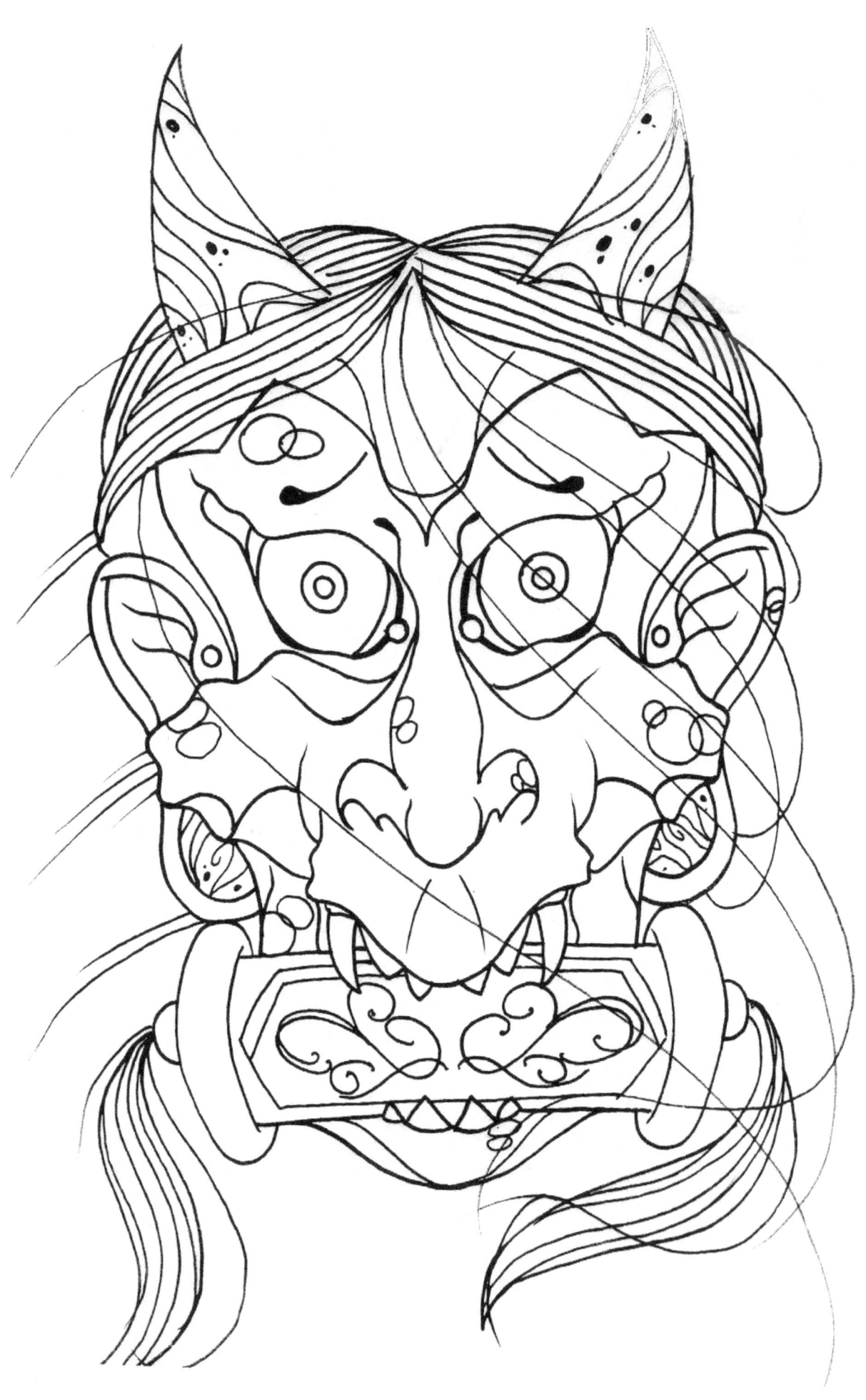

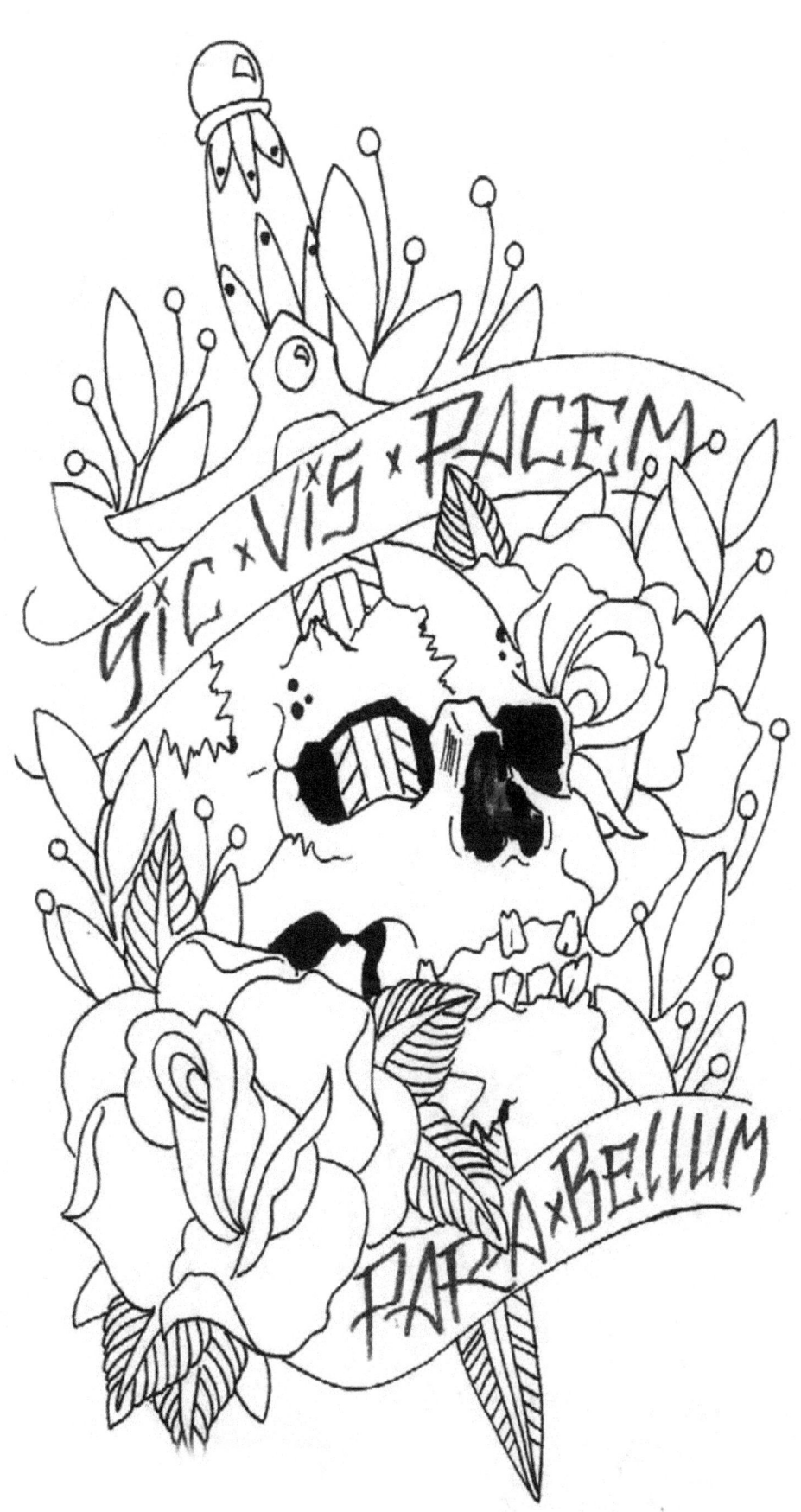

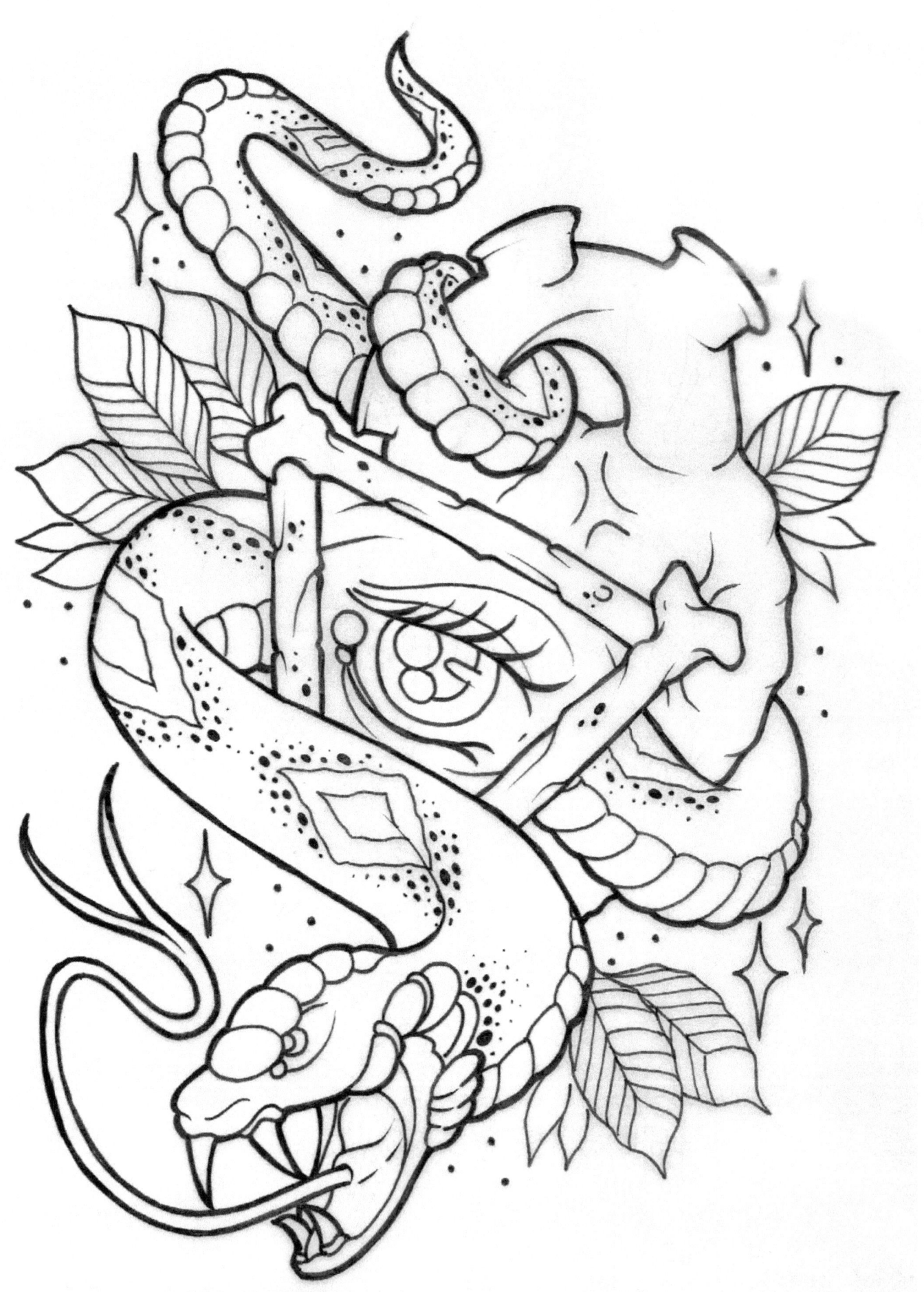

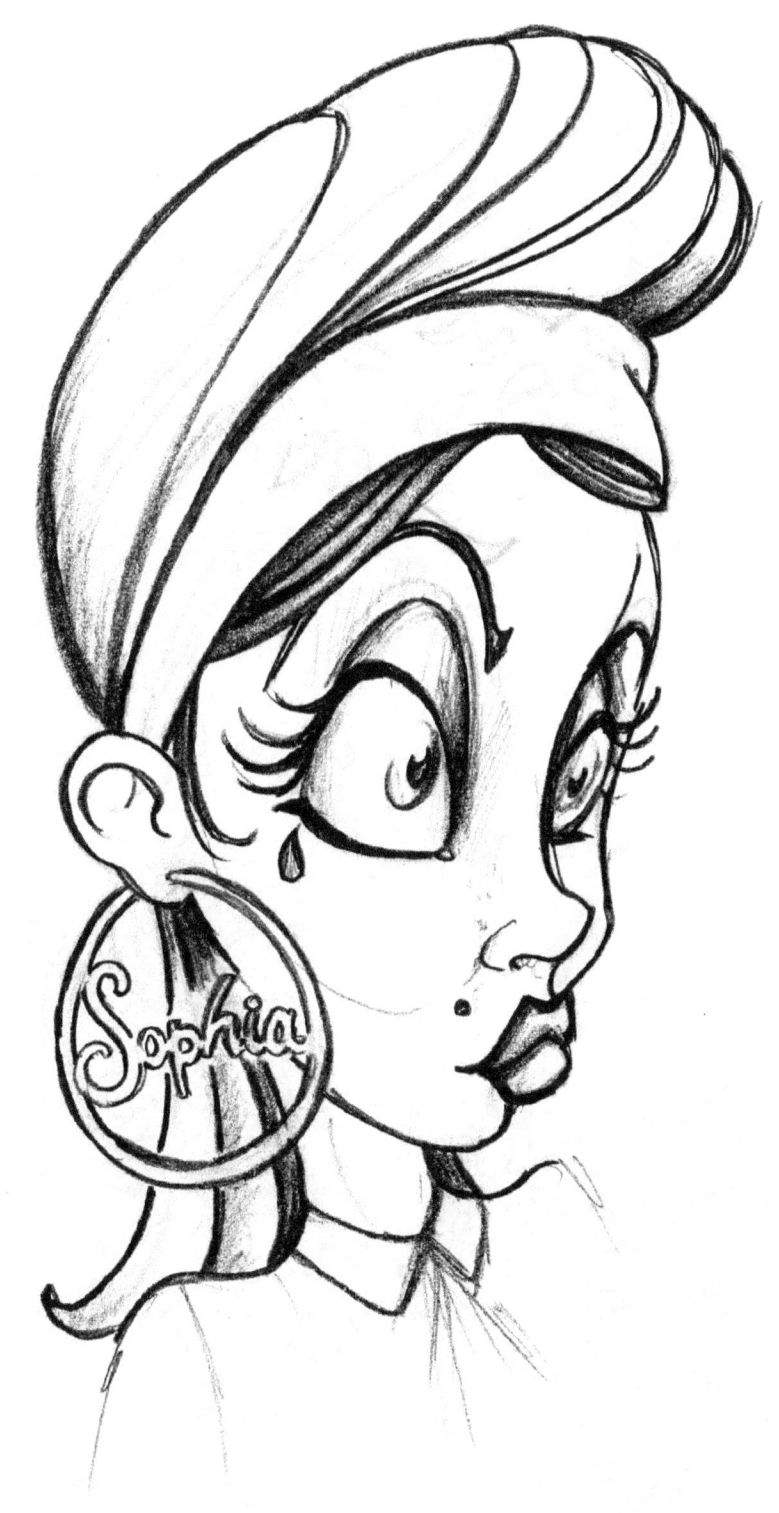

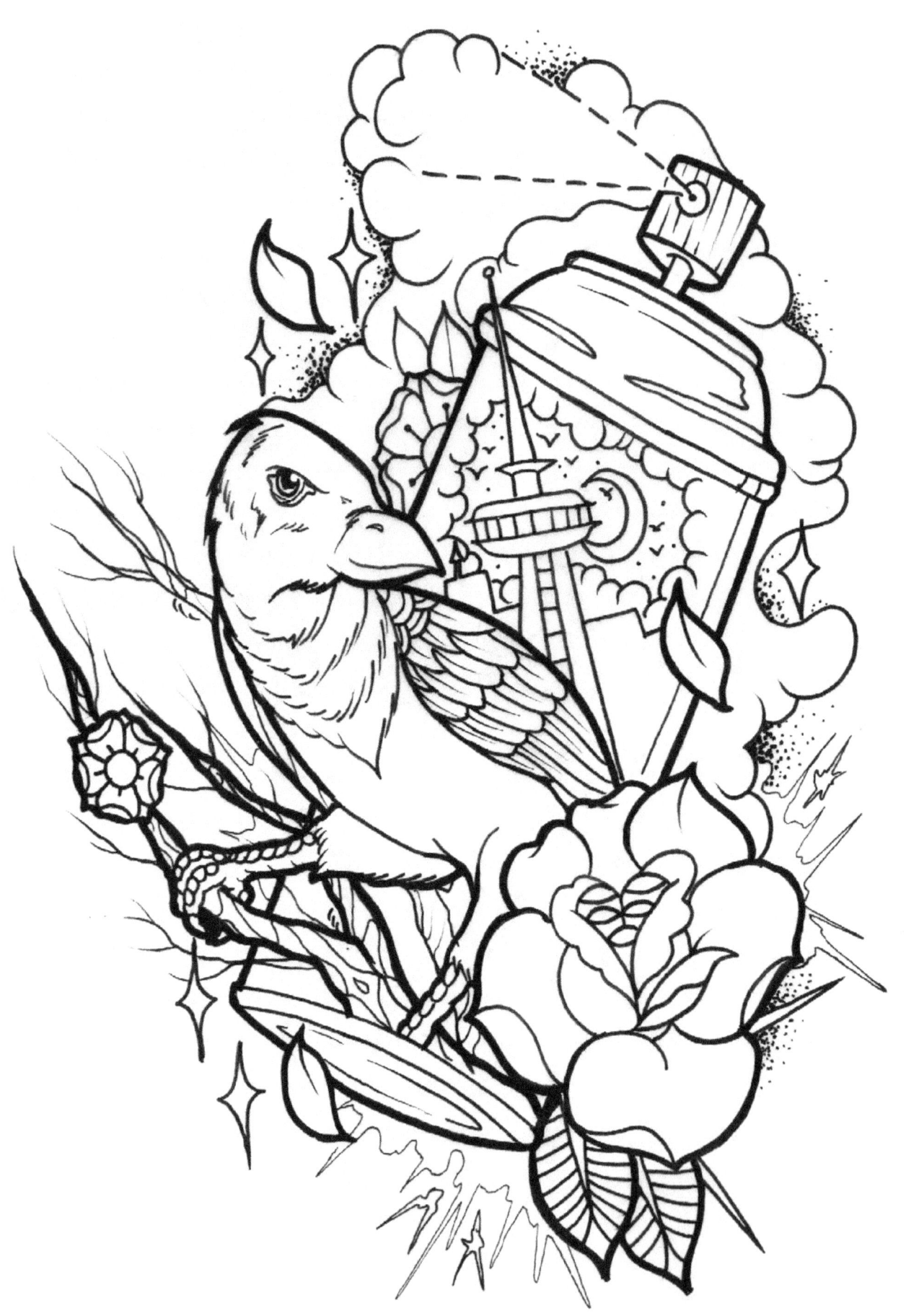

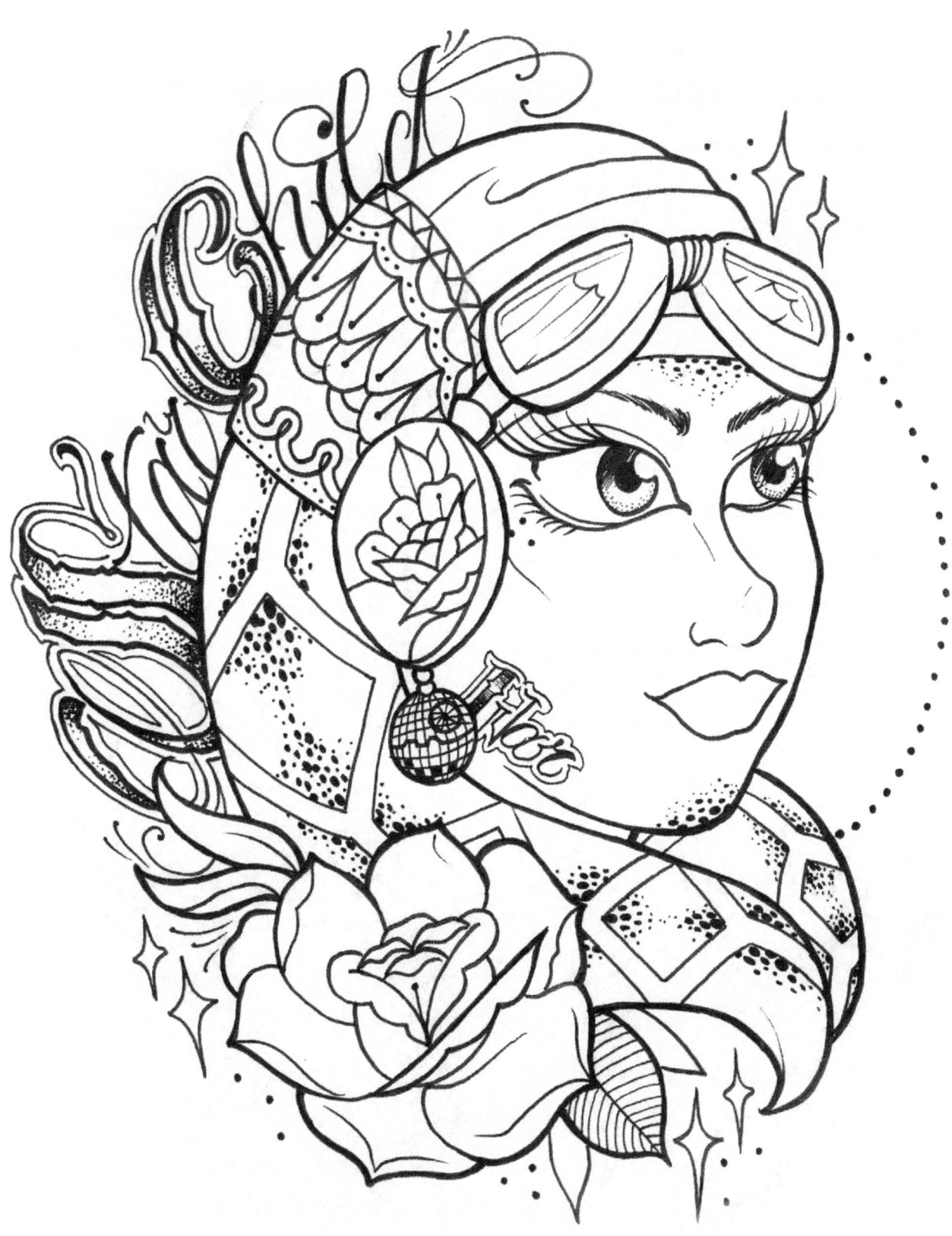

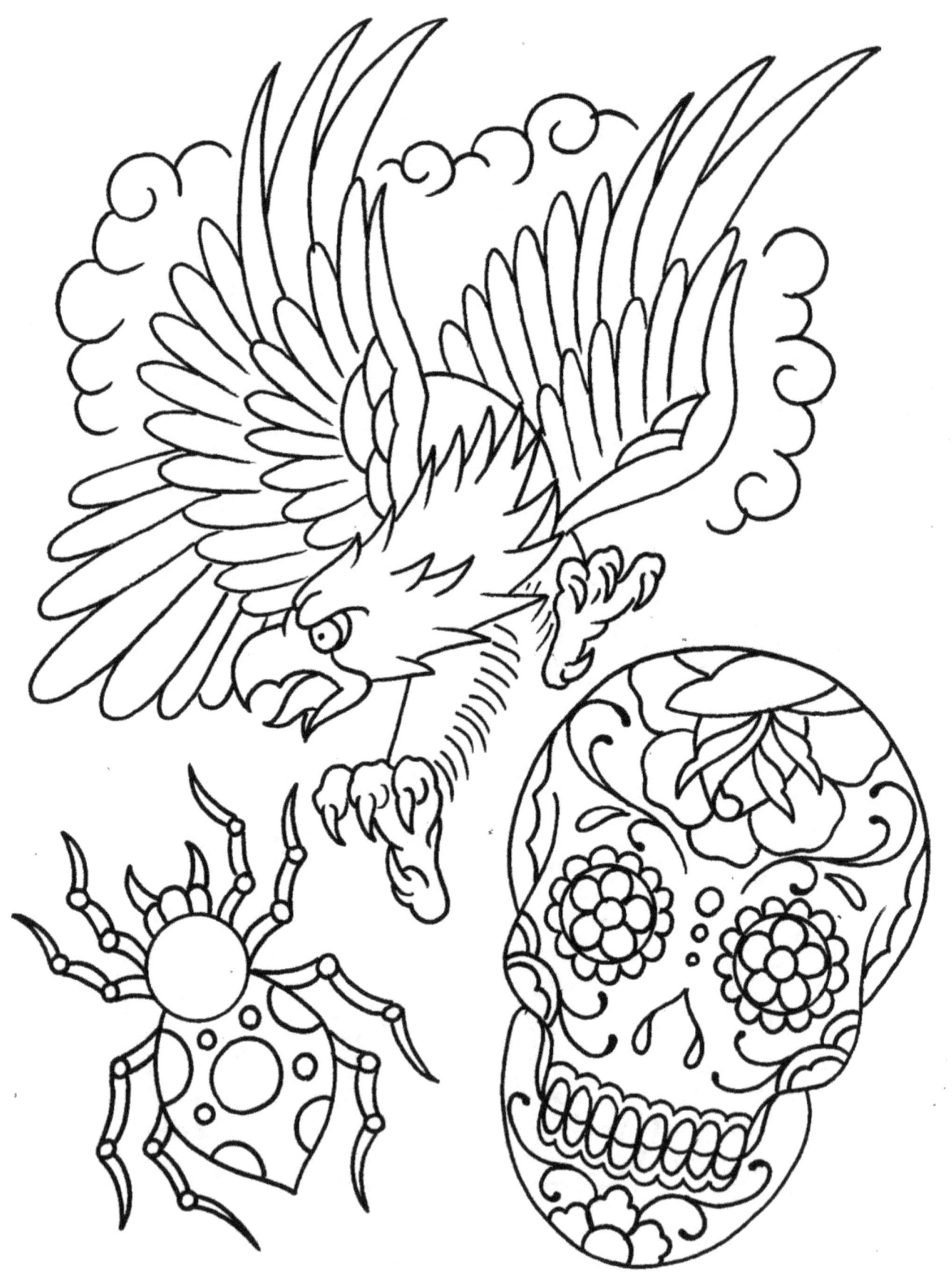

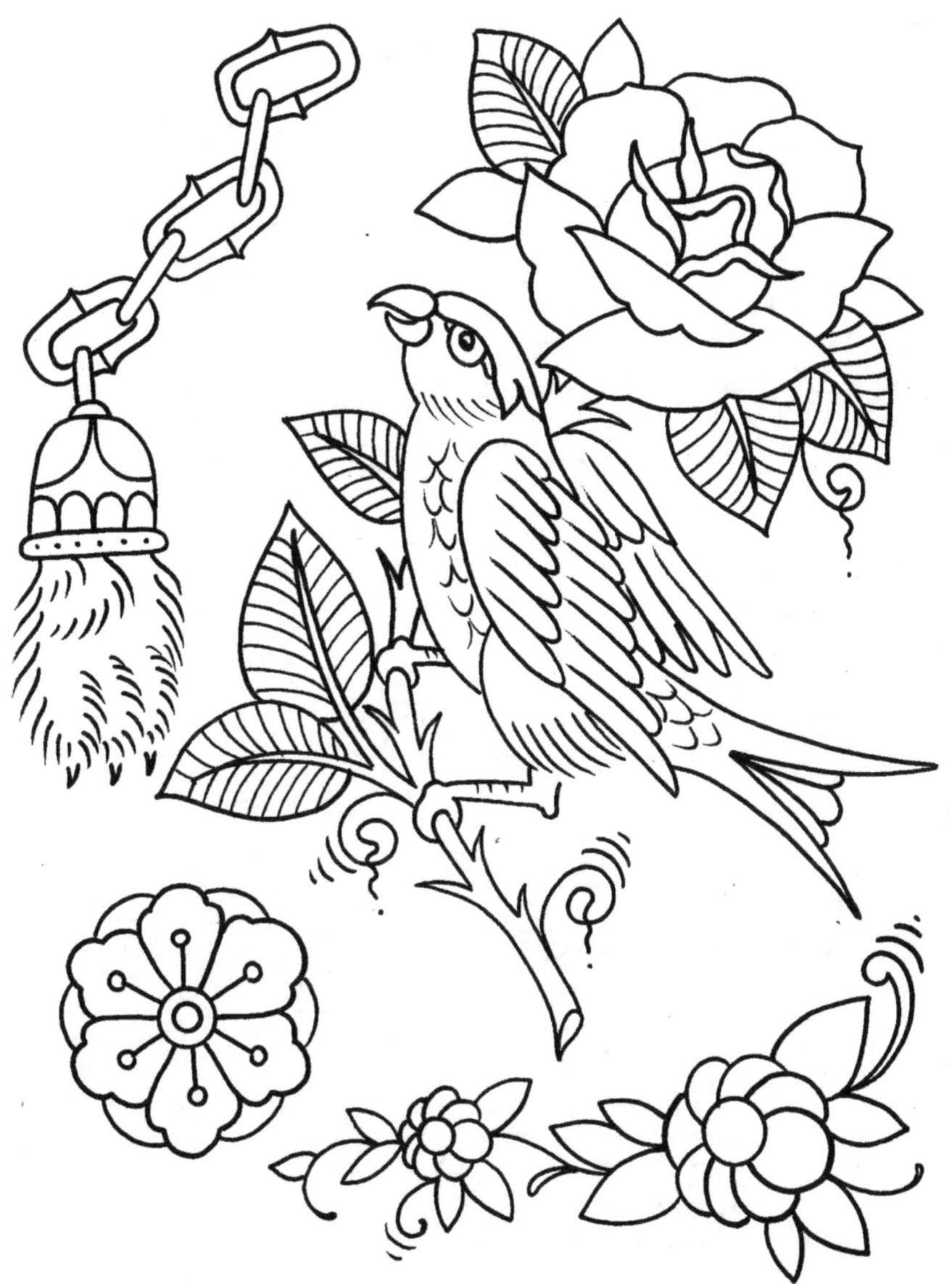

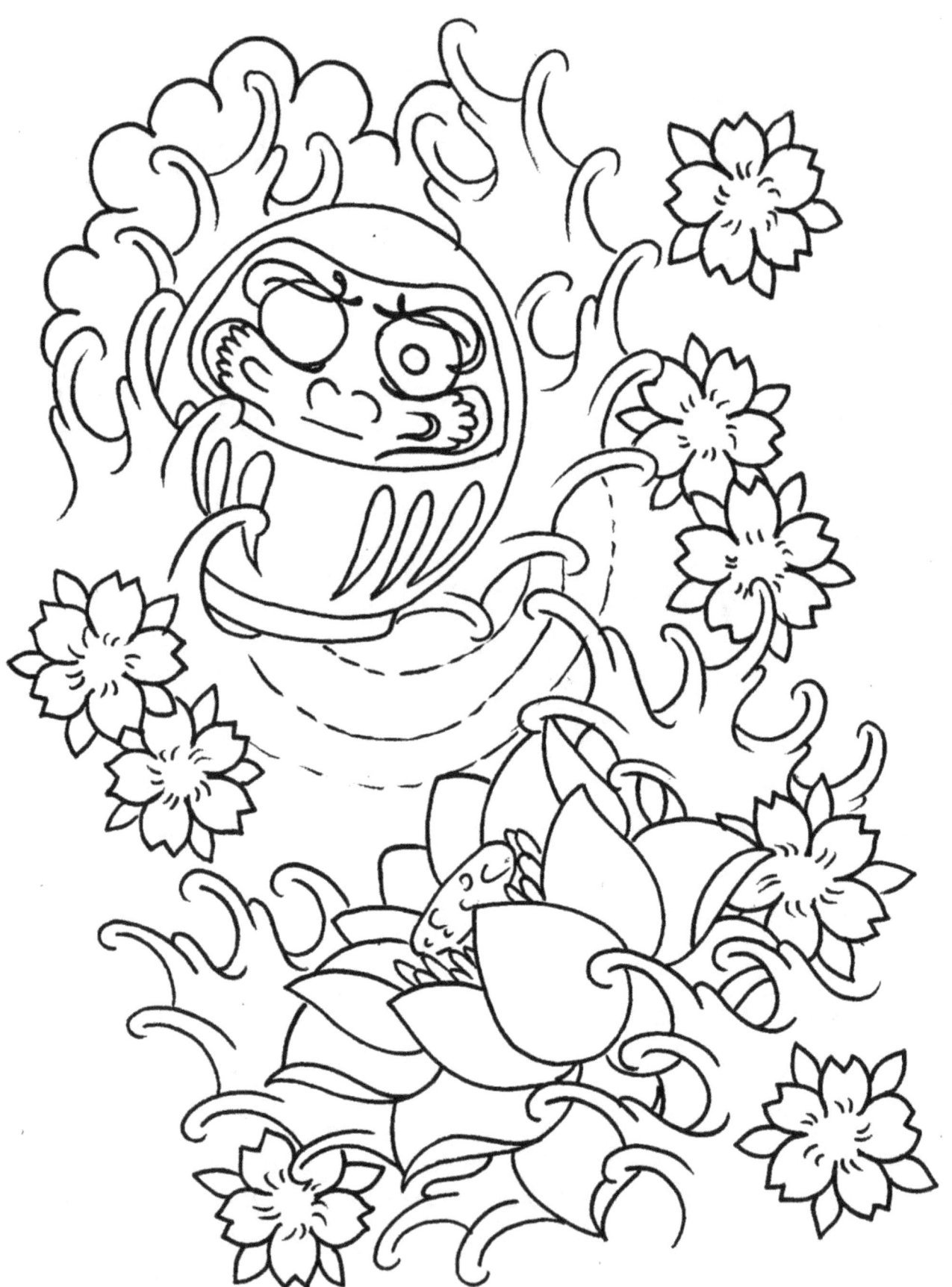

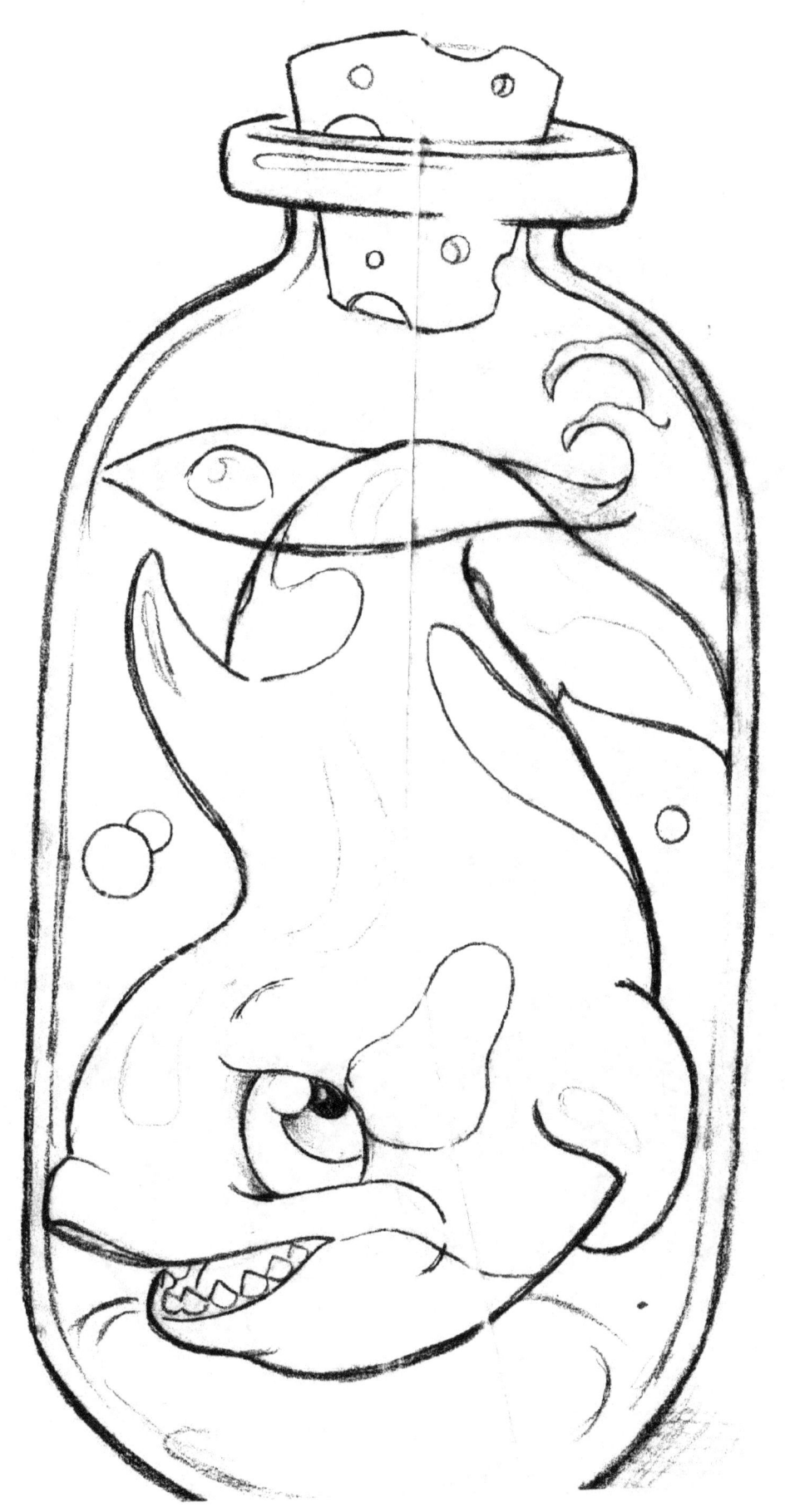

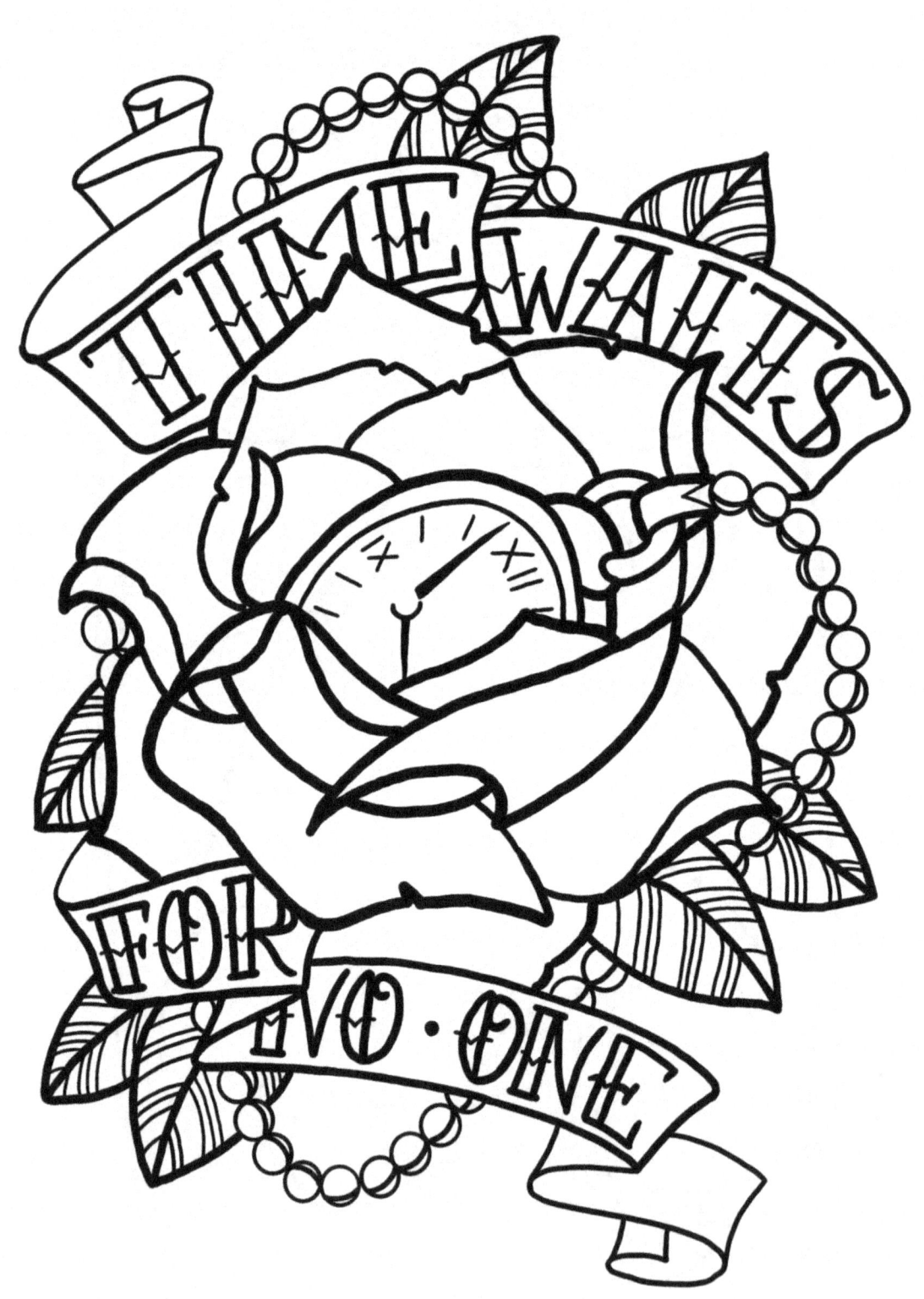

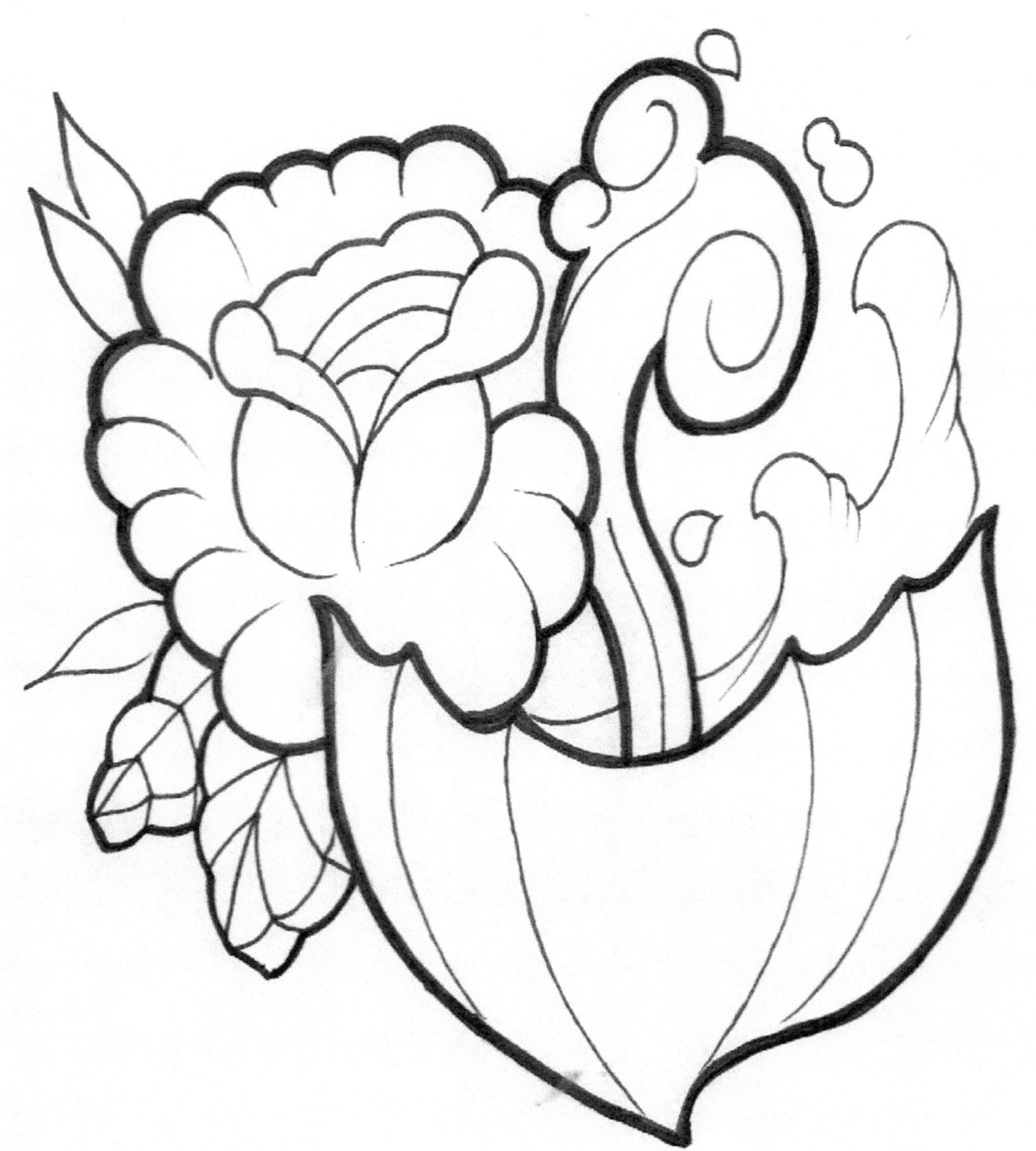

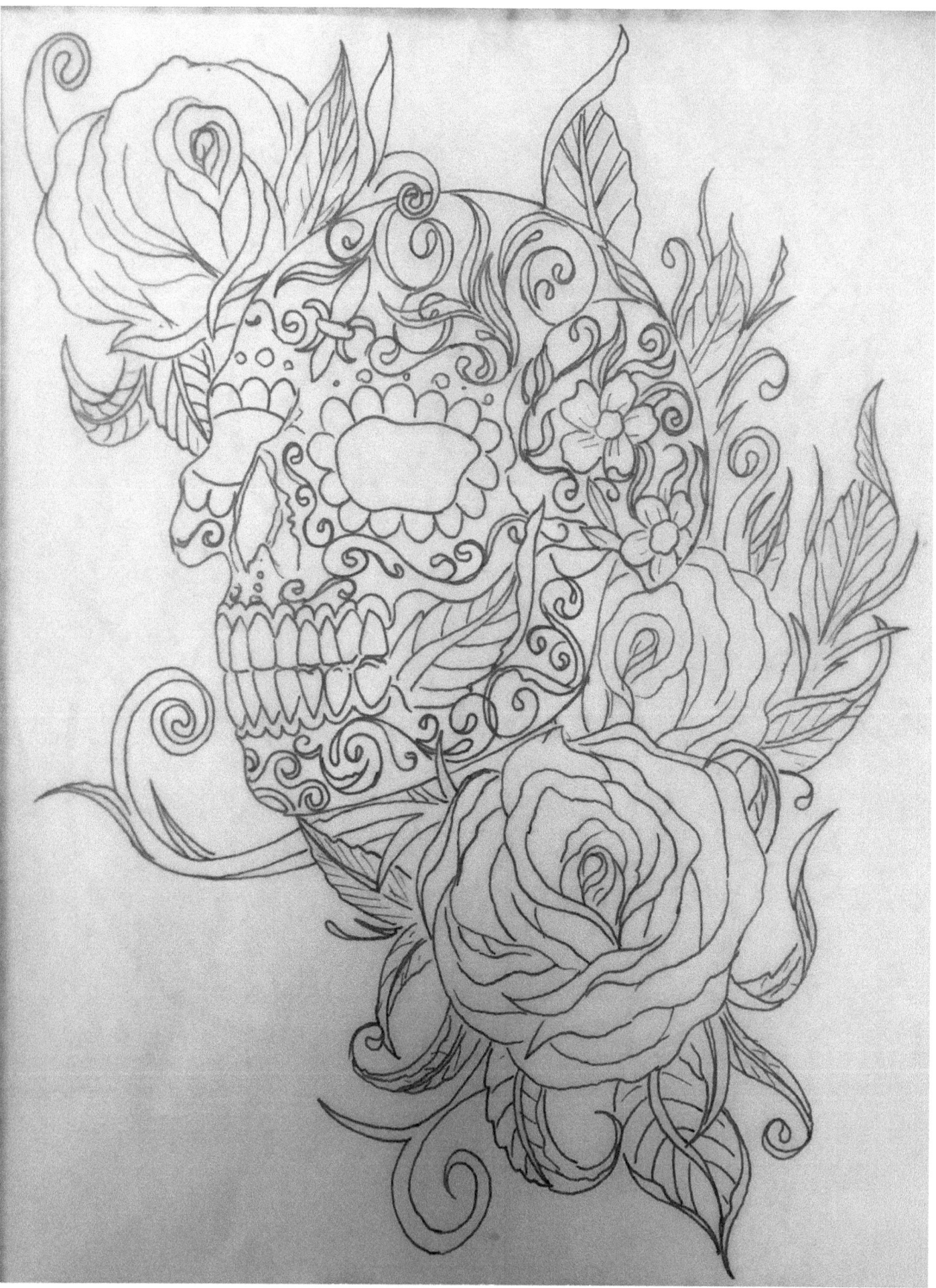

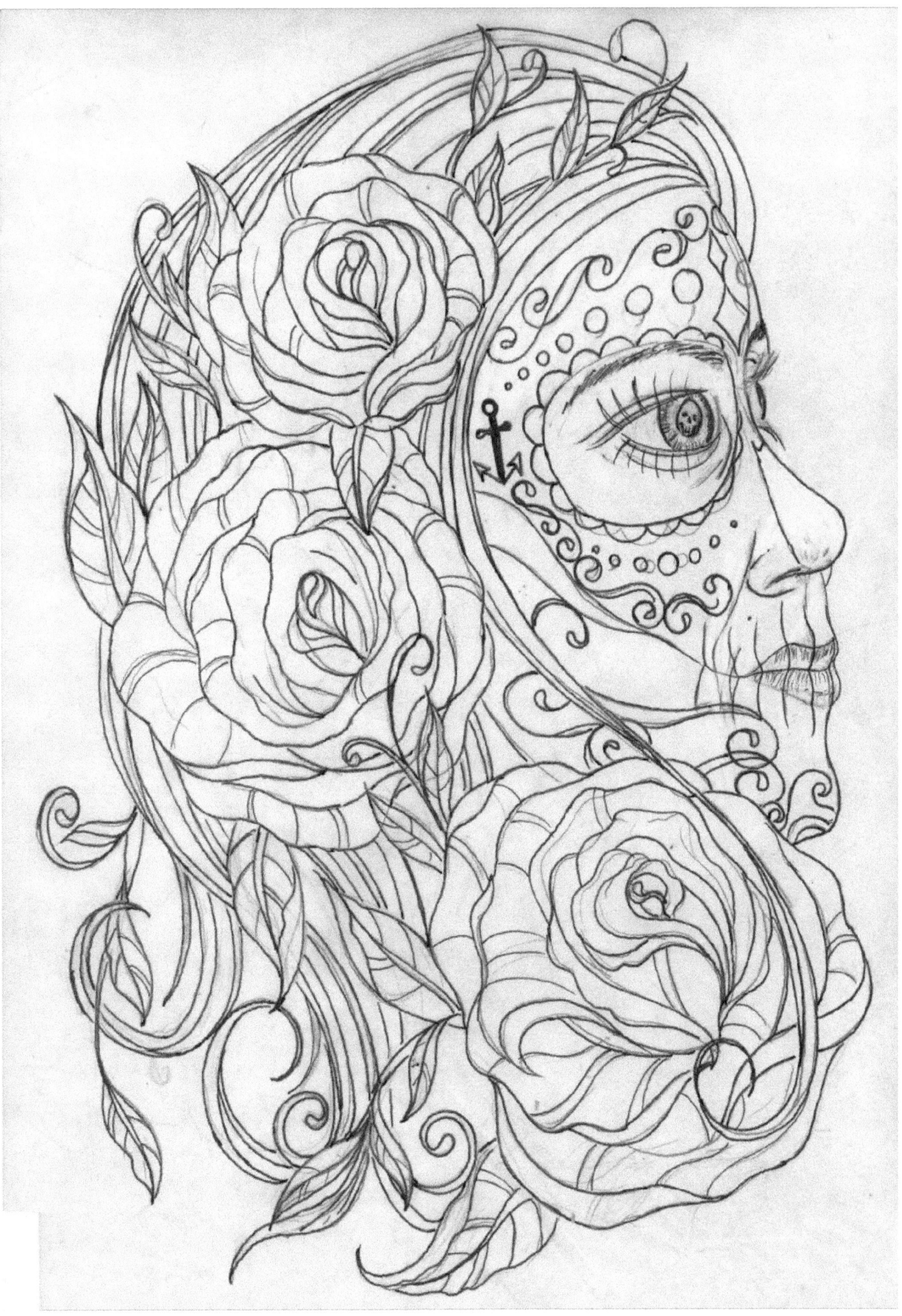

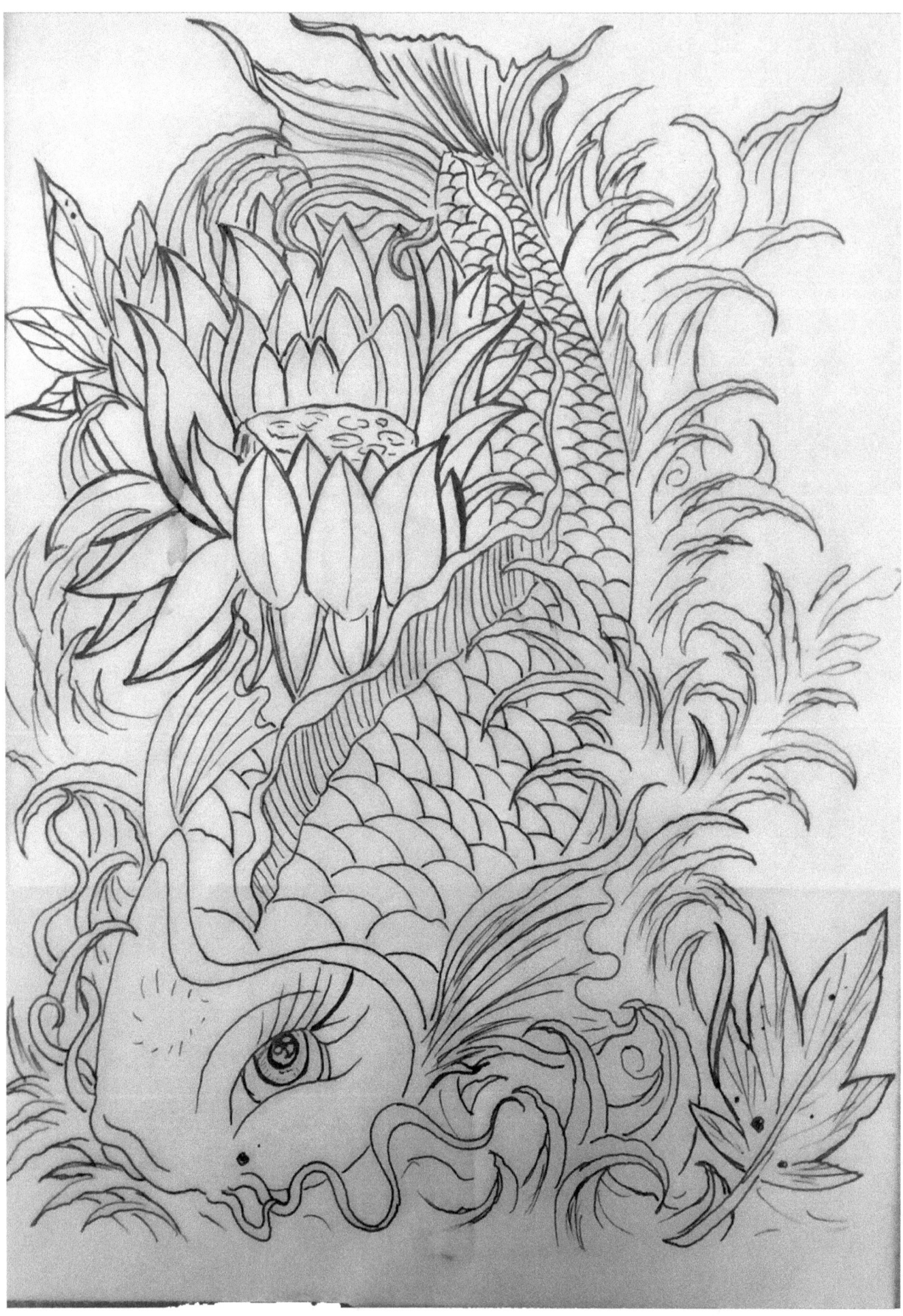

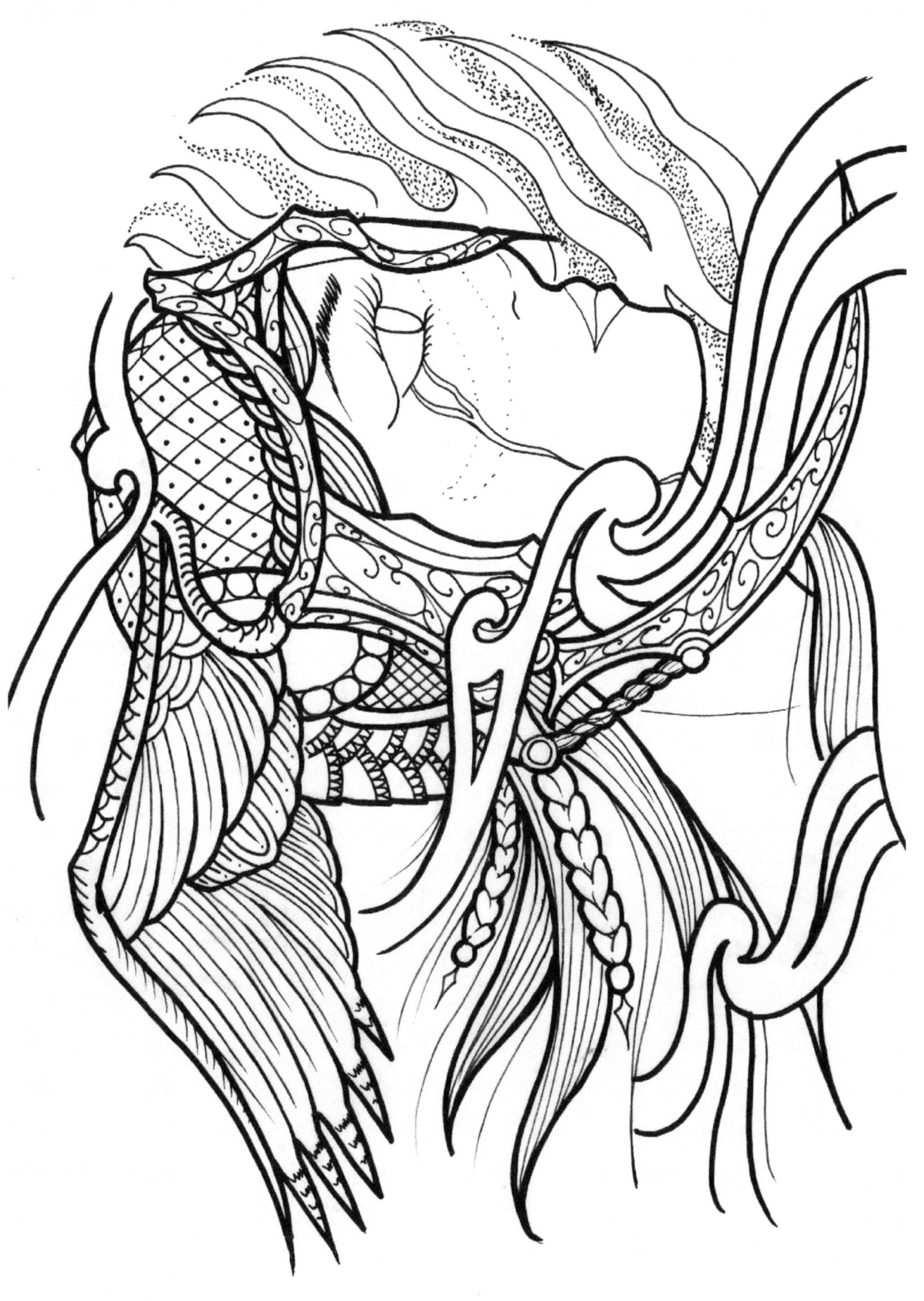

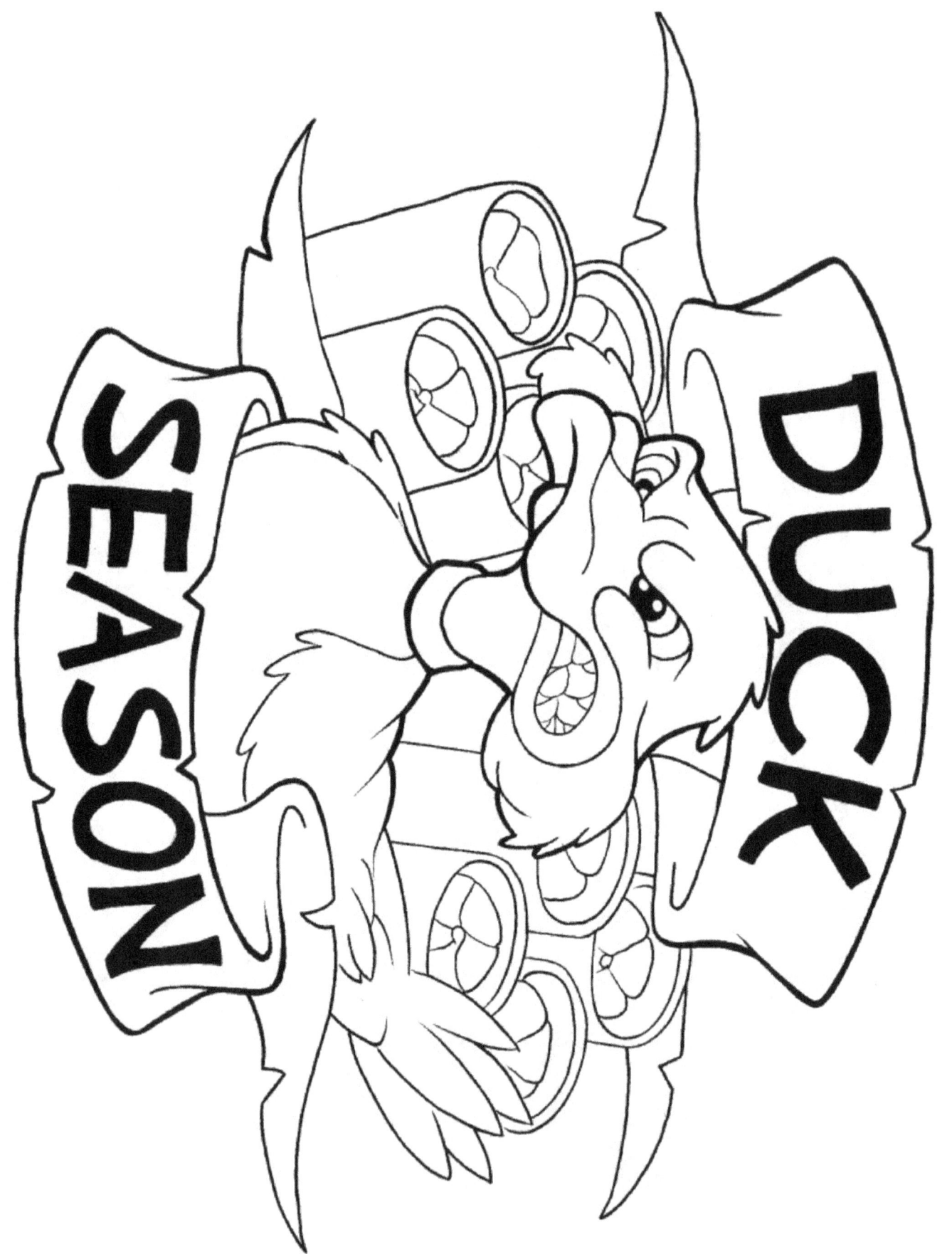

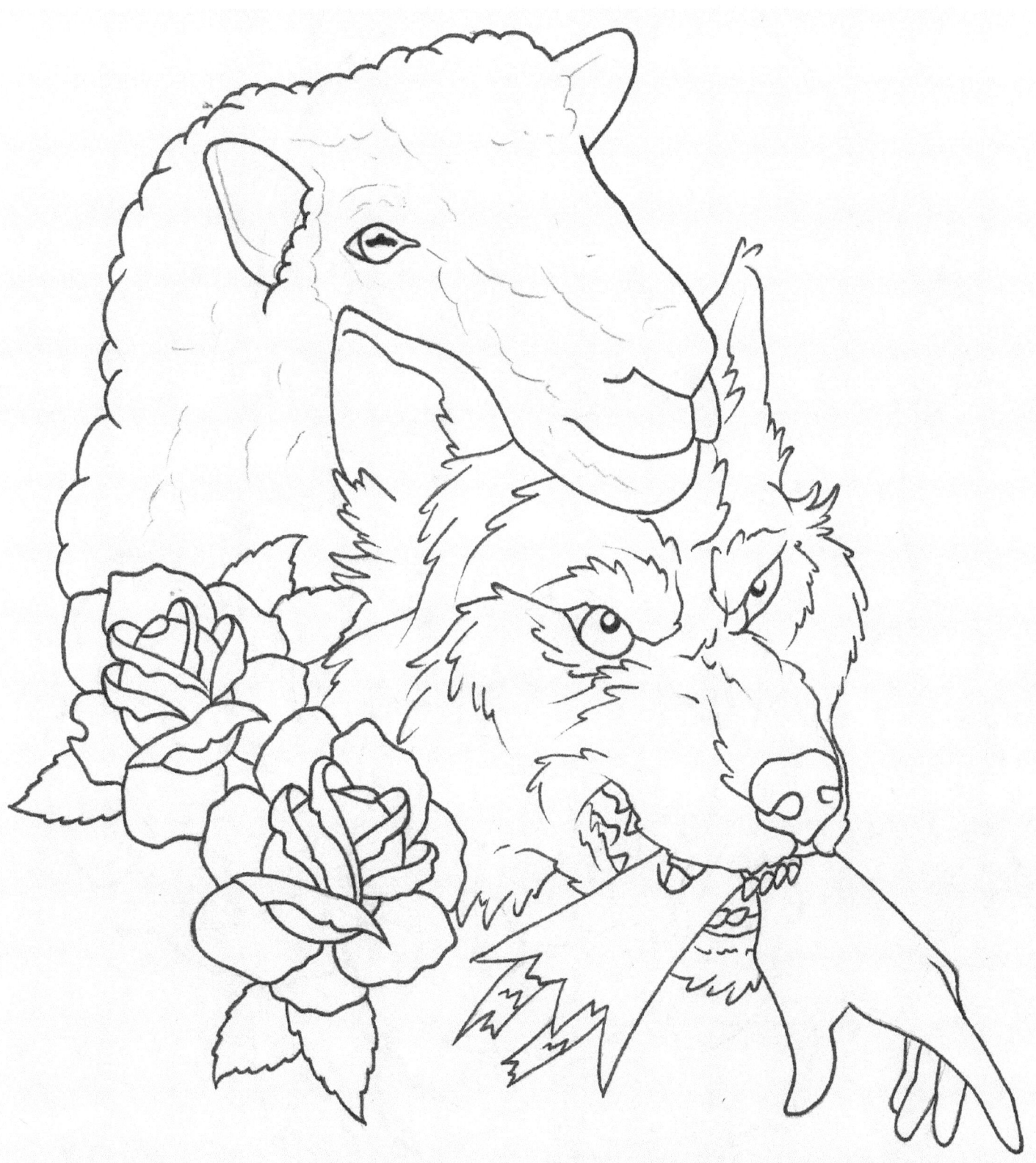

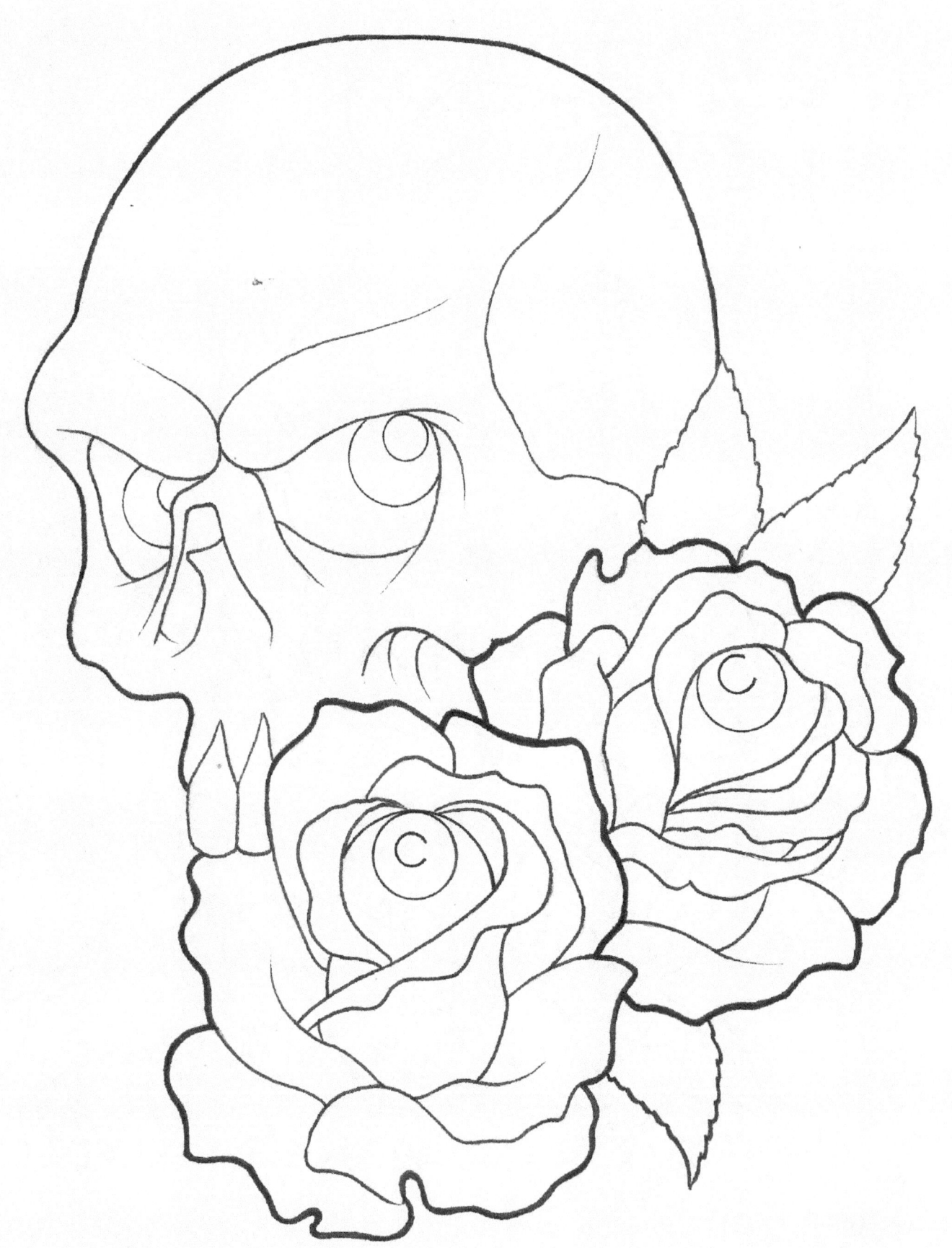

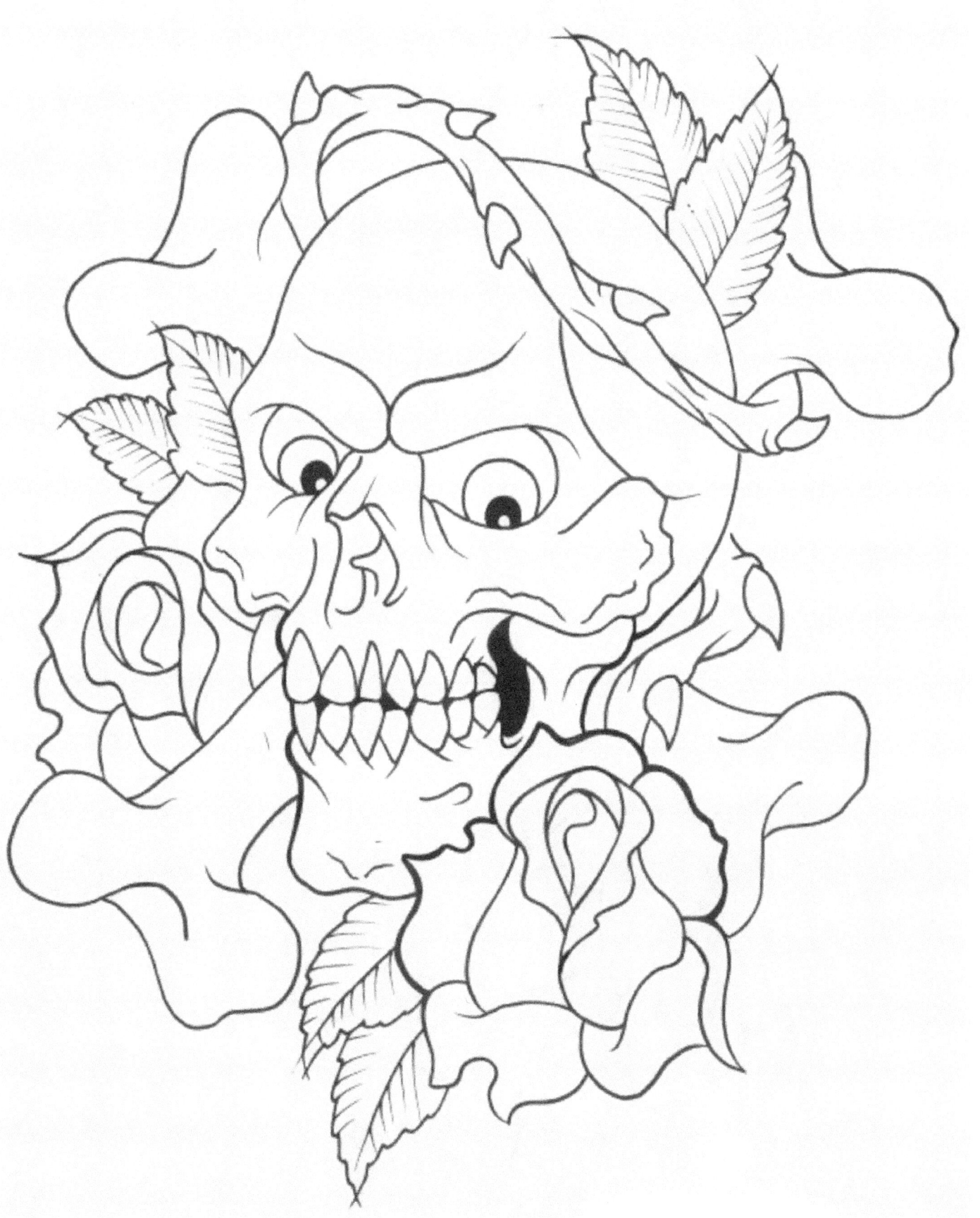

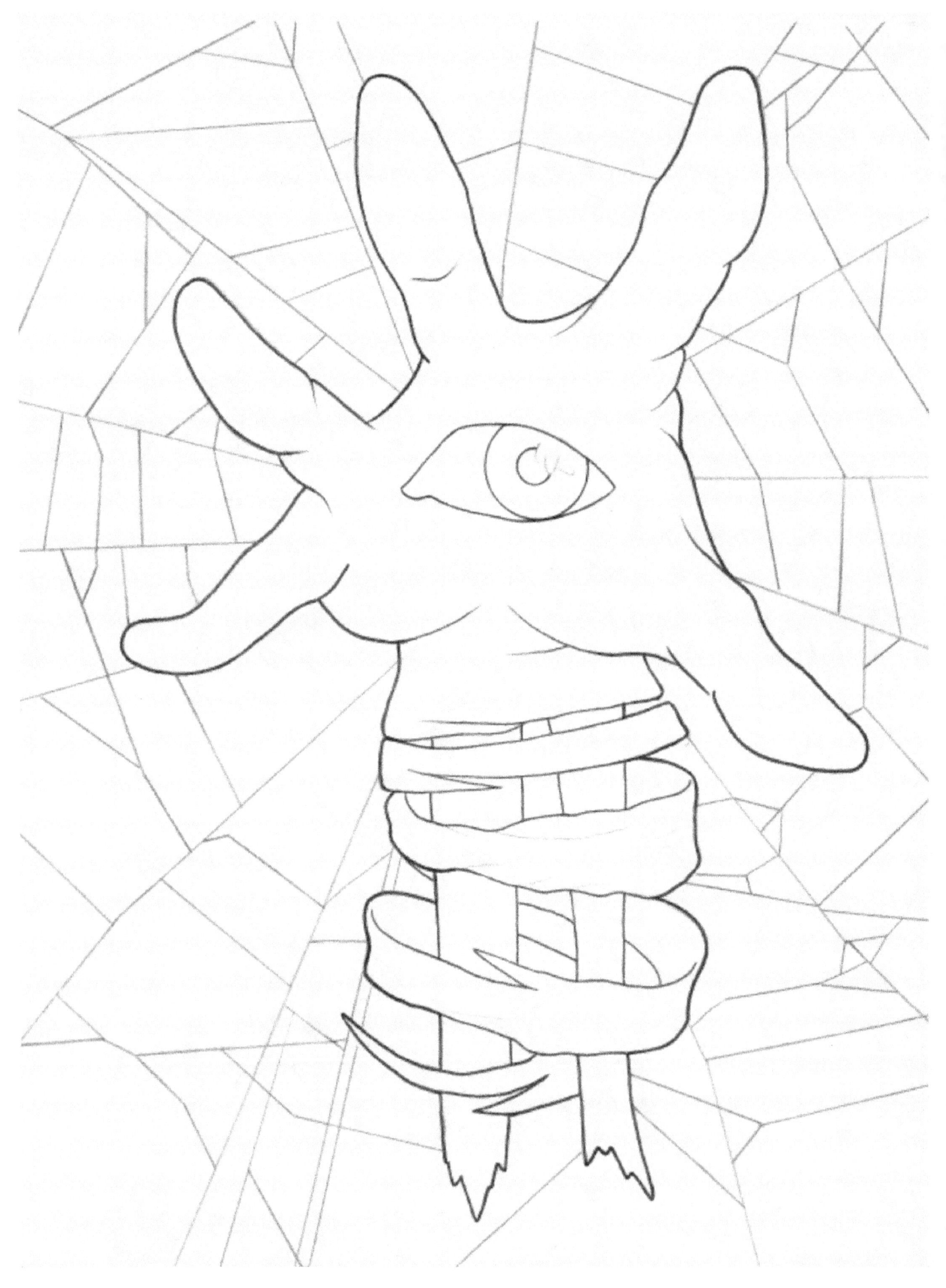

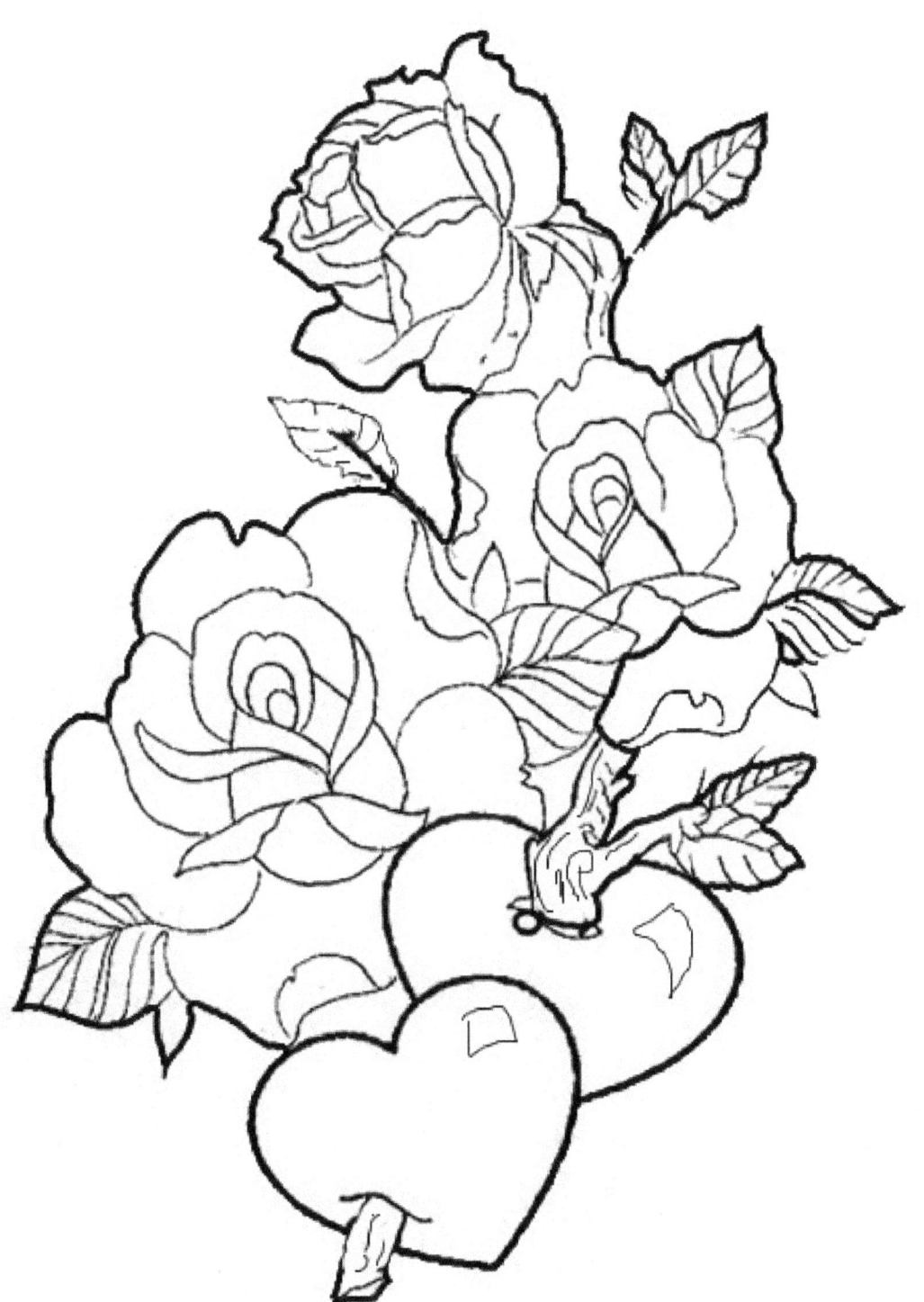

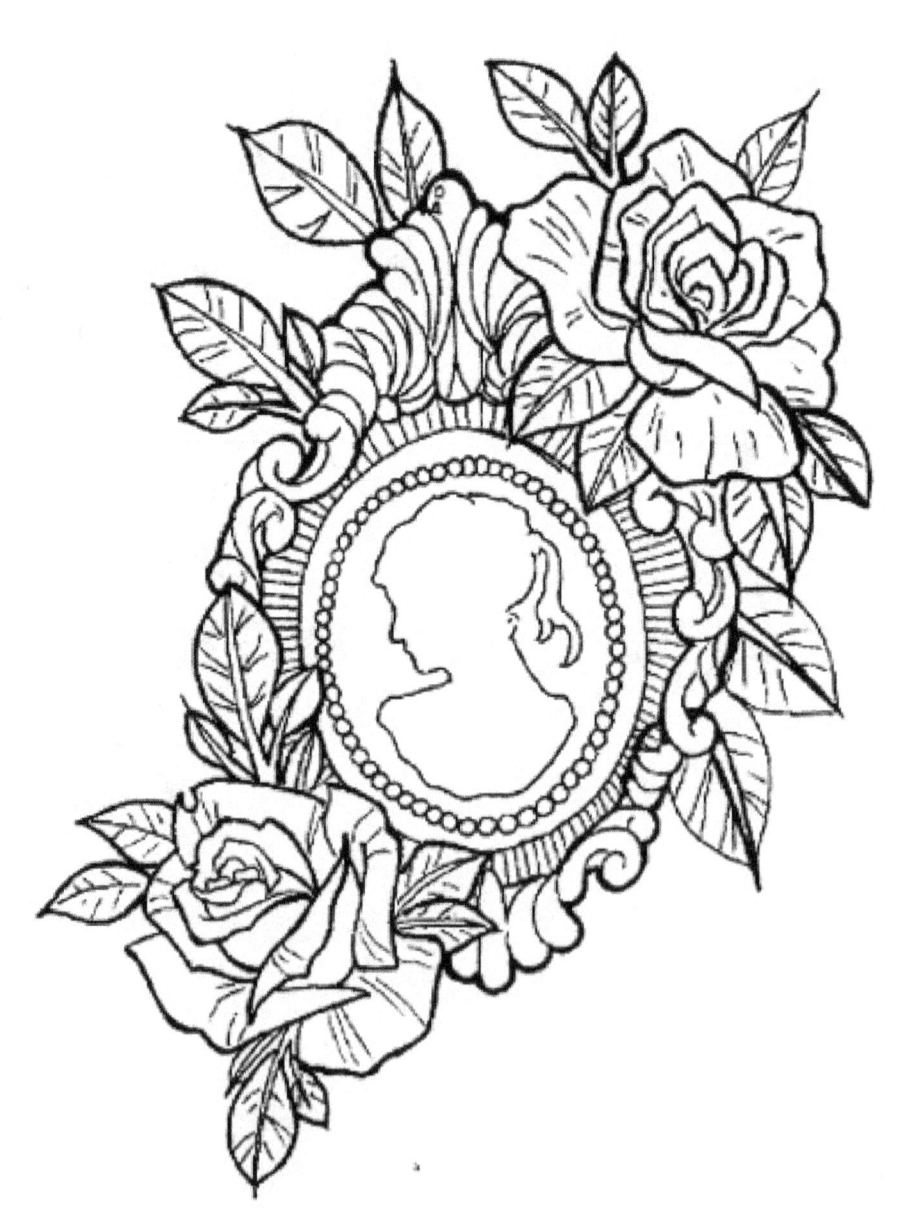

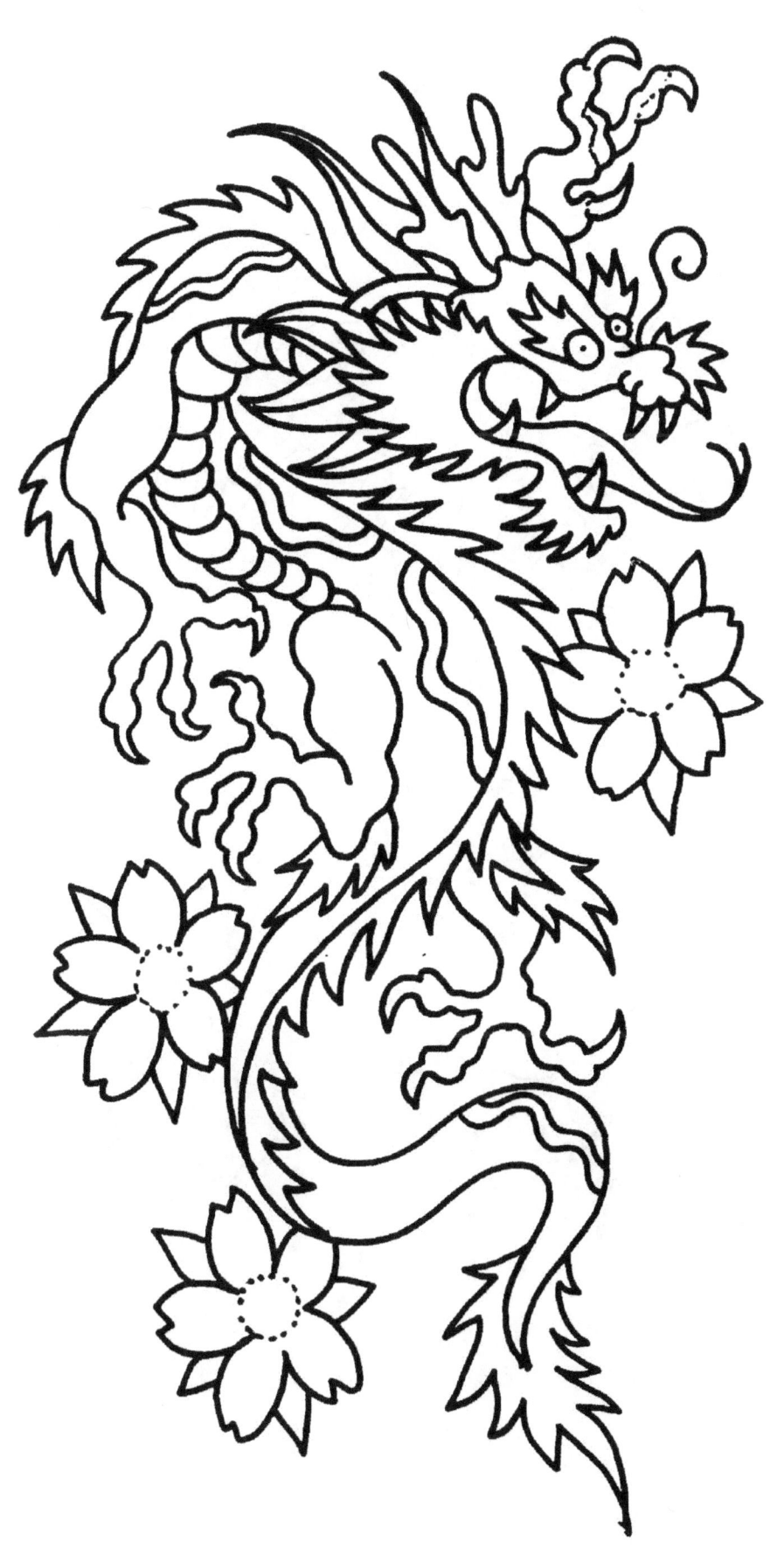

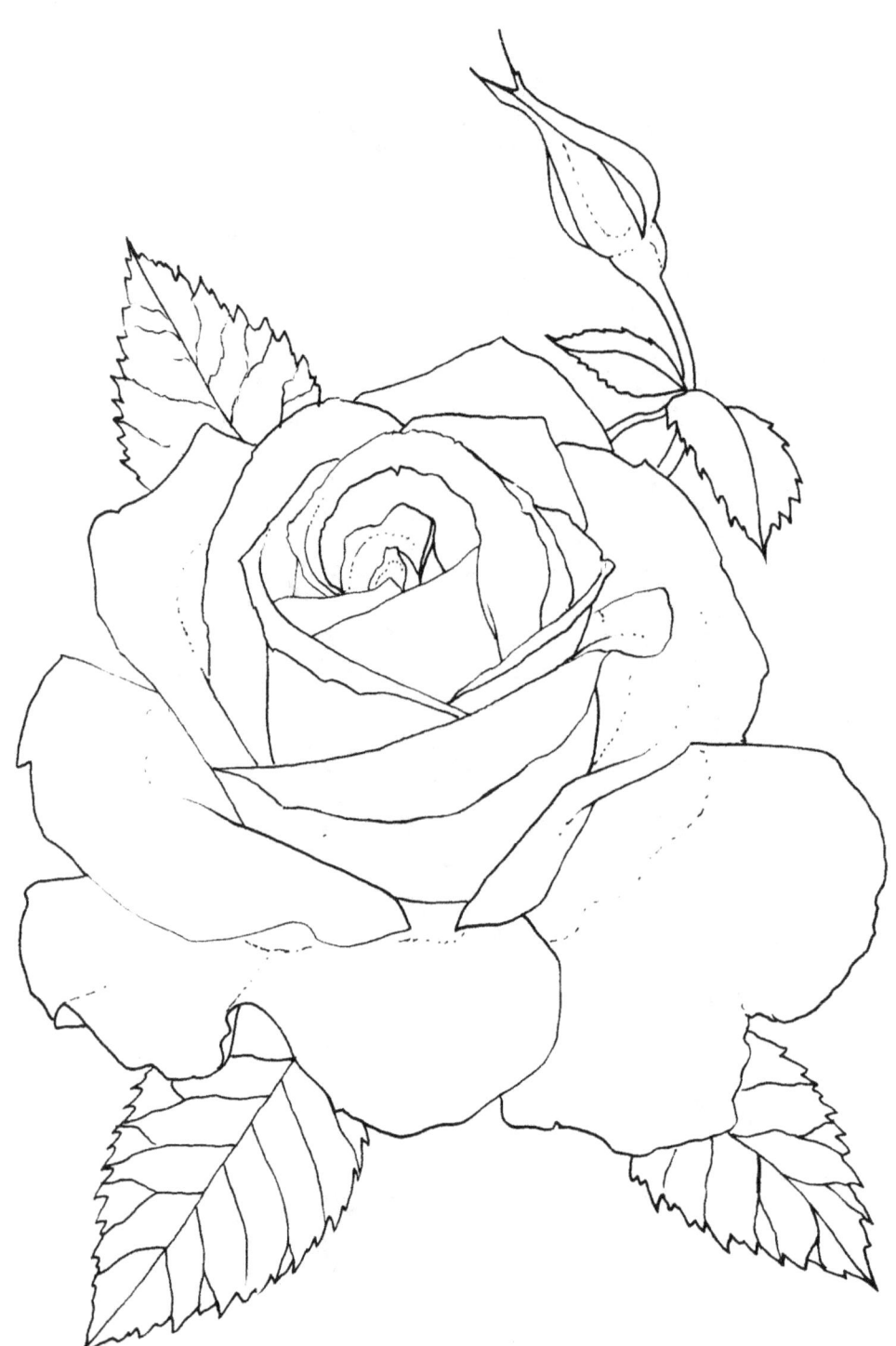

www.ingramcontent.com/pod-product-compliance
Lightning Source LLC
Chambersburg PA
CBHW080715190526
45169CB00006B/2381